PRAISE FOR
The Secret of Scent

"Luca Turin's engaging new book . . . doesn't feel at all like something we've read before—which is a tribute both to its subject and to its author. . . . Turin's subject is fascinating and his prose is vivid." —*New York Times Book Review*

"He has a natural fluency and a sense of humor that shines through every page. . . . Whatever aspect of this book strikes you as the most interesting, you will come away from it better informed and intensely sensitized." —*Los Angeles Times*

"This is a science book that reads like a mystery novel, with vividly drawn characters (both human and odoriferous) and chemical clues." —*Discover*

"A delightful book about the science of smell, *The Secret of Scent* takes the reader through a tour of the almost infinite range of human olfactory possibilities." —*Science*

"What distinguishes this account, besides the author's wit and his enthusiasm for fragrance, is his florid writing about scents. Turin has a remarkable ability to detect and describe their complexity: For him, they are not simply odors; they speak and have personality and colors . . . overall a fascinating tour of the world of fragrance, provided by a knowledgeable and passionate expert."

review)

"I didn't skip a word in this book, not even on the second reading. . . . How can you not love a scientist who writes respectfully of the terse haiku produced on strict budgets by functional perfume chemists, especially the Basho masterpiece that was the 1972 fabric softener Stergene?"
—Veronica Horwell, *New Statesman*

"The best science book of the year so far." —BBC Radio 4

"You can see the world in a grain of sandalwood, and heaven in a wildflower—rose, lily of the valley, or jasmine—with Luca Turin at your side. . . . This is one of those books that focus on a tiny patch of human ingenuity and in doing so opens new windows on the wider world. . . . He writes brilliantly, with the easy confidence of the expert and the infectious enthusiasm of the true amateur, and this book is a reminder that the entire natural world, ultimately, is a chemistry set, and nature the greatest perfumer of them all."
—Tim Radford, *Guardian*

"A rich sensory trip . . . this indispensable guide to all things smelly is as good as it gets." —*Sunday Telegraph*

Desa Philippi

About the Author

LUCA TURIN was born in 1953 and educated in France, Italy, and the UK. He holds a Ph.D. in biophysics from the University of London and was for ten years a tenured staff member of the Centre National de la Recherche Scientifique (CNRS). From 1993 to 2000 he was Lecturer in Biophysics at University College, London. Since 1996 he has worked on primary olfactory reception and the prediction of odor character. In 2001 he became chief technical officer of Flexitral, where he uses his theory of olfaction to design new fragrances and flavor molecules.

The Secret of Scent

The Secret of Scent

ADVENTURES IN PERFUME AND
THE SCIENCE OF SMELL

Luca Turin

AN **ECCO** BOOK

HARPER ● PERENNIAL

NEW YORK ● LONDON ● TORONTO ● SYDNEY

HARPER PERENNIAL

First published in Great Britain in 2006 by Faber and Faber Limited.

A hardcover edition of this book was published in the United States in 2006 by Ecco, an imprint of HarperCollins Publishers.

HarperCollins books may be purchased for educational, business, or sales promotional use. For information please write: Special Markets Department, HarperCollins Publishers, 10 East 53rd Street, New York, NY 10022.

FIRST HARPER PERENNIAL EDITION PUBLISHED 2007.

Library of Congress Cataloging-in-Publication Data is available upon request.

ISBN: 978-0-06-113383-1
ISBN-10: 0-06-113383-3

ISBN: 978-0-06-113384-8 (pbk.)
ISBN-10: 0-06-113384-1 (pbk.)

07 08 09 10 11 ID/RRD 10 9 8 7 6 5 4 3 2 1

To Desa

~ Contents ~

Acknowledgements

I thank Tania Sanchez for brilliantly turning a messy manuscript into a book. Much of the historical information came from interviews with Bruce Clayman, Kevin Wright, Barry Beyerstein, Jennifer Maynard, Clifton Meloan and Bob Jaklevic. To all many thanks. I am grateful to all my friends especially Jane Brock, Tim Arnett, Martin Rosendaal, Michael Reid Hunter and Chandler Burr for their kindness over the years. Susan Hunter-Joerns is the world's best neurologist, and I owe her a great deal. I am also indebted more than I can say to Geoffrey Burnstock for making room for me in his great Anatomy Department, and to Marshall Stoneham for his generous welcome at UCL Physics since 2001. My perfumer friends, especially Guy Robert, Calice Becker, Chris Sheldrake and Roger Duprey, patiently explained to me a great many things I could never have figured out for myself. Thank you, Julian Loose and Henry Volans at Faber. Thanks to Flexitral CEO Jacquelin Grant for turning a dream into a dream job. Last but not least, my love and gratitude goes to my mother Adela for bringing me up tenacious and occasionally reckless.

The Secret of Scent

❦ *Nombre Noir: how I got into perfume* ❧

In 1981, at the age of twenty-seven, I moved from London to Nice. I remember wondering how long it would take me to tune out the beauty of the place, the strangeness of its dream-come-true villas, the pearly quality of its morning light, the surprise vistas at every turn of the various *corniches*. The answer eventually came: I never got used to it. But I soon found out that, behind the dazzling concave smile of the Promenade des Anglais, the rest of the place was in need of major dental work, full of shabby remnants of the 1960s: millineries selling crosspoint patterns; dismal driving schools; Alsatian restaurants serving *choucroute* in the summer heat.*

At some point in the past, perhaps due to the proximity of Grasse, the perfume business must have flourished. Every few blocks stood a sad little perfumery with shelves full of forgotten wonders gathering dust. Different professions seem to foster different attitudes. French bakers tend to be friendly, florists snobbish and curt, butchers salacious. Perfumeries in Nice were staffed by brassy middle-aged women in a permanent sulk. No doubt the fierce competition from department stores accounted for some of the bad mood. This made the job of ferreting out strange perfumes more interesting, a kind of reverse charm school. At around that time, I befriended a Belgian antiques restorer who scoured flea markets for furniture and picked up old (and cheap, in those days) perfumes for me. That started my perfume collection.

Early the following year, during one of my periodic visits to the Galeries Lafayette, I noticed a shiny black arch in the corner of the perfume floor. This was the brand-new walk-in stand for a Japanese company I'd never heard of called Shiseido, and

* The best description of Nice imaginable can be found in Patrick Modiano's novel *Dimanches d'Août*.

3

it showcased their first 'western' fragrance: Nombre Noir. I still remember the black-clad sales attendant spraying it from a black glass octagonal sampler on to my hand.

The fragrance itself was, and still is, a radical surprise. A perfume, like the timbre of a voice, can say something quite independent of the words actually spoken. What Nombre Noir said was 'flower'. But the way it said it was an epiphany. The flower at the core of Nombre Noir was halfway between a rose and a violet, but without a trace of the sweetness of either, set instead against an austere, almost saintly background of cigar-box cedar notes. At the same time, it wasn't dry, and seemed to be glistening with a liquid freshness that made its deep colours glow like a stained-glass window.

The voice of Nombre Noir was that of a child older than its years, at once fresh, husky, modulated and faintly capricious. There was a knowing naivety about it which made me think of Colette's writing style in her Claudine books. It brought to mind a purple ink to write love letters with, and that wonderful French word *farouche*, which can mean either shy or fierce or a bit of both. I immediately bought a very expensive half-ounce in a little square black bottle. It bore the initials SL for a mysterious name: 'Serge Lutens'. A few months later my girlfriend took it with her when we parted, and soon after the fragrance was discontinued. Little did I know at the time that I would have to wait twenty years before smelling it again.*

I had always liked perfumes, but this was love. I had just then got my first real job, and thanks to the election of François Mitterrand as President, France embarked on a brief but intense period of profligate hiring of civil servants. The 1982 vintage was to become legendary: never, before or since,

* Only last year did I manage to trade a pristine ounce of Coty's 1917 Chypre against a large (black, octagonal) spray full of Nombre Noir in the possession of a journalist friend. Nombre Noir was composed by Jean-Yves Leroy, who tragically took his own life this year.

4

has it been so easy to get lifetime tenure as a scientist. I had a proper job, I had time on my hands, access to an excellent library, and I did what scientists are supposed to do: start thinking. It was Nombre Noir that got me started on a long journey towards the secret of smell, a journey that would take fifteen years.

The secret is this: though we now know almost everything there is to know about molecules, we don't know *how our noses read them*. Hundreds of times each week chemists somewhere on earth make a new molecule. In the days before safety officers, chemists used to routinely smell and taste the fruits of their efforts. They no longer do. My colleague Daniel Boerger thinks those who did died early and failed to propagate their genes, and the species *homo chemicus* var. *gustans* has disappeared. Still, if it is powerful enough, and they either open the vial deliberately or forget to close it, they will smell it. Every time it is an absolute mystery what each molecule is going to smell like. It is as if each new molecule were an inscribed clay tablet with a word written in an unknown script, and a smell to go with it, like banana or rose or musk. The pile of tablets is now enormous, so big in fact that no one can have smelled more than a small fraction of the total, and we still don't understand how the things are written. The smell is encoded in the molecule using a cipher. This mysterious cipher is what this book is about. Like all good mysteries, it is hidden in plain sight. It has, if anything, deepened as our knowledge of smell has increased. Like most enticing enigmas, it is simply stated: what is this chemical alphabet that our noses read so effortlessly from birth?

Part of the reason for the lack of interest in the subject must be that smell science produces little that is useful to the sober pursuits of medicine and technology. There are few diseases of smell, and those that exist are usually incurable and get little sympathy. And though it is big business, fragrance is a

low-tech, frivolous and fickle world. The relative neglect of smell compared to other senses may also have to do with the fact that it cannot be easily transmitted like images and sound. As a colleague of mine put it, 'You still can't fax a perfume.' Possibly also, it is wrongly held to be less reliable as a sensation than vision or sound. Finally, there is a definite 'real men don't do this' side to smell and fragrance. I have found that male scientists frequently blush and titter like schoolchildren when given smelling strips during a lecture, whereas women eagerly smell the strips and compare notes with each other. Whatever the reasons, the cipher remains unbroken.

This does not mean that people do not care. Everyone has wondered about the nature of odours from antiquity onwards. Smell was (rightly) taken as evidence for the existence of atoms and (wrongly) for their having different shapes, some smooth (roses), some sharp-edged (mustard). Modern theories are only slightly different. Basically, they say that the shape of the smell molecule, i.e. the geometric arrangement of its atoms, determines its odour character. As we shall see, shape-based ideas have conspicuously failed to explain the central problem of smell. This is no longer strictly a problem for professionals, since they have failed to crack it. Everyone can have a go. Even Enrico Fermi, the great Italian physicist said to have been the last man to know all of physics, once remarked to a colleague[*] while sniffing the aroma of frying onions, 'Wouldn't it be wonderful to know how this works?' In fact the Central Problem of smell has joined the ranks of a very small, élite band of conundrums. Like the origin of life, the mechanism of general anaesthesia, the extinction of dinosaurs, the kinship of the Basque language, it is a scientific Sword in the Stone. And, great and small, Nobel Prize winners and complete unknowns, experts and beginners, many have come up to the stone and

[*] Giorgio Careri, of the University of Rome, who told me this story.

heaved on the sword and come away with nothing but a sore back. Once in a while some claim to see the sword budge, but the heavenly light still hasn't shone on anyone, the prize is still there for the taking.

Here I tell the story of how I think I finally cracked the code. Actually, as often happens, it had been cracked twice before by brilliant minds, but nobody took them seriously. All I did was extend their work, and this book is my tribute to their insights. As will become apparent, the scientific jury is still out on whether my theory is correct. But there is a huge difference: for the past three years I have been designing new perfume molecules for a living, *using my decoding method*. This involves predicting odour from molecular structure, which was until recently reckoned impossible. The company that has taken the bold step of hiring me as chief scientist is called Flexitral, and I fondly hope that they will not regret their decision. Until they hired me, I was an academic scientist living in a world where money, like sexually transmitted diseases and car accidents, is something that only happens to other people, and not very prudent ones at that. All that has changed. If, as I believe is the case, I have managed to decipher how smell is written into the structure of a molecule, there is a lot of money to be made by efficiently designing new fragrances and flavours.

When people ask me what I do for a living, for simplicity I now say 'fragrance chemist'. Nothing could be further from the truth, since I have no formal training in chemistry. Worse than that, my work, if successful, may make specialist fragrance chemists largely redundant. However, it is as good an opening gambit as any. Chemistry has an ill-deserved reputation for dullness,* and the conversation usually stops there. If not, what happens next falls into a pattern. Some immediately

* It is merely badly taught, like most sciences, especially at the age when kids are first interested, i.e. between six and ten years of age.

make the association with Suskind's book *Perfume* and the conversation pleasantly moves on to sex and bodily smells. Hypochondriacs start complaining about their allergies to various fragrances. A few declare their eternal allegiance to one perfume or another. Occasionally someone asks where one can still get some deleted masterpiece (eBay). Many people want to know why modern perfumes are so crap. For the most part, though, no one seems to have much of an idea of what perfume is, how it is made, and for that matter of how smell works.

❦ *A recipe* ❧

Perfumes are complex mixtures of what the people in the industry call 'raw materials'. The raw materials in turn can either be extracts from natural sources (mixtures of molecules) or synthetic raw materials (usually single molecules). Mixtures, both natural and synthetic, are often beautiful, whether they be designed by evolution to attract bees or by us to attract each other. However, they tell you almost nothing about how smell is written into molecules, i.e. what property of molecules is responsible for their smell. The study of smell requires one to exit the realm of the beautiful to descend into what German philosophers used to call the Sublime, and come face to face with the enduring strangeness of raw sensation.

I remember once walking across a parking lot between industrial buildings at the headquarters of a perfumery firm and suddenly catching an intense whiff of some molecule they had just finished making and were probably dispensing into drums. It smelled of fruit, but not of any particular fruit, perhaps some compromise between peach and apricot, though more vivid and less subtle than either. It only lasted a few seconds, but left an impression of indefinable oddness. It was

8

only much later that I managed to put a finger on why it was odd, and it came to me suddenly as a picture, not words. What was strange about the fruity whiff was what was missing: *colour*. The grey of the concrete, the pleasant wind in the blue sky, the green of the English countryside – all were accounted for, pictures and smells present and correct. Suddenly this huge orange-coloured smell comes out of nowhere. To justify its presence, there should have been a pile of ripe fruit one hundred metres high, but there was nothing, only a light breeze coming from a nondescript building. This severing of effect from cause is one of the wonders of smell. It gives it the quality of a hallucination, and makes the first contact with pure perfumery synthetics a strange experience. Walk down the shelves in the perfumery lab and pick a little brown glass bottle at random, then another, and then another. Each, when opened, will release a different genie, a hologram of an object with attendant mood, at once familiar and impossible to name. What's more, only you, with your nose in the bottle, actually smell it. Others around you go about their business untroubled by the enormous apple that has just appeared next to you and which you alone can see. Even when you dip smelling strips into the little bottles and hand them round, you still get the feeling that you are alone. Smelling is an active process and you cannot tell when others are sniffing or for that matter whether they feel what you feel.

Individual synthetics are almost never beautiful alone, because they have a raw, unfinished quality about them. Going from perfume to pure synthetics is a bit like being a lover of mosaics, and being shown boxes full of little squares of a single colour. A mental readjustment needs to take place before one can focus on the exact tonality, texture and mood that the little square elicits. For example, cis-jasmone is a character material, meaning an essential ingredient, of natural jasmine smell. Indeed, no decent jasmine reconstitution is possible

without it. Smell it by itself in the pure form and it is not remotely reminiscent of jasmine. Instead, it has a sweetish anise-like or liquorice smell, but with a cut-grass (or *green* as it is known in the trade), almost earthy quality. Come back to it half an hour later, and you will decide to rearrange these elements differently. The green-anisic has become a clearcut celery note, whereas the sweet-earthy remainder, your mind has now decided, is more in the nature of caramel sugar. Smell it again another day and it will be reassembled into another pattern. The underlying sensation remains the same, but its features, like an incomplete photofit, can fit different familiar faces.

The words used above are called descriptors, and they are merely what come to mind when smelling the stuff. As with any effort at appreciation, as one progresses from dumbfounded novice to expert, the naming comes more easily, but the list does not get longer. One merely learns to use descriptors that have acquired currency by common agreement. We are now familiar with television presenters on food programmes sipping a cheap supermarket white and immediately reeling out lush lists of descriptors. Some of them may be faking it, but the game is not as ridiculous as it looks – only it takes some training. What makes the wine business interesting is not so much the result, pleasant though it is, but the requirement that this chemical cornucopia be achieved using grapes alone.

The fragrance industry is held to no such moral principle, and has always been able to rely on artifice. Instead of natural-ness, however, its obsession is with *purity*. The problem with smelly molecules, or *odorants* as they are known in the trade, is that their potency differs enormously, the strongest being as much as a million times more powerful than the weakest. This means that in the extreme case a million-to-one impurity of the strong stuff in the weak one will contribute 50 per cent of the smell. If you consider that 99 per cent purity (one in a

hundred impurity) is as good as it gets in chemistry, you know that trouble is brewing. Indeed, impurities have fooled fragrance chemists time and again, and many a pure product smells totally different from the slightly impure and very successful commercial product.

∾ *How perfumes are composed* ∾

There are six* big perfumery firms, billion-dollar multinationals, and countless small ones. The Big Six (and the tiny company I work for) have the privilege of creating new perfume molecules. The others merely mix the ones that are available for sale outside the parent company. Those that aren't for sale are called captive. In order to understand how a perfumer works, look at her[†] desk. On the right, a little tray prepared by the commercial department contains twenty or so 5-ml bottles of the stuff that has just appeared on the market, composed by other companies. This is only a selection of the most interesting or most successful ones. Bear in mind that in 2003 there were eight launches a *week*. It is hard work just to keep abreast of what is happening. Actually, things aren't that bad because everyone is mostly copying successful fragrances, so the endless (and needless) versions of the same thing are weeded out first.

Next to the current-affairs tray, a stack of annotated computer printouts contains the analysis by gas chromatography and mass spectrometry of the most interesting new perfumes. These land on the perfumer's desk only days after the stuff becomes

* In alphabetical order: Firmenich, Givaudan, IFF, Quest, Symrise and Takasago.
† Perfumery used to be a male preserve, but in recent years, and in particular since ISIPCA (an independent perfumery school) opened, the proportion has gone to fifty-fifty and many of the world's most successful perfumers (artistically and commercially) are women.

available. The annotations are made by highly skilled analytical chemists, because groups of peaks (each peak is an individual chemical) come from natural materials and have to be recognized as such, while others are pure synthetic stuff, some captive. The captives cannot be copied because they are under patent, and some, particularly the very powerful ones present in small quantities and therefore hard to isolate, are literally unknown. These captives seldom make a huge difference to the final product, because alternatives are usually available. Armed with the printouts, perfumers can copy any simple fragrance in days. Which is handy because what most clients want, in their infinite wisdom, is the same (an existing success), only different. Things get a lot more complex if the fragrance contains lots of natural materials, because these have more complex signatures and may be harder to identify and to source.

Next to the printouts is a tray of novel raw materials. Some are naturals, brought by extraction firms all over the world and deposited on the desk of perfumers in the hope that they will specify them in their next Big Fragrance. Even at 1 per cent in the final product, a huge success like Dior's J'Adore translates into *tons* of, say, jasmine absolute. If you're a small Indian producer, and you are selling it for a few hundred dollars a kilo, that's a lot of money. Naturals are often superbly complex, rich smells. But they are not cheap, and their quality is variable. Before specifying one, a perfumer must run the gauntlet of the accountants and the buyers who are reluctant to commit to a novel natural until it has been supplied at constant quality for years. If your firm is just starting out or you have a new product, that looks like Catch 22: nobody buys it because nobody's bought it.

In front of the perfumer are the latest versions of whatever she is working on. Typically a perfume goes through several tens of, sometimes several hundred, revisions. They are put together in the compounding lab next door, by technicians

who spend their days weighing out formulae. The different versions are labelled by project name and version number, and evaluated daily, by specialist evaluators who come in, smell the different attempts, discuss what to do with the perfumer and select the ones that are going to be shown to the client. All this is in response to a brief from a brand, namely a description of what the brand wants. Briefs range from the sublime to the ridiculous with a strong preponderance of the latter. Nevertheless, perfumery firms compete for briefs, and when the brief is won many more modifications are still needed before the final fragrance is arrived at.

Perfumes are smelled on thin strips of blotting paper with the company logo on it. They are attached to little 'trees' that rest on the table so that many strips can be smelled in quick sequence when doing comparisons. Finally, to the right of the perfumer, next to the telephone, is the all-important computer that calculates the price of a formula on the fly as the modifications are made. Ten years ago a fine fragrance used to cost €200–300 per kilo. These days €100 is considered expensive. Bear in mind that only 3 per cent or so of the price in the shop is the smell. The rest is packaging, advertising and margins. The cheapness of the formula is the main reason why most 'fine' perfumes are total crap. Other reasons include slavish imitation, crass vulgarity, profound ignorance, fear of getting fired and general lack of inventiveness and courage.

The vast bulk of perfumery is not fine fragrance, but 'functional' perfumery. Everything is fragranced these days, and someone has to decide what to put in it. To functional perfumers, a budget of €100 a kilo would be like winning the lottery; €15 is more like it. It is a credit to their genius that many household things smell good, and that some of the ideas in functional perfumery trickle up to fine fragrance rather than the other way round. Some functional perfumes are true works of art: I would pay real money for a bottle of the 1972

fabric softener Stergene, which smelled sensational. One last word on the grubby subject of money: in fine fragrance there is a threshold below which a good fragrance is impossible, and we are probably there right now. However, more dosh does not necessarily mean better perfumes: some of the great fragrances of the past were actually relatively cheap formulae, and it is still quite possible to mix expensive raw materials and get an expensive mess.

❧ *What perfumes are* not *about:* ❧ *memory and sex*

The first reaction of most people when the subject of smell comes up is to mention its 'evocative' power, and to illustrate it with an anecdote about Granny's perfume. But the peculiar thing about smell *cannot* be that it evokes memories, because just about everything does. How many times, for example, has one felt the pleasant pang of nostalgia upon hearing a pastel-coloured Bacharach melody gently rain down from the ceiling speaker above an airport loo? Ever tried going out for dinner with the sister of a girl who dumped you and feeling those slightly rearranged facial features touch your heart when the light is right?

No, the special thing about smell is that it is *idiotic* in the proper sense of the word, namely unique. There are no exact equivalents in smell, you have to hit the tiny nail smack on the head or you'll miss it by miles. That's why the event is rare, and that's why we notice it. If what did it for you was *This guy's in love with you*, no amount of Raindrops can stand in, and your ex's sister might as well be a complete stranger. The uniqueness goes right down to the molecule level. As I've said, there are no synonyms: no two different compounds out of the hundreds of thousands made so far have identical smells.

Much less with mixtures: what *was* special about Granny's perfume is that, unfortunately for you, it was Guerlain's first (1962) version of Chant d'Arômes. It smelled divinely of peachy skin, and no other floral lactonic before, during or since ever hit that exact spot. And furthermore, they messed with the formula some years ago when the bean-counters took over, thereby putting your late grandmother's smell *permanently out of reach*. You are now officially at the mercy of fate, waiting for that moment fifteen years from now when you'll walk past a stall in a flea market, pick up a small sample bottle in a tattered black and gold box and stand there transfixed. Or maybe you won't go to the market that day.

The other thing you hear when smell is mentioned in polite company is the question of whether fragrance works for the opposite sex the way shit works for flies. The facts of the case are, at the time of writing: (a) human pheromones exist, otherwise for example the menstrual cycles of women who share accommodation would never synchronize, and (b), as far as we know, pheromones are perceived by a separate organ in the nasal septum that is wired directly to the engine room, bypasses all the higher functions and simply says, 'Take me to your ovaries.' No smell sensation, in other words.

Clearly, this is the usual confusion between hardware and software. Hardware is the machine your genes built: opium kills pain, salt tastes salty, hormones go up and down. Software is what's on the hard disk with your name on it: dope gets you down, Mahler is vulgar, flat shoes are sexy. If fragrances were full of powerful biological attractants, you'd think they would at least work, considering how much they cost. But then why do most men's fragrances smell so vile? Why does the woman in the red dress who sits next to you at a concert wreck the evening by wearing half an ounce of Poison? It's time for a thought experiment. Imagine you lose your sense of smell, just like when you had that bad cold five years ago, but this time, as

occasionally happens, it never comes back. Food would become unutterably boring: you might as well join Weight Watchers, eat textured mushrooms and feel good about your bum. But sex would still be OK, because your eyes, hands and ears ('I love it when...') would still work. I rest my case.

∾ *What perfumes* are *about:* ∾ *beauty and intelligence*

Software it is, then, and probably Art too, if one defines art as any craft that is both difficult and beautiful. There are actually two branches to the art of smell: perfume and flavour. Both are in a peculiar position compared to other arts, e.g. music. The music composer does not have much competition from the natural world, aside from the occasional three a.m. nightingale recital. The Niagara Falls cataract makes a huge noise, not a symphony,* and only the blessed perceive natural sounds as music. But perfumers and flavourists are constantly humbled by the greatest perfumer of them all, Nature. A walk through a rose garden in June will reveal every varietal to have a unique smell, ranging from that peculiarly lemony style which one never encounters in perfume, to the heavy oriental via all shades of peppery tea. A ripe mango, with its combination of incense-like austerity and sulphurous decadence, is a perfumery idea of pure genius. The exhaust blast from the coffee-roasting shop down the street is as rich and beautiful as anything bottled by man. That is probably why most perfumers see themselves as craftsmen, not artists.

* There may be a deeper connection between the two than was hitherto realized, in so far as many types of noise, including clapping hands, have a spectrum, that is to say a statistical distribution of pitches similar to certain types of music. Unlike the pitches of melody, however, those of noise are scrambled. It is as if your gourmet soup-to-nuts meal of music was served all at once, after being put through a blender.

Flavourists are to perfumers roughly as Stubbs is to Kandinsky, and they feel about each other much as their figurative and abstract counterparts in the visual arts do. To perfumers, flavourists are flat-footed imitators. To flavourists, perfumers are pompous abstract painters who can't even do a good likeness. Both are, of course, highly skilled. The job of the flavourist is the olfactory still life. Everyone knows what the object is like: strawberries, chocolate, salt and vinegar, bacon. The game is to get it right, occasionally with humour. Accordingly, almost all the molecules used in flavours are 'nature-identical', which is to say, found somewhere in nature. If you find that reassuring, reflect upon the fact that bitter almonds are lethal, and that the biting edge in horseradish is due to a variant of a war gas. Indeed, if someone invented horseradish today, they could never get it past the food safety agencies, and the same applies to watercress, mustard, angelica root and a number of other earthly delights.

By contrast, most fragrance raw materials are novel molecules with entirely new smells to make perfumes that resemble nothing in particular. Very seldom does a perfume reveal its sources of inspiration. There are, to be sure, some fragrances like Diorissimo that are meant as hyperrealist depictions of a flower, in this case lily of the valley. They make artistic sense only because there is no such thing as lily of the valley oil. Muguet, as the French call it, is too expensive and fragile for that. Edmond Roudnitska famously planted muguet in his garden near Grasse when he was composing Diorissimo in order to be able to compare his portrait to the real thing. Another example of realism is found in perfumery bases. A base is a composition, a mixture of many pure molecules, to be used as a sort of prefab building block in a fragrance. No perfumer would waste weeks recreating a peach note if that wheel has already been invented.

I have on my desk as I write this a smelling strip dipped in the peach base Pierre Nuyens composed for Quest, one of the Big Six and ICI's fragrance division. It is a huge, velvety, fluorescent peach thirty feet in diameter, with fuzz on it as deep as pile carpet, like Magritte's huge fruit inside a room. It is a peach played slowly, an *arpeggiato* chord that lets you enjoy in slow motion the entire sweep of that astonishing Persian plum, from mouthwatering fruity acid, via biscuit-like softness, to powdery, almost soapy bottom. Nuyens, by his own admission, spent months on it and the formula contains nearly two hundred different pure compounds.

But these perfume portraits are the exceptions. By and large, perfumery lost interest in depicting anything in particular as soon as abstraction became possible, when chemists started making New Smells. It is hard to date that event accurately since chemists have been making smells for hundreds of years. One thing seems certain, however: the first perfume that made use of a man-made smell was composed in 1881 by Paul Parquet for Houbigant, and was called Fougère Royale. Don't bother asking for it in a store. It hasn't been made in decades. In any event Houbigant, after a period of meretricious trading on its name with an awful range of fragrances, has now almost vanished from the landscape. The only place you will find Fougère Royale today is the Osmothèque in Versailles, the world's only proper perfume museum.

∾ *A visit to the perfume museum* ∾

Take the suburban train from Gare Saint-Lazare to Versailles Rive Droite, a twenty-minute ride. Get out of the station, which already feels provincial with its line of waiting Mercedes taxis, their idle drivers chatting to each other, and set off down the interminable Avenue du Parc de Clagny. The entire suburb

emits the sadness of fulfilled dreams. On both sides are the large houses of those who made it a century and a half ago, giving off the curious mixture of luxury and meanness that comes from building them almost as large as the grounds, with only a little room to spare. The straight road climbs and gets to an intersection. There on the right is the pair of villas joined together that houses the ISIPCA. The acronym is typically French. It stands for *Institut Supérieur International du Parfum, de la Cosmétique et de l'Aromatique Alimentaire.* In other words, Perfume School.

Founded in 1984 it was, astonishingly for a country that has made so much money from selling fragrances worldwide, the first of its kind. Until it opened, those who wanted to be perfumers had to join one of the big fragrance composition firms, usually as a technician. Then they had to wait for years until someone noticed that they would be better employed composing fragrances than weighing mixtures all day, and claw their way up the ladder. The School has since produced some of the great contemporary perfumers, from Patricia de Nicolaï (New York) to Francis Kurkdjian (Le Male). Like most educational institutions, the school does its best to keep out some useful talent. For example, it requires two years of university-level chemistry prior to entrance. Since the majority of older perfumers, including the very best ones, cannot tell one end of an aliphatic aldehyde from the other, this requirement is clearly perverse, and seems designed to exclude the Arty Types the school so sorely needs. It is as if painters had to know dye chemistry before joining Art School, or composers needed to be familiar with Rayleigh's Theory of Sound.

But there is more to the ISIPCA than the Perfume School. Housed in the basement, and in a small room to the left of the entrance, is the Perfume Museum. To be sure, other, glitzier establishments claim to be such. Fragonard's splendid collections in Paris and Grasse are all about bottles and distilling

equipment, but the only smell in evidence until you reach the museum shop is that of floor wax. But here is a big difference. The Versailles Osmothèque is a modest, shoestring affair, not open to the general public, but entirely, fanatically devoted to smell. The only thing you can buy at the Osmothèque is a subscription to its learned *Bulletin*, which looks like a well-produced school mag and is full of arcane details about long-forgotten perfumers.

The Osmothèque was founded in 1990, almost too late to fulfil its mission, which is to preserve, and in many cases recreate, the great fragrances of the past. Perfumery firms, more often than not tied to such ephemera as fashion houses, have gone bust by the dozen. Worth, Piguet, Houbigant, Jacques Fath, Coty, all died. Sometimes the name survives. Coty, for example, is now owned by the German firm Benckiser and still sells perfumes that bear the glorious names of François Coty's creations: Émeraude, l'Origan, l'Aimant. But these bear no relation to the originals. Generations of accountants have simplified and cheapened the formulae until what remains is a ghastly changeling. To those who knew the real thing, this is like being stuck with Jacques Loussier, while all J. S. Bach scores and recordings are methodically destroyed. Call the firm to complain, and with luck you will be put through to someone in PR who will swear blind that the original formula has not been tampered with.

Go to the Osmothèque, however, and you will smell the Past. But even that is not so easy. The ordinary visitor has no direct access to the collection. Instead, he or she must attend a guided tour of the museum, consisting of lectures given by retired perfumers and accompanied by distributions of smelling strips to illustrate the points made in the talks. The smelling strips are dipped in little bottles, and the little bottles are dilutions of the Big Bottles stored in a dark, airless cold store in the basement. That part is out of bounds to non-professionals. I have earned

the right to visit it by donating a rare fragrance to the Museum, a pristine ounce of Houbigant's 1900 Parfum Idéal which I found, unopened, still in its original box, in a Moscow antique store in 1991.

You can, of course, take the smelling strips with you when you leave the Osmothèque and if you ask them nicely, they will even provide little cellophane sleeves to slide the strips in. That will keep the perfume for much longer, sometimes weeks rather than hours. When you visit perfumers at work, you will often see on their desks the little Osmothèque sleeves. Ask which fragrance is on them, and the answer will often be: Houbigant's Fougère Royale. It is Fougère Royale that I have come to smell today, calling in my one favour to the place.

◈ Royal Fern ◈

Some say Fougère Royale is to fragrance what Kandinsky's first abstract gouache of 1910 is to painting: a turning point. Even the tongue-in-cheek name ('royal fern') announces that the game has changed: ferns, of course, have no smell, and there is nothing royal about them.* What made Fougère Royale so special in 1881? It made use of a freshly minted *synthetic* ingredient called coumarin. To be sure, coumarin was contained in many natural products available to Parquet. But to have it pure, and cheap, allowed him to use a big dose and to get a different effect altogether. I am sitting across the desk of the *osmothécaire* waiting to be summoned down to the cold room to smell Fougère Royale. At last he appears, and we trundle down a flight of stairs and along a corridor to the cold room, where row upon row of unprepossessing, opaque aluminium

* Houbigant did supply French royals with perfumes in the late 1700s, famously causing the disguised Marie-Antoinette to be recognized by a passer-by during her attempted flight from France: the perfume gave her away.

bottles of different sizes are stored. The whole affair looks mundane until you read the labels: Émeraude, Iris Gris, Ambre Antique. It is like being taken to a corner of a zoo and allowed a glimpse of sabre-toothed tigers. The assistant finds the small bottle of Fougère Royale, dips two smelling strips, hands me one and keeps the other for himself. He's smelled it a hundred times, but I have noticed professionals go through this little sharing ritual. Is it because fragrance memory is fugitive, and they welcome a reminder? Is it a small stolen pleasure? Whatever, it has the feel of a brief communion, a quick pipe of peace inhaled in the presence of something great.

Here it is at last, under my nose. The Fougère dynasty has spawned vast numbers of familiar fragrances, almost all masculine, notably Brut, Azzaro Homme and the elusive Canoë. All are angular, soapy and quite unabashed. I imagined the founder of the line to possess those virtues in undiluted abundance. It makes the surprise even greater when Fougère Royale starts the way some Bruckner symphonies do, with a muted pianissimo of strings, giving an impression of tremendous ease and quiet power. It does smell of coumarin, to be sure, but it is also fresh, clean, austere, almost bitter. This is the reference smell of scrubbed bathrooms, suggestive of black and white tiles, clean, slightly damp towels, a freshly shaven daddy. But wait! There's a funny thing in there, something not altogether pleasant. It's a touch of natural civet, stuff that comes from the rear end of an Asian cat and smells like it does. Suddenly I understand: we're in a bathroom! The idea here is *shit*, and what's more, *someone else's* shit, that faint shock of slightly repellent intimacy you get when you go to the loo at someone's dinner party and smell the air. Small wonder Fougère Royale was such a success. At a distance, he who wears it is everyone's favourite son-in-law; up close, a bit of an animal. Months later, as I write this, the smelling strips still work their magic. I'd give anything to have a bottle on my shelf.

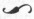 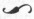

But what was so interesting after all about Parquet specifying coumarin for his new fragrance, and why did he do it in the first place? And for that matter, what does coumarin smell of? The great Steffen Arctander, author of the reference book on smelly molecules,* describes it as 'Sweet, herbaceous-warm, somewhat spicy odor, in extreme dilution more hay-like, nut-like, tobacco-like'. We are so used to associating this smell with buff-coloured things that it is impossible not to think of the colour beige when smelling coumarin. Whoever made coumarin for Parquet was merely replicating a thing found in nature. The tonka bean, from which coumarin is extracted, contains so much of the stuff that when the beans are dried it crystallizes on top. Remarkably, tonka beans contain little else, so it is not as if the smell was new in its pure form. The main justification for using a man-made material, then as now, is that you can get it cheaper than by extracting it from the real thing. Coumarin costs €10 a kilo, Tonka bean absolute €400 a kilo. Fougère Royale also contains many naturals, chiefly oakmoss and lavender. I'm guessing, the formula is not in the public domain. These good old-fashioned ingredients are plants that people pick, these days mostly in Russia and former Yugoslavia. They get heaped on to trucks, carted to the nearest extraction plant and stirred with some hot solvent. The good stuff is extracted from within the plant and later steam-distilled from the mixture. Unsurprisingly, the result is fragile, variable and, given the roughness of the process, often damaged. In some ways, natural raw materials are to their plant of origin as orange preserve is to Seville oranges, or shrunken Jivaro heads to the live enemy. If you have the run of

* *Perfume and Flavor Chemicals* (ISBN 0931710375). Two volumes of faultless, consistent, pernickety descriptions — the Robert Parker of smells.

a perfumery lab or, more easily, of an aromatherapy store, it is instructive to open up the little bottles, sniff them first and *then* read the label. The origin of the oil often comes as a surprise. Rose oil, for example, smells like a concentrated version of those intense and unexpectedly colourless liqueurs from Alsace that are the pride of the distiller's art: Poire, Framboise. That is to say, it does not smell much of roses. The wonderfully expensive and almost impossibly rich narcissus absolute made by the small Grasse-based firm of Monique Rémy smells like a farmyard *tutti*. Hay, flowers, honey, cowpats, earth, even ham in some ways, but totally unlike the hand-picked Auvergne narcissus flowers from which it is made.

In a way, the very existence of perfumery is due to the raw materials being such poor replicas of the real thing. If rose oil really smelled of roses, the perfumer would merely hang her head in shame and give up. Instead, her task is to mix these gnarled, cooked, mangled bits of dried-up live things and, much like an embalmer, give them the bloom of life once again. But what makes natural materials desirable, and is at the same time their chief drawback, is *complexity*. Complexity is hard to define and easy to recognize. Think, for example, of the early music synthesizers and their boop-boop sounds. Those are simple, machine-like sounds. The sound waves follow a simple pattern, mostly one or a few sine waves mixed together. The novelty effect is great, but soon wears off, because we are used to more complex sounds, like voices or violins. Natural sounds – for example, a few notes played on the flute – are rich and complex. The same goes for smells. We have a nose as well as an ear for complexity. Pure, single chemicals smell simple, rather bare and never pleasant enough in the long term to be used alone in a fragrance. Naturals, even when not particularly pleasant, smell rich because that is what they are.

But the drawback of complexity is that it makes it harder to compose original fragrances, because you never have control

over individual notes within the fragrance. Each natural ingredient smells of many different things, and they all come together. It is as if you were building a prefabricated house from pieces, each of which contains the wiring, the plumbing, the wallpaper, even the pictures on the walls, all glued together. The house goes up quickly and may even look interesting in the end, but you cannot redecorate it or make alterations. In perfumery, the world's hardest job belongs to the chief perfumer for Aveda, who not only specifies all naturals, but is now upping the ante by specifying all organics!

❧ Why 'chemical' does not always mean bad ❧

People react badly to the word 'chemical', and it is a generally accepted nostrum that allergies are on the increase and that unspecified 'chemicals' are responsible for them. But natural essences will make you come out in a rash as often as synthetic ones, as any aromatherapy textbook will aver. To look on the bright side, it is a mark of the overall success and opulence of our civilization that many people have nothing worse to worry about than skin rashes, and therefore worry about skin rashes. The EU has published a list of twenty-six allergens which it intends to restrict in use. It makes interesting reading. Most of them are high-volume materials: that is to say, things to which a lot of people have been exposed to for a lot of time. That means the allergens list is in part due to a statistical effect: you need a quorum of people with a particular allergy before dermatologists notice it.

Above 'permitted' levels, the fragrance has to be labelled with a symbol that says 'may be bad for you' and the potential allergens listed. This is fine, were it not for the fact that the list reveals these things to be horrible chemicals, rather than the

lovely rose essence or some such that people thought was in there. People read labels and find things like 'Hydroxymethyl pentylcyclohexene carboxaldehyde', a.k.a. Lyral®, an excellent and of course largely harmless lily-of-the-valley synthetic. The notion that 'nature knows best' is so firmly entrenched in everyone's mind, partly through the noxious effects of the idiotic end of the 'green' movement, that the fragrance industry has almost given up explaining itself before it even tries.

Part of this is, of course, the industry's fault. The phrase 'lies, damned lies and . . .' should probably end with 'perfume press releases' rather than 'statistics'. The fragrance world has been coy about its chemical origins virtually since it started. This is related to the general practice, now fortunately going out of style, of treating women like complete idiots. Perfume advertising is full of the most laughable nonsense, non-existent flowers and woods, 'pink musks' and all sorts of folderol that would be funny if it weren't also sad. Had it been more upfront all along, the industry would not be in a pickle today. Add to this the fact that the tools of analytical chemistry are getting better all the time, and that analytical chemists can detect smaller and smaller amounts of perfume materials in places where they shouldn't be, and you have a recipe for mass rejection of chemicals by the public.

It seems to me that the true background to all this is what I call the Law of Conservation of Worries. As genuine reasons for anxiety, like polio, TB and smoking recede, they are replaced by phoney ones, so that the anxiety level is kept homeostatically constant. I can think of no process – save a major cataclysm such as a flu pandemic – that would reset this anxiety to a low level in the developed world. The phrase 'studies have shown' in a newspaper these days almost always prefaces a new worry to be added to the pile to make sure it does not shrink. Clearly, in this field, if material progress continues the worst is yet to come.

If you happen to be allergic to narcissus absolute (€30,000 a kilo), you need not worry, since the stuff is definitely not contained in your soap powder. If you have an allergy to hydroxycitronellal, which is everywhere and smells of lily of the valley, then you are likely to meet another person like yourself in the waiting room of the dermatologist. There are three possible approaches to the problem:

1. Ban fragrances: not good, because 'unfragranced' products smell *bad*.

2. Ban or restrict the offending chemicals: OK, but in due course they will be replaced by other bulk ones, likely to be just as allergenic.

3. Label the bottle properly, so people know that if they are allergic to something they can stay away from it. This solution is OK, except that a lot of the products concerned are supposed to be good for you, which would not agree all that well with a nasty EU allergen label on the bottle. Time will tell.

There is another, far more serious aspect of chemicals, namely environmental pollution. Part of the problem here is that soap powder is, this side of a blowtorch, one of the harshest environments to put fragrance in. As a result the fragrance materials that go into soap powder tend to be rugged fellows, which typically makes them tough enough to resist biodegradation. After all, even bacteria have to follow the laws of chemistry. Couple that with the fact that hundreds of tons of these materials, typically musks, are washed down the drain every year, and that analytical techniques get better and better, and you have a predictable result: these molecules are detected in fish, milk and all manner of places where they definitely shouldn't be. The best solution in this case is to create molecules that are less stable and more powerful (so fewer are needed), but can still make it through the roller-coaster

ride of washing machine and tumble dryer. Everyone is working on that. All this being said, synthetics are extensively tested for safety before being let loose on humans, which is more than can be said for naturals like hemlock.

∽ *Feynman's answer* ∽

In the meantime, despite our ignorance of their workings, our noses keep reading the air. Overheated electrical insulation is about to catch fire and finally torch the old car you're driving. Your ugly colleague is having a secret love affair with that gorgeous graduate student who wears patchouli. The champagne you're drinking (a major brand) illegally contains traces of a perfume added to each bottle so you'll remember it and come back. How does this work? Let us start from first principles.

When a journalist asked the great physicist Richard Feynman what single sentence would best encapsulate all science so far if it were to be the sole surviving scrap of all we knew, he replied, 'The world is made of atoms.' Indeed it is, and so are we. It is a source of constant surprise to me that, in polite UK company, someone who has never read *Hamlet* is considered ignorant, whereas someone who knows what atoms are is considered an *idiot savant* and encouraged to get out more often. Had Feynman been allowed a second sentence, he might have added, 'And the atoms connect with each other to make molecules'. Molecules are what we smell: smell is our *chemical* sense, and we are so used to it that we do not stop to think about how amazing it is. Consider this: a bit of brain grows downwards through a bone shot through with holes and dangles in the breeze somewhere up your nose. Smells, unlike sound and light, do not act at a distance: if you smell something, it is because pieces of the smelly stuff are evaporating from whatever it is you are smelling – whether

it is Rose de Nuit or frying bacon – flying though the air and ending up in your nose. The fact that they are colourless makes it look like a mysterious agency is at work, but if you were to add perfume to coloured smoke you would soon realize that you only smell the stuff when the colour reaches you. A complex smell is just what it says: a complicated mixture of different molecules, each adding its own odour, the sum total of which is the thing we call the smell. But what *are* these smelly molecules?

As Feynman didn't say, molecules are assemblages of atoms. Atoms come in different flavours, or *elements*, and the elements differ in their ability to connect with each other. As was figured out about a hundred years ago, atoms are not unlike tiny solar systems, with a central sun (the nucleus) and planets around them (electrons). The nucleus is made up of positive charges and the electrons are negative. Equal numbers of negative and positive charges are required to give a nice neutral, well-behaved atom. The negative planets don't simply stack up in increasingly larger orbits, but instead form groups – groups of eight to be exact. It's as if in each orbit there was room for eight planets, then when that orbit is considered filled up, you start with the next one.

What is important about all this is that the social behaviour of atoms – the branch of science known as chemistry – depends largely on how many electrons there are in the outer orbit. It is as if atoms are more comfortable with filled orbits, and are constantly searching for partners to swap electrons and achieve peace. For example, if one atom has seven electrons in its outer circle, it behaves like a collector trying to fill that yawning gap on its shelf and snaps up any electron around. Similarly, if an atom has just started the next electron orbit, and has only one electron in it, it is quite happy to give that up to go back to the neat arrangement of a properly filled eight-electron orbit. As you can readily imagine, when this

generous soul meets the manic collector, it's Love. This is precisely what happens when sodium metal (that shiny butter one cuts with a knife in chemistry lessons) and chlorine gas (nasty, heavy, yellow gas) meet up. They instantly strike this one-electron deal, and thereafter peacefully coexist as sodium chloride, or table salt.

Incidentally, the reason the table of the elements is called *periodic* is because elements which have the same number of electrons in their outer orbits will behave similarly. Carbon, the stuff of which almost everything around us and inside us is made, has four electrons available for bonding, and therefore makes at most four bonds with neighbours. The next one up is silicon (Si), the element of which, in the parlance of *Star-Trek*, 'non-carbon units' are made. It has eight electrons more than carbon. Because the next larger orbit is filled to the same extent (four electrons), silicon is a bit bigger than carbon, but also makes four bonds, for example to hydrogen to give silane, a nasty gas. Oxygen and nitrogen have two and three electrons in their outer orbits and will therefore make two and three bonds to neighbours, as will their periodic cousins sulphur and phosphorus. Everyone who shares a fondness for the periodic table thinks of it differently. I see it as a sort of class photograph. Fat guys at the bottom, thin ones at the top, arranged from left to right by *temperament*, with the placid types (eight electrons) at the far right, seated just next to the seven-electron psychopaths. The recklessly generous one-electron types are safely at far left, and the well-rounded individuals, those who should (and did) go far in life, somewhere near the middle.

What holds sodium chloride together is what holds *everything* together: electrical forces. It is hard to countenance the fact that our entire world is glued together by the same forces that make bits of paper stick to a rubbed plastic rod, but there you have it. In the case of sodium chloride, the sodium has lost

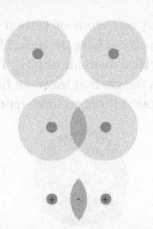

an electron and become positively charged, and the chlorine has gained one and become negatively charged. So they stick together. But even neutral atoms are held together by electrical forces, and the reason can be seen in the figure above, where the cloud is negative and the nucleus positive. When you bring two neutral atoms (top) together and their electron orbits overlap (middle), you tend to get an accumulation of electrons in the overlap region. Picture the two nuclei and this overlap region (bottom) and you have a neat little sandwich of positive-negative-positive charges that will tend to stick together.

However, things are not that simple, or chemists would not command large salaries and prestigious professorships. Each electron in the outer orbit independently makes its own little cloud of overlap. This means, for example, that carbon, which has four electrons in its outer orbit, can make four such clouds, whereas hydrogen, with only one electron, can only

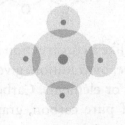

make, well, one. Put one atom of carbon and four atoms of hydrogen together and you have the *molecule* (on the bottom of the previous page) called methane or CH_4. This is also known as swamp gas, and it is the gas that leaks out from the rock in coal mines and kills people. A more accurate representation is shown

below. The white hydrogen atoms actually arrange themselves not two-dimensionally in a cross pattern but as far from one another as possible, at the four corners of a tetrahedron. The whole shape ends up not unlike those Tetrapak milk cartons of the 1960s. Most carbons will end up making four bonds like this, not just to hydrogen but also to, for example, other carbons.

Since we're on the subject, here is the structure of coumarin: from left to right, the model made of marbles, the structure showing the elements and the simplified notation chemists use nowadays. In the simplified notation, everything is assumed to be carbon (linked to the correct number of hydrogens to make up four bonds) unless otherwise specified.

The whole thing is like a construction set, and chemists like to play. Chemists have, by tradition, given colours to the different types of atom, or elements. Carbon got black because the cheapest form of pure carbon, graphite, makes a good

pencil lead. Sulphur is yellowish-green, just like natural sulphur deposits. Oxygen is red, perhaps because the chemical compound from which it was first isolated, the mercuric oxide

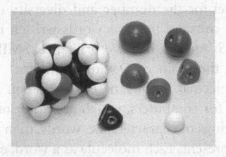

beloved of alchemists, is an intense fiery red. Small and primordial hydrogen (almost the entire universe is made of it) got white. Nitrogen got blue, which makes sense when you think the air in the sky is mostly nitrogen. These and all other known elements also got letters: C, H, O and N. The notation with the hydrogens omitted is the one chemists use when drawing things for explanation on the back of an envelope. It is not quite 3-D, more like ½ - D, but it does the job of representing the shape of molecules and their reactions reasonably well. It is also a good mnemonic, because our memory for shapes is excellent.

❧ *The beginnings of smell: chemical words* ❧

As I write, the German-based *Beilstein*, a venerable and now web-powered database, lists 8,128,462 different molecular structures reported between 1779 and 2001. Note the starting date, for that was when people finally gave up on the ideas of alchemy* and started using the notions of modern chemistry.

* The very best book on alchemy, which does full justice without condescension to these allegedly pre-scientific investigators, is F. Sherwood Taylor's slim volume *The Alchemists*, now unfortunately out of print.

These molecules are not merely theoretical constructs. Each was actually made by a chemist somewhere, and a recipe was published to enable other chemists to make it.

To get a feel for the number and diversity of molecules, it is useful to consider them as words written in a language called SMILES. An idea of pure brilliance, SMILES emerged in 1988 from the brain of David Weininger.* It stands for Simplified Molecular Input Line Entry System. The language was designed for computers, which are notoriously better at processing strings of characters, i.e. words, than pictures.

SMILES represents each molecule as a word, each of whose letters represents an atom, and provides built-in instructions on how to connect the ends. For example, cyclohexane (six carbons in a cycle), pyran (a conventional or 'common' name) and cyclohexanone (six carbons with a 'one' or C=O jutting out) are shown below. The way it works is pretty self-evident: when you have a closed circle, you cut it open and label the ends (C_1 connects to C_1) etc. Using SMILES, you can represent pretty much every molecule in a simple, machine-searchable way that does not rely on fancy algorithms to represent structures as graphs etc. For example, our coumarin would come out in SMILES as O=C1OC2=CC=CC=C2C=C1.

C1CCCCC1

C1CCOCC1

O=C1CCCCC1

Now here are several crucial bits of information to connect *smell* and SMILES:

* *J Chem. Info. Comput. Sci.*, 28 : 31–36.

1. Our nose likes short words, typically with fewer than twenty letters. For example: $O=C_1CCCCCCCCCCCCCCC_1$ smells of musk, but $O=C_1CCCCCCCCCCCCCCCCC_1$, two Cs longer, is odourless. Roughly speaking, anything with more than sixteen Cs stands a good chance of being odourless. Bigger things do not fit into our sensing mechanism.

2. The shorter the word, the shorter the smell. Spray CSC on your skin, and you will smell of truffles for thirty seconds. This is known in perfumery as a 'top note'. Every letter adds roughly a factor of two to the time. Try $CC(C)=CCCC(C)=CC=O$ and you will smell of lemon for thirty minutes, a 'heart note' for a fragrance such as a cologne. But spray on $CC_1CC(C)(C)C_2=CC(C)=C$ $(C=C_2C_1(C)C)C$ $(C)=O$, and you will smell of cheap musk for thirty hours or more. This would be a 'bottom' or 'drydown' note.

3. With a few exceptions – such as the garish, hyacinth-like bromostyrene, which contains big, brawny bromine (Br) and is no longer used – smelly molecules are made from only five types of atoms: carbon, hydrogen, oxygen, nitrogen and sulphur (C, H, O, N and S in SMILES). These *elements* all come from the same corner of the periodic table, the safe Upper East Side – unsurprisingly, since these are also the five elements that make up all life.

4. The molecules must be able to fly in order to reach our noses, so they should carry no charges that make them stick to each other (no positive and negative), and not too many sticky groups like -O at the end of a word. These make weak bonds to each another called 'hydrogen bonds', which prevent the molecules from taking flight.

5. If you're planning to sell the molecules in fragrance, they should be as unreactive as possible: no funny things like OO

35

and OOO (peroxides and ozonides) or N=NC (diazo), no nasty reactive stuff like OCN, NCS and others.

and most importantly:

6. No two words smell the same: for example, O=C1CCCCCCCCCCCCC1 smells of musk, but O=C1CCCCCCCCCCCC1, which is one C shorter, smells of cedar wood. *There are plenty of siblings, but no exact twins in smell.* How can we be so sure? Ask any fragrance chemist: hundreds of thousands of molecules have been made, each a different word. Compare them two by two if you like – they will never smell identical.

∽ *Smell becomes perfume: chemical poems* ∾

Many hundreds of such words make a perfume, the chemical 'poem'. Spray a smelling strip with fragrance in a store (they let you do that nowadays) and quickly smell it, then come back to it at intervals of a minute or so. When you get bored with this, put the strip in your pocket and go for a walk. Smell it a few hours later, then forget it and come back to it, say, a month later. What you will notice is that the perfume smells different every time: alcoholic at first, then typically fresh and floral, then the warmer, sweeter notes, then a long-lasting, quite stable heart and finally a 'drydown' which after a few days often becomes somewhat nondescript. What is happening is that the different kinds of molecules are leaving the strip at different rates, small ones bailing out early, large lumbering ones staying put until you finally trash the strip.

A perfume, once it has become familiar, works like an accurate clock. The procession of odorants, precipitous at first, stately later, tells us where we are in the story. Spray it on after work. The top notes, the first ones to fly out, say it is still early in an evening

that feels full of promise. Next come the heart notes, where the perfumer's art really shows itself, where fragrance tries (like us) to be as distinctive, beautiful and intelligent as possible. Lastly, by three a.m. the perfume has literally boiled down to its darkest, heaviest molecules at a time when our basest instincts, whether for sleep or other hobbies, manifest themselves.

This behaviour follows a physical law, as familiar to us as other manifestations of the arrow of time. Imagine the strangeness of a fragrance that was like a cologne played in reverse: first the sweet, soft, amber notes, then the spicy heart, and finally, in the dark of night, a blast of fresh citrus. It would be as scary as seeing the bath water sprout a shimmering column, head for the tap and disappear up the pipe.

What loosens the molecules from their perch is heat. On warm skin, the molecules are shaken by thermal motion more violently than on a cold surface. If you want to experience a perfume in slow motion, spray it on paper or on the outside of your clothes. Cold things have little smell, and one of the attractions of a snowy night is the total blank our nose perceives. Part of the fun with ice cream is the surprise when a huge flavour develops in the warmth of your mouth. Try this: put some strawberries and ice in a blender, give the mixture a twirl until the ice is finely crushed, wait for ten seconds, then take the lid off and smell. What you get is hard-boiled eggs, because the strawberries contain light, sulphur-containing compounds that alone manage to struggle free at this low temperature.

How big are molecules? Picture them on the smelling strip as a huge flock of birds settled on a white sand beach. They are invisible from afar, but as you come close, you realize that the sand is teeming with millions of birds of all sizes and colours as far as the eye can see. Dozens of different species ranging from starlings to mighty pelicans, each species standing for a different molecule in the perfume. Suddenly a breeze stirs and

the birds take off, small nimble ones first, gulls later, clumsy flamingoes and pelicans last. Swept along, they whoosh up your nose

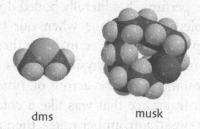

dms musk

A typical starling-sized molecule, dimethylsulphide (dms in the picture) – our CSC in SMILES notation – has a great truffle smell, though it is a great deal cheaper than truffles, at £10 a litre from chemical suppliers. It is made up of just nine atoms, and flies off so fast that on a smelling strip you have to be quick to catch it, and when you pass it on to someone else it is too late. The atom in the middle is sulphur.

Now a pelican: a musk, a ring of black carbon atoms studded with white hydrogens, with the red oxygen as a gem ruby. O=C1CCCCCCCCCCCCCC1 in SMILES language, this will smell for days, sometimes weeks, on a strip. How wide would the finger-wide smelling strip be if dms were *really* the size of a starling, or musk the size of a pelican? About 1,200 miles wide: molecules really are prodigiously small.

∽ *Reading the poem line by line* ∾

The process by which smaller molecules fly out first and bigger ones later is known to us by another name: distillation. The still is an old invention, and even the simplest one is capable of separating, say, alcohol from water: simply turn up the heat gradually, and observe what collects at the cool end of the retort tube. The first stuff to come through is alcohol.

But the ultimate still is called a gas chromatograph and was invented in the 1950s. I happen to have a nice reconditioned one, bought second-hand for the price of an old Jag, humming next to me in my basement lab as I write this, and it is a thing of beauty. This machine is to smell what a prism is to light. It separates perfume mixtures into their component parts. It is a device of exquisite elegance and simplicity, and without it the life of the fragrance chemist would be hell.

Here's how it works: remember the last time you had supper in a good Italian restaurant, and the tablecloth was thick, dense, white cotton? Did you notice that the drop of red wine you spilled on it seemed to separate into different colours as it ran along the cotton fibres, blue gaining the edge on brown? That is chromatography, and it was first noticed with dyes, hence the name. The idea is that different molecules can be made to travel at different speeds, like runners in an amateur marathon, and that if you get them all going with the starting pistol and stand ten miles down the road, they will come past you in a strung-out order, fast ones first, slow ones later, overweight stragglers last.

Picture a thin glass tube a fraction of a millimetre in diameter and thirty or so metres long, neatly coiled up so it can fit inside a temperature-controlled oven of normal turkey size. Coat the inside of the tube with a thin layer of a waxy substance in which smelly molecules will dissolve. Connect both ends of the tube to pipes that stick out of the oven so you can put things in at one end and collect them at the other end. Pass a stream of gas through the tube. Arrange the plumbing so that you can inject a small slug of a mixture at the *in* end of the tube without disturbing the flow of gas. Set the oven to some temperature, say 100°C. Position your nose at the *out* end, and inject a slug of fragrance into the tube. The different molecules will enter the tube at the same time, and be pushed along by the stream of gas. If they did not

attach themselves to the walls, they would also come out at the same time. But they stick to the coating of the tube walls every time they hit it, and have to 'boil off' again from the wall into the gas every time they get stuck. Understandably, the molecules that attach best to the coating will spend less time in the gas stream, while those that attach poorly will zip through. Since all the molecules with a given structure will behave nearly identically, they all come out more or less at the same time.

The result at the outlet of the tube is a separation of a complex mixture into its components. Put a mixture of smells into it, and little puffs of each component will come out at intervals of a few minutes. Each puff lasts a few seconds, and you had better be there when it comes, or the smell will be gone. To help in this, part of the output stream is sent to a detector wired to a recorder. When nothing is coming through, the recorder writes a flat trace on the paper. When a puff comes along, the recorder writes a 'peak'. The noise when the pen comes to life is the signal to rush to the outlet and start smelling. Add a few bells and whistles for convenience, and you can do this all day. A continuously rising oven temperature makes it easy to shake off even the really sticky molecules. Humid, warm air added to the outlet will make it easier to smell, for reasons unclear. A little computer tells you how much of the total stuff was contributed by each puff. Then you have a proper GC smeller. This machine, and this machine alone, can tell you what perfumes are made of and let you smell pure molecules.

∾ How molecules are made ∾

The recipe for coumarin, the iconic molecule of synthetic perfumery, uses the reaction called Perkin condensation, named

after the great industrial chemist William Perkin. It runs as follows:*

In a 250 ml round-bottomed flask place 2.1 g of salicylaldehyde, 2 ml of dry triethylamine and 5 ml of acetic anhydride and reflux the mixture gently for 12 hours. Steam distil the mixture from the reaction flask and discard the distillate. Render the residue in the flask basic to litmus with solid sodium bicarbonate, cool, filter the precipitated crude coumarin and wash it with a little cold water.

The first thing you notice if, like me, you are not a chemist is that this looks less tricky than, say, Beef Wellington. All you need is a bit of glassware and three building blocks, which Perkin would have had to make for himself but which you can buy now for a few euros. No one makes things from scratch these days. To be fair, even in Perkin's day nobody started from one-carbon building blocks. But where do these prefab bits come from? Ultimately, if you trace them back to their source, they come either from oil – that is to say, from ancient life forms† that painstakingly assembled them from single atoms – or from today's life forms, e.g. wood. Secondly, you will notice that the building blocks still have good old-fashioned names: salicylaldehyde (from *salix*, willow, from which it was first extracted), acetic anhydride from vinegar, litmus. In fact, the atmosphere is still agreeably empirical ('gently', 'a little water', 'basic to litmus'). Chemistry is clearly still an art.

The mechanism for this reaction is now well understood. To give you a hit-and-run feel for how synthetic organic chemistry

* This recipe is taken from Vogel's *Textbook of Practical Organic Chemistry*, fifth edition (ISBN 0582462363), an extraordinary book that gives you the feeling, unique among the sciences, that with minimal equipment, a good fume hood and a little money you could do professional-level chemistry. Try this at home.
† Not everyone agrees that oil is a fossil fuel. Thomas Gold, in his fascinating book *The Hot Deep Biosphere*, argues convincingly that hydrocarbons have a non-fossil origin.

works, look at the explanation of this reaction below. If you find it self-evident, your future is assured.

1

2

3

4

The art of synthetic organic chemistry is a peculiar one: its practitioners are like hunters, who need to think like their prey. They gain an intuitive understanding of the habits of molecules by becoming familiar with a million anecdotes, i.e. individual chemical reactions. Many solid rules exist, but chemistry is basically unpredictable. I remember once seeing a book entitled *Remarkable Chemical Reactions*. Each one of

several hundred pages merely showed reagents and products for a reaction that had given an unexpected result. What was extraordinary was that there was no text, other than the reference to the original scientific publication. For the aficionado, clearly none was required.

Elegance in academic synthetic chemistry means making a complex molecule from the ground up. Elegance in industrial chemistry is making a molecule cheaply and efficiently, with a

minimum of reaction steps. This is because the yield – the fraction of the reactants that ends up as what you want – is never 100 per cent. Most reactions have yields of, say, 70 per cent. The remaining 30 per cent can be anything – unreacted bits, unwanted products, all expensive waste. If you need ten reaction steps, you could end up with an overall yield of a few per cent. The stuff is going to be expensive, and you had better make sure people will want to pay for it before you build the plant. On a chemist's difficulty scale of one to ten, with one as 'easy' and ten as 'nightmare', coumarin would score a two. Some of the recent sandalwood molecules like Givaudan's weird and magnificent Javanol®, with its two three-membered rings and impossibly lush smell, would rate an eight and cost a lot to make. Fortunately, Javanol® smells great and is very powerful, so it can be sold for a lot of money.

～ A problem of nomenclature ～

A few years ago I was invited by some mathematicians in Cambridge to give a talk on smell. Talking to mathematicians is always a pleasure, because they have a fair amount of time

on their hands (you can't think about maths all day), they are usually very curious about the rest of science and they have the hale alertness of those who spend their entire lives in the bright sunshine of truth. It is also useful because unless one makes a real effort to keep up, one has no idea what is going on in the world of mathematics. Tune out for a few years and then come back, and you discover that some things which you thought impossible have been done. What's more, they can be downloaded in the form of a programme from the web, for free of course: wavelet transforms, neural networks, fractal compression algorithms, nonlinear waves, all there for the asking.

David MacKay of the Cavendish Laboratory had invited me, and we got talking about smell and smelly molecules. I explained to him that in the course of conversations with fragrance chemists the question had come up of what 'molecular typos' smelled of.

Suppose that smell is 'written' into the molecule in some notation. What do you get when, by altering a specific part of a molecule, you mistype the original word? With words, of course, you can get other words with both related and unrelated meanings. For example, you can go from 'face' to 'lace' or to 'fade'. The space of words is not continuous. What about smells? Specifically, the question I had asked the distinguished fragrance chemist Charles Sell of Quest International was this: when you're making a few dozen molecules while searching for, say, a musk, what do you get when (as is usually the case) you *don't* get a musk? He said without hesitation, 'Woods and ambers.'

His answer got me thinking. This suggests that somehow woods and ambers are 'near' musks. Since you never get roses or peanuts, that means these are further out. But when you make rosy molecules, you sometimes get woods, sometimes lemon. So that means woods are connected to rose *and* to

musks, but rose and musk don't have a common border. Playing with molecular typos is like putting a pin into the map blindfolded, but in the correct general neighbourhood. To use the language of artillery, when you aim for a specific smell your circle of error can sometimes get you into the next county, but not into the next country. I was recounting this to MacKay and in typical mathematician fashion he said, 'You can unfold this with a Kohonen self-organizing map.' He patiently explained to me how it works. Suppose you take a thousand molecules, each of which has a smell that can be described by, say, four words in decreasing order of aptness: for example, woody, rosy, soapy, sweet. The Kohonen algorithm will figure out which combinations of words come most often together* and rank things by distance to iron out all the wrinkles and unfold a proper map that would in principle give you the map of smell.

To do this you would need a lot of descriptors, and that means tapping into one or more databases of the big manufacturers who have produced hundreds of thousands of molecular typos (as well as some resoundingly beautiful words) over the years. These databases are jealously guarded, because they contain proprietary information. The most jealously guarded bit of all is the molecular structure corresponding to each smell. But all hope is not lost: what is interesting about the smell map is that you would not need to know the molecule's structure, since you are operating here only at the level of its smell. David MacKay and I got rather excited about the prospect, and I promised to do something about it, namely to ask one or more of the big firms for an edited version of databases containing no structures, only descriptors. At one point, this had been conceivable, as I'd been brought into

* If you want to know more about it, search for Professor Teuvo Kohonen or read his 2001 book *Self Organizing Maps*, third edition (ISBN 3540679219).

a few of these companies for talks that went nowhere. Unfortunately, by that time (late 1997) my relations with the big manufacturers were at a low ebb* and I never got hold of the data. Frustratingly, aside from those databases, the information is widely scattered, or would require tremendous amounts of work to input into a computer, so I gave up the idea temporarily.

∿ *The landscape of smell* ∿

Until we finally see the Kohonen map of smell, it's anyone's guess what the landscape looks like, so I can take the reader on an imaginary trip without fear of contradiction. Along the way, it will become clear that similarity in structure does not mean similarity in smell, and that the mystery of the smell cipher is untouched.

Vanilla

Let us start on the tropical island of Vanilla. Vanilla is the first, and still the greatest, success story of synthetic fragrance chemistry. Without it, Guerlain fragrances would not exist, chocolate would be an austere, saturnine drink favoured only by Yucatan monks, and ice cream would be forever stuck in sorbet territory. Vanillin, the 'character impact' molecule of vanilla pods, was first made in 1874 by Ferdinand Tiemann and Wilhelm Haarmann. The firm of Haarmann and Reimer had been founded a few years earlier in the middle of the forests of central Germany, to extract vanillin from wood. It was, and still is, situated in a place called Holzminden (*holz* means wood). Only a few years later, H&R's own chemists made wood largely redundant. Their method of synthesis

* The comical story is told in Chandler Burr's *The Emperor of Scent* (ISBN 0375507973).

started with guaiacol (the fellow on the left of the diagram). Then they punched in an aldehyde group, using the reaction

that is named after them, and which they published in 1876 after the patent was granted (since then as now, publishing destroys your chances of getting one). They made a bundle from it. In molecular terms, the vanilla territory is tiny. Every vanillic molecule known to date resembles vanillin fairly closely. Remarkably, though vanillin is very powerful, *iso*-vanillin, in which the four o'clock and six o'clock groups have been interchanged, is a very weak (but still vanillic) odorant.

From vanilla you can go in several directions. Add an extra carbon to the group at four o'clock and you get ethylvanillin, with extra power, subtlety and sparkle, though still firmly in

vanillic territory. Go back a step, remove the aldehyde and smell guaiacol, and you are likely to be amazed by how much difference three measly atoms (HC=O) make: guaiacol is smoky, like so many molecules with an OH attached to a benzene ring. In fact, guaiacol smells a bit like phenol, above, the molecule first used by Joseph Lister in 1865 to kill bacteria during an operation. Smell habits are very long lasting: we have only recently emerged from the Phenolic Age, with the familiar Jeyes Fluid and Wright's Coal Tar Soap as staples

of Spartan antisepsis in public places and schools.* The subliminal fear of bacteria which made Lister's phenol so popular has taken over a century to subside, and antiseptics now increasingly smell lemony-clean rather than ruggedly tarry. One exception is the wonderful (and in my experience entirely useless) French cough medicine Pulmosérum, which contains guaiacol and looks and tastes like the late nineteenth century. Similar hygiene time-travel is provided by the tar compositions used to paint fences.

Guaiacol is still recognizably vanillic. To be more exact, one can smell with the mind's nose a faintly cough-syrupy, medicinal note in pure vanillin. Indeed, some very phenolic compounds are used as replacements in cases, such as in soaps, where vanillin cannot be used because it rapidly turns chocolate-brown. Natural vanilla extract contains lots of phenolic notes, and smells a bit like a fresh exotic-fibre carpet or smoky, wet tea leaves. This is desirable, because pure vanillin is a little too clean all by itself, and needs a bit of phenolic raunch to perform at its best in perfume. Indeed, when Jacques Guerlain used vanillin in fragrances, he always chose a somewhat impure grade which smelled nicer (the firm of De Laire sold it to him for more than the pure stuff). He then mixed, say, ten parts of this stuff to one of the expensive vanilla absolute to make it both cheap *and* rich.

Birch and beaver

Further afield in the phenolic jungle, we encounter the cresols. There are several: this one is the *p*- or *para*-cresol. Cresols have a leathery-smoky smell and are found in, among other things, rectified (meaning cooked until brown) birch tar oil, the raw material contained in all serious leather fragrances, from Knize

* The British in particular love the bracing, institutional smell of phenol. When I want to recall the Old Days in the UK, railway platforms and college stairs in the morning, I take a sniff of TCP, which you can still get in most chemists.

Ten to Chanel's Cuir de Russie via Caron's Tabac Blond. The animal component is very strong in some *p*-cresol derivatives, as exemplified by the mother of all beastly smells, castoreum – an oil actually obtained from beaver pelt and the very embodiment of the colour brown in the realm of smell.

A clue to the neighbouring countries just across the border from vanillin is provided by looking at guaiacol and benzaldehyde. This is not entirely surprising, because if you superimpose the structures of guaiacol and benzaldehyde in the correct orientation, you get vanillin. What this tells you, however, is that when you move away from vanillin – in particular, messing with the guaiacolic bits, the undercarriage of

the vanilla molecule as drawn above – you should not be surprised if things get almondy. And indeed they do, as exemplified by heliotropin, discovered in 1869, which has a 'warm, almost herbaceous-fruity note' reminiscent of almonds but more floral. Heliotropin – so named because its smell resembles

that of heliotrope flowers – soon became popular in fragrances. The only one of that period that still remains is Guerlain's sublimely melancholy Après l'Ondée, which does justice to the spring-like warm-fresh contrast inherent in the molecule.

Further towards the light in the fresh-almondy direction, we encounter the related molecule Helional®, a typical marine

note which, to be exact, smells fresh-metallic – the smell of a silver spoon after you've sucked it. It gives fragrances an over-exposed, bleached quality which did sensationally well during the anorexic 1990s. Note also that the 'other' highly successful marine note, Calone, responsible for the edgy metallic zing of New West, Kenzo Homme and Eau d'Issey,* also contains a benzene ring attached to two oxygens, but in a seven-membered rather than a five-membered ring. So far, nothing all that surprising. But going over the next ridge to bitter almonds lands us in a strange place teeming with weird molecules, and poses our first major puzzle. So far, similar structures have given similar smells, but that is about to change.

Bitter almonds
No doubt partly because the smell of bitter almonds is so easy to recognize for everyone who's ever had marzipan or Amaretto, or has bitten into a peach kernel, chemists have

* Calone, and marine notes in general, possess the peculiar quality of getting stronger and stronger as one gets used to them, which means that perfumes composed at a time when these things were new now smell as if they contained nothing else.

turned up a large number of compounds that possess the bitter almond character to a greater or lesser degree. Most

HO
N
water →
O
+
H
N

people don't realize, however, that the proper 'bitter' almonds were quite toxic, and that mutants have been selected which lack both the toxicity and the bitter flavour, since one was responsible for the other. Modern almonds taste great, but show no hint of marzipan. Why were they so toxic? Proponents of Intelligent Design in evolution* will appreciate the answer. The smell of bitter almonds is due to a compound called mandelonitrile. It belongs to a class of compounds called cyanohydrins, which have a CN and an OH group next to each other. Like all cyanohydrins, mandelonitrile falls apart in water, giving an aldehyde and cyanide, in this case benzaldehyde and hydrogen cyanide, the famous poison. Benzaldehyde ends up in marzipan, cyanide in murder novels. Now here's the *real* killer – both smell of bitter almonds! If there is a Creator, and It has a sense of humour, this would be the sort of thing It would dream up. If you want to understand smell, this one is a real enigma: there is no structural similarity between them whatsoever.

In learned texts that deal with the bitter almond smell from the standpoint of molecular shape, this fact is usually dealt with in one of four ways. It is: (1) ignored altogether; (2) explained by the *ad hoc* notion that there are two receptors for the smell, one for HCN, one for all the others; (3) dismissed

* Not all Intelligent Design proponents are fanatical dimwits. Michael Behe, for example, has written an interesting book entitled *Darwin's Black Box* (ISBN 0684827549), which argues that life is simply too wonderful to be the result of an accident. If you're a biologist and find coffee-time conversations dull, try mentioning it.

by saying that HCN does *not* smell of bitter almonds, which is true for a minority of humans; or (4) neatly accounted for* by an evolutionary hypothesis, namely that since the two molecules always come together in almonds, we have learned to give them the same smell. This last explanation begs the question of why we haven't done the same for the main components of rose etc.

But when you look more closely, things get worse still. Look at this gallery of rogues: from left to right, benzonitrile,

azidobenzene and nitrobenzene, which are all almondy to some degree, though none stands the remotest chance of ending up in marzipan eaten in this solar system. You may con-clude from this that a benzene ring with some highly charged group attached does the business. And you'd be wrong. Look at the rightmost compound, *trans*–2-hexenal: that means six carbons, double bond in the two position starting from the aldehyde end, carbons on either side of the double bond in an N-shape pointing away from each other. That smells nicely of bitter almonds, though harsher and less sweet than benzaldehyde, and clearly has none of its features save the aldehyde.

Chanel 5 and other numbers
We leave bitter-almond territory, chastened by this experience, and take the lead from *trans*–2-hexenal into a new country, that of straight-chain aldehydes. Among these, only *trans*–2-hexe-

* By Charles Sell in his *The Chemistry of Fragrances* (ISBN 0854045287), essential reading for those interested in the subject.

nal smells of bitter almonds. The others form a series, depending on the number of carbon atoms, whose smell goes from the

8 H_3C ⌇⌇⌇⌇⌇O

9 H_3C ⌇⌇⌇⌇⌇O

10 H_3C ⌇⌇⌇⌇⌇O

11 H_3C ⌇⌇⌇⌇⌇O

12 H_3C ⌇⌇⌇⌇⌇O

morgue all the way to the boudoir. The first, without an extra carbon, is formaldehyde, used to pickle dead things, which has a pleasant but somewhat aggressive apple-like smell. The next member, acetaldehyde, is also fruity and is in fact responsible for the difference between fresh and stale orange juice; it is unstable, and present in the fresh stuff. The next six are harsh compounds variously reminiscent of swimming pools and rancid fat, and all endowed with a definite 'chemical' character – i.e. something that tells us to stay well away. Octanal is the first presentable member of the family and in dilution smells orange-like, though still slightly fatty. From then on it's smooth sailing all the way to the twelve-carbon dodecanal. These aldehydes are present in such common places as citrus peel, and were synthesized as far back as the 1850s. Their hour came, however, when Ernest Beaux put a 'secret' (in the days before chromatography) mixture of the ten to twelve aldehydes into a rose-jasmine floral commissioned by Gabrielle ('Coco') Chanel. Stories abound on this subject, and every perfumer seems to have his or her own version.* The fact remains that

* Was it a mistake by his lab assistant, which Coco Chanel, to Beaux's horror, preferred to the others? Was the name 'No. 5' borrowed from the number on Beaux's tester? What of Molyneux's No. 5, launched the same day as a joke between Chanel and Molyneux and initially more successful? Was the bottle 'borrowed' from the window display of the shirt-maker Sulka at the corner of Rue Cambon? And so on . . .

at a then unprecedented concentration greater than 1 per cent, these molecules lent an abstract, marmoreal, blue-white radiance to what would otherwise have been a lush but relatively tame floral. To understand what aldehydes do to perfumes, imagine painting a watercolour on Scotchlite, the stuff cyclists wear to be seen in car headlights: floral colours turn strikingly transparent on this strange background, at once opaque and luminous. The best place today to experience this aldehydic character, short of ordering the stuff from a manufacturer, is to smell Estée Lauder's White Linen.

As if the perfumes weren't good enough, the aldehydes have another astonishing trick up their sleeve. The ones with an *odd* number of carbons smell predominantly waxy with a citrus character in the background, while those with an *even* number of atoms smell predominantly citrus-like with a waxy character in the background. By waxy I mean the smell you get when you blow out a candle, and by citrus-like I mean orange peel. Now this is decidedly weird! One might imagine a smell receptor that measures the length of a carbon chain and, say, accommodates all aldehydes up to C_8, but imagine a receptor that counts atoms like beads on a rosary and gives a different impression according to whether the number is odd or even. Not easy.

In aldehydes such as these, each carbon in the chain is attached to its two carbon neighbours and to two hydrogens: $-CH_2-$. If two adjacent $-CH_2-$ give up a hydrogen and use the spare electron to make an additional bond, you end up with a double bond: $-CH=CH-$ Adding double bonds to aldehydes has strange effects. Two double bonds added to the soapy, waxy nine-carbon nonanal gives trans,cis–2,

6-nonadienal.* Nonadienal, aside from being extraordinarily powerful,† is also one of the few pure raw materials that elicit an immediate identification when smelled by naïve subjects: 'Cucumber!' Adding carbons (CH_3) sticking out from the chain tends to make the smells less fatty-waxy and more incense-like. Adding both double bonds and carbons can do a million things. One of them is citral, the 'character impact' molecule of lemon, based on octanal. Citral is amazingly lemony all by itself, and has exactly the right mixture of sweetness, resinous zing and pungent soapiness that somehow adds up to the message 'lemon', with all its associations of fresh, clean and sour (I salivate as I write this).

The association of lemon with cleanness would normally put citral in harm's way, in such uncomfortable places as bleach and acid toilet-cleaners. But chemistry doesn't care about our little habits: the aldehyde group is unstable in bleach, and the whole molecule degrades rapidly in acid. Our insistence on having these nasties scented with lemon is one of the biggest headaches the fragrance chemist faces.

Indeed, the inventor of a bleach-stable lemon would probably become rich, though arguably not famous.†† But 'bleach-stable aldehyde' is like saying 'fire-resistant violets', so chemists have come up with a Plan B in the form of nitriles, which mysteriously smell similar to the corresponding aldehydes and don't break down in bleach or acid. Nitriles elicit mixed

* The terms 'trans' and 'cis', as before, refer to whether the four-carbon unit with the double bond in the centre forms a C or a Z pattern.
† In perfumery labs, the real nasties are kept in sealed bottles inside jam jars, to make sure they don't stink up the place. Just opening the outer jar of nonadienal releases a fearsome cucumber smell.
†† Unless he or she worked for a big company, in which case it would be neither.

reviews among those who smell them. Some find them close enough to the corresponding aldehydes to be one-for-one replacements. Others (myself among them) find them unpleasant, with a snarling, metallic, wet-dog background, no better a replacement for aldehydes than the Hound of the Baskervilles is for your pampered pooch.

This nitrile-aldehyde replacement illustrates the fact that while messing with carbons is like a walk in smell space,

tampering with functional groups is usually more like seven-league boots, and can deposit you in completely different lands. The definition of a functional group is 'whatever group of atoms dominates the molecule's chemistry', so it can be a little vague, but for our purposes it means aldehyde, alcohol, thiol, nitrile, oxime (left to right in the figure). We shall now leap from citral into the adjacent country merely by replacing its aldehyde group with an alcohol (-OH), to give geraniol. Surprise – the lemon has gone, and we are now in roses, more specifically in geranium-rose territory. Taking away a double bond from geraniol gives citronellol, still lemony-rosy but less geranium-like, more fresh-soapy. To anyone who has stuck his nose into several luscious varietals in full bloom, the connection between rose and lemon will not be all that surprising, though in the flower itself it is typically not achieved by mixing citral and geraniol. Given the price of rose oil – between €2,000 and €20,000 a kilo depending on quality – the rose scent is understandably popular among fragrance chemists, and a good array of rose smells is available ranging from sweet (phenylethyl alcohol) to metallic (rose oxide) via geranium rose of geraniol itself. To make a decent rose smell, however, requires some padding out with eugenol (cloves), citral and many other things.

Flowers real and fake

The field of floral smells has been revolutionized in recent years by the invention of a technology called 'headspace' or 'living flower', depending on whether you're talking to Givaudan or IFF press people. Headspace is not, as its name suggests, something ageing hippies do in their spare time, but simply the space above and around a living flower held in a jar. If, instead of brutally extracting the stuff from the flower, you simply suck enough air to be able to identify the molecules in it, you have *in principle* a better reproduction of the real thing than the extract would give you. That's the good news. The bad news is that you can't actually bottle the stuff because the amounts in air are microscopic. What you do instead is ask your chemists to find out what's in the air and replicate the mixture as closely as possible using synthetic materials. In essence, you are taking a master's degree at God's own perfumery school.

This process is not as easy as all that, because the proportions of the stuff in the air are not the same as those in the liquid mixture you're trying to compose, since each molecule has a different aptitude for flight. Furthermore, though most of the smell is due to three or four majority components that are usually well known and likely to be cheap, the bloom on the flower's smell, what makes it real, is carried by a host of little minority peaks which can be (a) expensive, (b) unknown or (c) both. Given that an accountant is sooner or later going to look at the formula, the law of diminishing returns operates and the chop always comes just short of a holographic reproduction of rose (or any other flower). The headspace school has been less a scientific tool than an artistic one. In the hands of skilled chemists and perfumers it has led to rose smells shedding some of the heavy ballast that is usually over-represented in the oily extracts. A fine example of the transparent florals that can be achieved in this

fashion is Estée Lauder's Pleasures, about as bright as a perfume can be without actually giving you a tan. Compare that to the sunset glow of Jean Patou's Joy, where most of Bulgarian Rose ends up, and decide which perfumery school you prefer.

Lily of the valley

A hop and skip from Roseland, achieved by adding back an aldehyde group to citronellol to obtain hydroxycitronellal, lands us in a Maxfield Parrish painting, bathed in eternal misty morning light: muguet territory. Muguet (curiously, the word is derived from musk) is French for lily of the valley. As

everyone knows, particularly Frenchmen on 1 May,* the muguet smell is wonderfully complex and delicate, somewhere between rose, cut grass and lemon, but with a fleshy, slightly raspy whiteness that recalls the eponymous lily. There is to my knowledge no such thing as muguet oil, because

* The anniversary of the first industrial strike, a public holiday when everyone wears a sprig of lily of the valley.

the natural smell gives a very low yield and is unstable. Hydroxycitronellal is not a bad likeness, though lacking in subtlety. The other muguet molecules are much less convincing. In a hundred years of synthetic chemistry, there seems to have occurred a sort of linguistic drift in this area, which has caused some decidedly un-muguet-like smells to be so named. They are mostly variations (one or two carbon dance steps) around a basic skeleton of a benzene ring with a three-carbon aldehyde attached. They are called (top to bottom) Bourgeonal, Lilial and Cyclamenal, a fine illustration of the fact that chemists find it hard to drop chemspeak even when they're feeling a bit lyrical. Cyclamenal was the first to be discovered, by French chemist G. Blanc in 1919. Apparently he showed it to Léon Givaudan, who had it in production two years later. The bottom one is an ugly duckling that turned out to be a swan. It is called Lioral* and, uniquely for muguet materials, contains a sulphur atom. Putting a sulphur in a muguet is a bit like asking Tommy Lee Jones to play a nun. Nevertheless Lioral is very powerful and keeps its infernal thoughts to itself.

These weird muguets are big business, because if you start from hydroxycitronellal and turn down the rose, the sweet and the green until the whole smell goes barely off-white, stopping just short of the snowy, blinding aldehydic character, you have what everyone calls 'fresh'. And fresh is the most desirable character of all in the engine room of perfumery: so-called 'functional fragrance'. This is the stuff that goes into everything you use rather than wear: soap powders, fabric softeners, liquid soap for woollens, face creams. More often than not, the perfume simply covers the smell of the ingredients that do the job. Try some 'unfragranced' fabric softener

* From the Hebrew name Lior, which means 'light'. I designed the molecule for Flexitral, Inc. and had the privilege of naming it.

and smell for yourself. Functional perfumery is serious stuff – our perfume memories are made of this. Poetic justice: these cheap compositions, the terse haiku of the perfumer's art, bring in as much money as all the fine fragrances, and are just as hard to get right on a one-tenth budget.

White flowers

Since we're in supposedly floral territory, let's move away from the pale, bloodless muguets and towards more robust smells. Floral is, as one might expect, a catch-all category with little or no logic to it. What flowers are trying to do is to spread their DNA, and evolution's four-billion-year market research study has given them plenty of time to come up with things that insects will like. These range from the noxious, rotting-meat stink of Rafflesia, clearly designed to attract flies, via the full-on trombone section of tuberose, to the lovely smell of gardenia, so perfectly pretty from every angle it almost hurts, like early pictures of Audrey Hepburn. Remarkably, floral smells are not simply symbols, like insect pheromones. If, like some insects, all you're trying to do is advertise your presence, then any smell will do, as long as it's loud and specific – so that you don't waste time flying on instruments for half an hour only to find that your moth date turns out to be a useless beetle. But if, like flowers (or humans), you're fighting to be noticed, then you need to come up with things that are more like music than like foghorns. One could even imagine an evolutionary scenario* where only the healthiest, most nec-tar-laden flowers can afford to produce Shalimar, so to speak, and only the smartest insects, those who can tell the difference between that and mere Vanilla Fields, can home in on the

* Matt Ridley's *The Origins of Virtue* and Geoffrey Miller's *The Mating Mind* are two wonderful books that convey the heady, almost paranoid ('there has to be a reason') atmosphere of this field of inquiry.

booty. Result: both species prosper. How one wishes that also worked for humans, eradicating Poison in one generation!

Not surprisingly, given this billion-year charm school, floral fragrances are seldom simple, but they can often be reproduced in a pixillated sort of way with four or five synthetics. For rose, 90 per cent of the job can be done with eugenol (cloves), phenylethylalcohol (sweet rose), geraniol (green rose) and citral (lemon). But most floral smells are horrendously complex. Generations of chemists have reverse-engineered nature's work to produce 'character impact' materials for most flowers. These can be surprising: indole, probably the most unfairly maligned molecule on earth,* smells bitter and inky, but is an essential component of all raspy-voiced white flowers like lilies, tuberoses, etc. No perfumer would dream of making a synthetic rose from first principles, and will instead use one of hundreds of excellent floral bases. These ready-made confections can then be bent this way or that to make them individual.

Violets
One exception to the 'complicated flowers' rule is violets.

Haarmann and Reimer, following the isolation of irone from iris root, managed to separate the different isomers of methyl ionone in 1903. The reason for their interest was simple: it is said[†] that one kilo of violet (*flower,* not *leaf*) absolute then cost 80,000 German gold marks, which according to my

* Its smell is described as 'fecal, floral on high dilution', which is libellous. Arctander as usual gets it right: 'tarry-repulsive'.
† Philip Kraft, *Synthesis*, 1999, pp 695–703.

calculations is €295,000 today. This sort of economic proposition focuses a chemist's mind wonderfully, and the newly synthesized ionones proved a sensational success. Alpha-methyl ionone *does* smell convincingly of violet flowers. Within a few years, everyone was wearing violet perfumes, most famously Berdoues' 1936 perfume Violettes de Toulouse, named after a traditional floral produce of that city and still made today. Indeed, ionone made its way into flavours as well as fragrances, which is how Flavigny violet bonbons came into being. One bite of a Flavigny will explain ionone's success. The peculiarly poetic combination of warm, sweet, floral and woody notes carries within it a mixture of delicacy and brutality which, to my mind at least, is an allegory of childhood love. Violet smells are rare in perfumes nowadays (the last *big* violet was Balenciaga's Le Dix in 1947), a victim of their own success. Such is the biblical curse visited on over-exposure that people whose *parents* are too young to have smelled the original violet fragrances still find the smell cheap, which it isn't. Its day will come back, probably soon.

One carbon is all that stands between ionone and a surprisingly different smell: irone. The best way to describe the huge yet subtle difference between ionone and irone is to compare it with the difference between a major and minor scale in music. Where ionone radiates sentimental warmth, irone has the slightly funereal character of a sepia print – not mystical purple, but faded lilac. A complex mixture of irones is what gives iris root butter, probably the most expensive perfumery raw material in existence (over €73,000 a kilo), its magnificent, melancholy smell.

Good iris notes in fragrance are correspondingly rare, but when properly executed exude a frosty luxury which everyone falls in love with sooner or later. Chanel's Cuir de Russie has it, as does Serge Lutens's Iris Silver Mist. This area of perfume chemistry is a sort of olfactory Switzerland, where a half-hour's drive can take you from one world to another. Witness the damascones, first isolated in rose oil, which differ from ionones simply by the fact that a bit of the tail is grafted on the opposite way around. These are also warm-woody, but whereas ionones and irones are properly floral, damascones are outrageously fruity, and convey the full range of dried-fruit notes, all shades of translucent golden browns. Damascones bring to mind autumn issues of women's magazines, full of red-haired beauties pictured out-doors in big sweaters. Dried fruit, like dried spices such as cloves and cinnamon, and resins such as incense and myrrh, have what I would call an archaic smell, suggestive of a time when spices and drying were used as preservatives. These remnants of the pre-phenolic age smell intensely salubrious. This may be some sort of ancestral memory, because they are. Put little blotters dipped into any one of those 'spices' on a Petri dish where bac-teria are growing, and many will clear a bacteria-free circle around the blotter. Cloves are particularly good at this.

Fruits

Over the next hill now and into properly fruity territory, leav-ing the Brahmsian browns of damascones for the Mozartian colours of esters. An ester is a molecule which contains the linking group depicted below, -C(=O)-O-, joining up A and

$$A \overset{\overset{\textstyle O}{\|}}{\underset{O}{C}} B$$

B, where A and B can be *anything at all*. Esters are easy to make by bringing together an acid and an alcohol and removing water, and as a result thousands have been made, so many

that a well-worn joke among chemists is the series 'methyl-ethyl-propyl-*futile*'. By convention the acid on the left is considered to be the father of the ester, and ester names read like the Russian polite form of address: B son of A, Mikhail Alexandrovich, ethyl butyrate. Made from butyric acid and ethyl alcohol. If it were the other way round – made from ethanoic acid and butyl alcohol – Alexander Mikhailovich would be butyl ethanoate. What do esters have in common? For a start, the ester linkage seems to impart a fruity (overripe apples, nail-varnish remover) smell of its own to all of them. This fruity character is then modified by A and B in an almost infinite variety of ways.

Once again, as with floral smells, no single ester gives the full picture of a fruit. Under the heading 'apple', the Aldrich catalogue* lists thirty-eight esters, ranging from allyl propionate to cis-3-hexenyl-2-methylbutanoate. For 'pear' fifteen esters are listed, but for 'quince' only one: diethyl sebacate. Esters are a peculiar area of fragrance chemistry. Ordinary odorants like ionone carry their smell enciphered, and do not smell like the sum of their parts. Many esters, by contrast, smell somewhat like A + B, though the AB and BA compounds will always smell different. For example, the slightly cheesy character of pineapple and banana smells comes from the fact that they are esters of butyric acid, very cheesy indeed all by itself. This raises an awful possibility, which will send shivers down the spine of anyone trying to solve the structure-odour problem: could it be that the esters are breaking down in the nose into their component parts, which are then separately smelled? If this is the case, does it apply to other odorants? Were this so, it would complicate things still further.

* Aldrich (*www.sigmaaldrich.com*) is a pioneering chemical supplier founded by a remarkable man, Alfred Bader, who tells the early history of the company in his book *Adventures of a Chemist Collector* (ISBN 0297834614). Aldrich makes an esters kit containing twenty-four compounds, well worth buying.

Some esters have defined their era. When we put together a time capsule of the 1980s – assuming that this is a wise thing to do – along with shoulder pads and *Top Gun* screensavers one should in all fairness include a 1 per cent solution of allyl amyl

glycolate. One per cent is all one can decently take without rushing out to buy a mint copy of Olivia Newton-John's 'Physical'. It smells like a pineapple the size of a carnival float, and forms the core of huge pedal-to-the-metal fragrances like Giorgio and its imitators. Other esters, thankfully, act in more discreet ways. Benzyl salicylate, one of the most widely used in classical perfumery, has no smell at all to most people, and a very weak one to the rest. It is a stealthy raw material, capable of improving the richness and depth of floral compositions out of all proportion to its actual smell. Even perfumers who cannot smell it immediately detect its presence in a formula. It almost goes without saying that this phenomenon remains a complete enigma.

The great lactones
Esters are (there is no other way to describe them) *transparent* smells, watercolours for the nose, but they have close relatives

that are more akin to pastels: the lactones. A lactone is what happens when a single molecule carries both the acid and the alcohol groups on it: like the alchemical snake Ouroboros,

it bites its tail and forms a ring. If the snake is too short, the molecule has trouble reaching its tail. If the snake is very long, it has trouble *finding* it, and more usually ends up connecting to a neighbour's tail, which rapidly leads to a hideous polymeric orgy. Not surprisingly, the easiest lactones to make have five and six-membered rings, which you can chemically accessorize (butyl, futile again) as you wish. Lactones, coumarin among them, must be the cuddliest smells in all perfumery: almost every one is soft and powdery, sometimes to a fault.

The confusingly named delta-undecalactone, made by adding a six-carbon side chain at ten o'clock to the lactone above right, has a fuzzy peach odour. Discovered in 1908 by Russian chemists Zhukov and Shestakov, it was sold under the name Persicol and is directly responsible for two of the greatest fragrances in perfume history. The first is Mitsouko, the masterpiece Jacques Guerlain created in 1919 during his arms race with François Coty. Two years earlier, Coty had come up with the splendidly abstract but austerely angular Chypre. Guerlain was apparently bowled over by Chypre, and tried to go one better. Typically, his idea was to add a bit of comfortable plush to Coty's austere chic, and he hit upon Persicol. To say that Persicol made Mitsouko is a bit like saying Carrara marble made Bernini's *Daphne*. It took all of Jacques Guerlain's genius to make it work. Fortunately, though Chypre is long gone, Mitsouko is still with us and Guerlain's new

owners, LVMH*, have so far treated it with respect. The second, perhaps even more astonishing, fragrance is Jacques Fath's Iris Gris of 1947. Composed by Vincent Roubert, it is to date perhaps the *only* completely successful iris. Most irises are ideal fragrances for a funeral. Faced with this chronic melancholia, Roubert hit on the brilliant idea of livening it up with the equally powdery but vastly more sanguine peach of Persicol. The result went seamlessly from grey to pink like the feathers on a pigeon's throat. Shame Jacques Fath no longer makes it.

Into the zoo

We now stand at the Khyber Pass of fragrance chemistry: behind us, peaches and roses; before us, the lands of musk, incense and sandalwood. As we approach the ridge, strange hybrid creatures make their appearance: esters and lactones that already smell musky. But first, a few words about the musk character. Everyone has heard of musks, and some suppose them to be gamey smells suggestive of their provenance: the rear end of a furry animal.[†] In fact, musks are harmless, quiet smells that patiently wait until everything else has evaporated to play their *pianissimo* strings. In perfumery, they play the role of both gesso and varnish. They act as a smooth, off-white backdrop on which colours look brighter, and they fill the gaps in a fragrance and give it a richer, deeper glow. What we call the smell of clean linen is actually the smell of synthetic musks developed in the 1960s. Every soap powder contains one or more musks, usually inexpensive ones. In fact, every fragrance contains synthetic musks, ranging from the cheap-

* LVMH stands for Louis Vuitton Moët Hennessy and is to fragrance what Microsoft is to computing, except that there is no Apple.

† This applies far more to civet, which comes from the zibeth or civet cat and is definitely a smell with claws and a bad attitude. You know it's going to be trouble when you see it in perfumery labs, kept in a jar within a jar the way big cats are separated from zoo visitors by both a fence and a moat.

est (phantolide, with its metallic, putty-like smell) to the most expensive (pentadecanolide, the one actually favoured by musk deer themselves). Some fragrances – Gaultier's Le Male, for example, with its striking Glenn Miller barbershop timbre – are made of almost nothing but musk. This means, of course, that musks are worth a lot of money. Before chemists figured out how to make them, they came from animal sources and were worth a lot more still.

The poor beasts that ended up as perfumery raw materials sound like a litany of road kills: sex glands of the musk deer, face glands of the musk ox, dried blood of the alpine goat, faeces of the pine marten, urine of the rock badger and many others. Thousands of musk deer died to make us smell good and the species became virtually extinct. Perfumers in the 1800s were actually using rock-badger urine collected, concentrated and sold as *hyraceum*! This orgy of animals and excrement fosters the romantic image of the perfumer as someone who will go to the ends of the earth to rip the gonads off some near-extinct animal. These myths are less persuasive in their vegetarian version – in truth, one of the best natural musks comes from the seeds of a relative of the common mallow and hibiscus: *Abelmoschus moschatus*, or ambrette. I have on my desk as I write a sample of ambrette absolute extracted by a low-temperature method, and it smells not at all raunchy. There is a definite russet apple note to it, but with a linseed oil background. Musk is one of those smells that works best from a distance. Walk out of the room where the smelling strip of ambrette is drying, and come back in after a few minutes. The peculiar fruity-oily smell now feels like the murmur of comfortable, clean, possibly edible things. It's as if musk ambrette were the olfactory equivalent of 'brown noise',* the

* Noise whose power spectrum goes down as f^{-2}. Look for 'brown noise' on the web to hear sound samples.

waterfall sound they pump into open-plan offices so that people can talk without being overheard.

To pursue this analogy, different musks can smell as similar to each other, and yet be as immediately recognizable, as different varieties of noise. Think, for example, about the ease with which we distinguish applause from rushing water or traffic. Some musks, like galaxolide, are more 'pink' coloured and smell like blackberries. Others, like pentadecanolide, are nearly 'white'. The story of synthetic musks is amazing.

In the 1880s there was a lot of money to be made from musks, since rock badger urine, Algerian gazelle shit and other naturals showed little industrial promise. A somewhat variable synthetic musk had previously been made by 'carefully adding, drop by drop, 3 parts of fuming nitric acid to 1 of unrectified oil of amber'. Oil of amber, strangely enough, is just what it says, and is obtained by 'destructive distillation [of solid amber] in a retort. [It] yields first an acid liquor, which contains succinic and acetic acids; then some succinic acid is deposited in the neck of the retort, and an empyreumatic [smelly] oil [oil of amber] comes over, at first thin and yellowish, afterward brown and thick; toward the end of the operation, a yellowish light sublimate is observed in the neck of the retort; this is called by Gmelin, *amber-camphor*.'*
Promising, but still far from cheap.

The sweet smell of TNT
That was also the time when synthetic chemistry took off in earnest, and it was only a matter of time before someone hit upon a musk. And when it happened, it was, as always, by accident. In 1887, Baur was trying to make explosives based on trinitrotoluene. As its chemical name indicates,

* Both methods come from *King's American Dispensatory* by Harvey Wickes Felter, M.D., and John Uri Lloyd, Phr.M., Ph.D., 1898.

toluene trinitrotoluene

trinitrotoluene, familiar to us as TNT, is a molecule of
toluene to which three nitro groups have been attached. This
is achieved by mixing toluene with a reagent as ancient as
chemistry itself, the *aqua regia* of the alchemists, a mixture
of fuming sulphuric and nitric acids. This molecular rivet-
gun can punch nitro groups into almost any carbon-based
molecule.

Why do explosives need nitros? Because things need to
combine with oxygen (O_2) to burn. What prevents them from
burning fast is that oxygen in the air is slow in reaching the
burning part. If the oxygen is made readily accessible by
putting it in the molecule itself, as in the nitro groups, then
each molecule will go up in flames at tremendous speed when
heated. The ratio of oxygen to the carbon atom fuel has to

Musk Baur

70

be just right in order for the thing to explode. It was while adjusting this molecular barbecue that Baur accidentally discovered synthetic musks. All he did was add four carbon atoms to TNT. The result was a useless explosive: the extra carbons all but put out the fire. But to his amazement, Baur noticed that his molecule had a lovely smell: clean, sweet and ethereal like most nitro compounds, but with a heavy, glistening, creamy smoothness that lingered for hours on the skin. He had achieved the same effect as with nitration of 'oil of amber', but much more cheaply. He showed it to some perfumers, who used it in formulae and found that it worked just like the fearfully expensive ingredient, natural musk tincture, but could be made a thousand times cheaper. The highest honour for a fragrance chemist is to have a molecule named after him, and this one is now called Musk Baur. He immediately filed for a patent in Germany, but it was only granted a year later and in the meantime two of his competitors managed to file the same patent in England and France and got away with it. Immediately, all of perfumery began to use nitro musks. Baur joined a chemical firm and made them and himself very rich.

Dozens of nitro musks were made, all variations on the nitro-decorated benzene ring. They differ from one another in power and exact character. The one that every perfumer would love to use (but can't) is Ambrettolide. It has that most desirable character: 'powdery'. All nitros are banned in developed countries, because they absorb light strongly in the near-UV; this causes some undesirable chemistry to go on in bright light, which makes some of them potential photosensitizers. In other words, some people who use them may get rashes. Personally, I'd risk scrofula to have my old Brut back. Nevertheless, musk ambrette is still used in India, among other places, and I have a sample before me from Maschmeijer (India), one of the best manufacturers. It looks like large

lumps of slightly yellow sugar and smells sensationally sweet-powdery in dilution.*

A healthy profit motive has driven the manufacture of synthetic musks from its inception. Waves of novel musk classes have followed each other, each improving on some perceived or real defects of the previous ones. In this they resemble sleeping pills. A new generation of sleepers, by the merest coincidence, always surfaces just as the patents for the previous one are running out, and is supposed to be less addictive than the previous one. In fact, the main difference is that the new ones work less well than the old ones. Compare 1980s Halcyon to 1880s chloral hydrate, if you get a chance.

Musks and more musks

Musks are exemplars of all the mysteries of fragrance chemistry. For a start, no other smell category exhibits such wild variation in structure to give such similar smells. This abundance is in part due to the fact that musks have been more extensively researched than any other area, because of their commercial importance and the splendid impracticality of their natural sources. Whatever the reason, chemists have turned up, not just two or three, but at the latest count as many as ten completely different ways of constructing a molecule so that it smells of musk. After Baur's early success, things went relatively quiet for three decades as chemists explored all the variations on the nitro idea. These nitros were cheap to make and smelled great, though bearing no relation to natural musks. But what do natural musks contain? This question was only answered in the years 1921–25 by the great Croatian-born

* Smelling solid, especially crystalline, perfumery materials is often misleading. As Charles Sell of Quest International explained to me, crystal growth pushes impurities that do not fit into the crystal out of the way, i.e. towards the surface of the crystal. This means that when you open the can you are smelling the stuff far less pure than it actually is.

chemist Leopold Ruzicka, then working for Chuit, Naef and Firmenich.* And the answer turned out to be a complete surprise, which earned him the 1939 Nobel.

Conventional wisdom at the time had it that rings larger than nine carbon atoms could not be made. This was a combination of empirical observation and theoretical justification. The methods which had been used for making six, seven and eight-membered rings just didn't seem to work on larger ones, and the German chemist Johann von Baeyer had suggested that this was because the rings were planar, and therefore could not be made in arbitrary sizes. To understand this, watch your child trying to build a circular railroad from curved wooden rails. If the circle's radius of curvature is larger or smaller than that of the elements, there is going to be strain where the rails connect. Von Baeyer felt that the natural amount of turn introduced by one carbon was 60 degrees, hence six-membered rings were easy. Anything larger or smaller required some bending, and the strain prevented the synthesis.

Nice, but wrong. When Ruzicka purified the musky substance from musk deer and subjected it to a standard procedure that breaks rings open, he found that the main piece was fifteen carbons long, and that it did not smell of musk. He experimented with a range of possible explanations before reluctantly coming to the conclusion that the natural musk molecule was an unheard-of fifteen-carbon *ring*. The wrong assumption that von Baeyer had made was that the rings were flat. As a matter of fact, they swivel. As Ruzicka himself charmingly admits in his Nobel lecture: 'I was hindered less by the caprices of the substance itself than by the general prejudice, shared by myself, against the probability of the existence of a 15-membered [. . .] ring.' Identifying it was hard enough;

* Now called Firmenich, this family-held company has been the undisputed leader in its field since its foundation.

making the stuff turned out to be heroically difficult. He made all the rings from nine to twenty carbons and found that the musk odour appeared at around fourteen carbons and vanished again at twenty, when the molecules became odourless. The small rings smelled of camphor and those with ten to thirteen carbons of wood.

The yields of his reactions, particularly with mid-size rings, were appallingly low, of the order of one part in 1000. However, he could make 5 per cent or so of the sixteen-membered ring. The reason for the difficulty has been hinted at before: small rings find it hard to touch their toes, large ones find it hard to *find* them. Despite working for Firmenich, Ruzicka could not make a commercially viable musk. That, remarkably, came only in 1935, and from unexpected quarters. Wallace Carothers, a brilliant chemist working for DuPont, had become very good at making molecules daisy-chain to produce the polymers that have so changed our lives: he invented nylon and started the whole field. Sadly, he committed suicide in 1937 at the age of forty-one and never witnessed the colossal impact of his creations. His expertise in controlling the joining-up reactions was put to work in preventing them from happening, and the result was the futuristically named Astrotone, the first *macrocyclic* (big ring) musk, still made today under the less evocative name of musk T.

The saga of musks continues to this day. In the 1950s it gradually became clear that the nitros were in some cases neurotoxic and caused allergies. The best-smelling macrocyclics, those without oxygens in the ring, were hard to make and so were (and mostly still are) too expensive. The search for

musks was on again, and soon gave rise to the most prolific and commercially successful series of musks, the polycyclics, so named because they incorporate several rings, rather than the single small one of nitros or the big one of macros. There are five different kinds of polycyclics, and they are the most familiar to us as clean-laundry smells. More recently they in turn have become unpopular, because they persist in the environment and end up in things we eat and drink. The search is on again, and new types of musks are still being found at the rate of one every two or three years.

As smell tablets to be deciphered, these molecules are maddening. The only thing they have in common seems to be size. All musks sit close to the maximum limit of 250 or so Daltons molecular weight, i.e. sixteen to eighteen carbons plus all the trimmings. Other than that, they are chemically as different as is possible. This being said, they are all chubby. If you think that their chubbiness might be the clue to their musk odour, let me disabuse you immediately. There are many molecules, like Cedramber®, as chubby as any musk, that do not smell at all musky.

Incidentally, these molecules are about as big as it gets in the world of smell. Anything larger, and you don't smell them at all. At the ragged edge, which is where all these molecules sit, some people can smell them and some can't. Galaxolide, for example, is completely odourless to a decent fraction of the population, probably as many as one in five. Perfumers know this better than anyone, of course, since they suffer from these specific anosmias just like the rest of us. That is why perfume formulae always include several musks, sometime as many as five, just to make sure all the bases are covered. There may be someone out there who happens to be anosmic to all five, in which case the fragrance will smell very different. Chubbiness seems to control intensity rather than odour type.

Woods and ambers

As I said at the beginning of this section, woods and ambers often turn up as failed musks, but of course they are much more than that. From wood to amber is easily the most salubrious journey in our smell continent. This is the land of the resins: incense, myrrh, storax.* Neither solid nor liquid, they are unloved of perfume factory hands because of their treacly stickiness, which makes them awkward to handle, and they usually sit forlornly in grimy drums at one end of the factory, like surly exotic beasts. I hesitate to use the word 'spiritual' when applied to molecules, but whereas musks were merely plush and sensuous, woods and especially woody-ambers and ambers have a radiant, otherworldly quality. This probably accounts for their extensive use in chasing away bad spirits from places of worship of all denominations.

What do synthetic woods and ambers smell of? Woods are immediately familiar, because everyone has smelled the sawdust, planks and shavings of resinous woods. If you've spent any time in a covered timber yard, you will know that it is hard not to feel good when in one of these natural cathedrals. Synthetic woods are all very woody, and differ from one another in what is called the secondary character, some being grassy-green, others sweet (sandalwoods), yet others spicy (vetiver). The woody ambers are harder to describe, though their uniquely clean character is reminiscent of certain kinds of windscreen-wiper fluids or of the stuff finicky old-timers used to clean real vinyl records with. In other words, they smell of isopropyl alcohol, only in a luxury class, fully upholstered version. Woody ambers are very popular at the moment,[†] because they add sparkle to all sorts of otherwise soggy and sweet oriental confections. As for ambers proper, they smell

* Storax (a.k.a. styrax) smells sensational and can be found in hippie stores. Burn it on hot coals while reading Symbolist poets.
† Chanel's recent Coco Mademoiselle and Chance are good examples.

very odd indeed. Some have described them as smelling of a hot tin can, others find them animalic. I find they have a very clean and penetrating odour without any resinous component. The best way I can describe them is to say that they are to woods as Miles Davis's silvery trumpet tone is to a military clarion.

Sandalwoods

Sandalwoods and ambers have provided the battleground for some of the most sustained attempts at cracking the Central Problem of the relationship between structure and odour.

In the case of sandalwood, the reason is simple. The natural raw material is of variable quality and fluctuating price, complicated in recent years by restrictions on the felling of sandalwood trees, whose number was dwindling alarmingly. Sandalwood is also hard to cultivate. All these are powerful incentives to the development of synthetics. An additional one is that (Z)-(-)-beta-santalol, the molecule present to about 25 per cent in natural sandalwood oil and largely responsible for its gorgeous smell,* is, synthetically speaking, a real back-breaker. The best total synthesis to date is an eleven-step affair, and any research chemist who tried to talk his production colleagues into making this would quickly be shouted down. As a result, hundreds of sandalwood molecules have been made based on related bits and pieces. Most of them are grounded on the idea of replacing santalol's left-hand end with something a little less ornery, for example campholene,

* There are two main olfactory aspects to sandalwood oil. One is sweet woody-powdery, the other one is a lightly sour yogurt/curdled milk note. Santalol carries the former.

and then attaching to it every conceivable straight or branched chain of roughly the right size bearing an alcohol (OH). Sandalwoods are a testament not only to the ingenuity of organic chemists, but also to that of the unidentified characters who name the molecules after they are made. For example, the molecule below is known by the cod-exotic names of Bacdanol, Bangalol, Radjanol, Sandranol and Sandolene, depending on which manufacturer you are talking to.

No one should get the impression that the search is easy, as in 'order some campholenal, weld a five-carbon alcohol on to it and start taking 100-kilo orders'. No, the reality is starkly different and usually hidden from view, since everyone would rather dwell on successes than failures. The neatly drawn page opposite comes from the workbook of fragrance chemist Jacques Vaillant, and describes his efforts in the 1970s at putting campholenate through its paces. Forty-five molecules are drawn on this page, forty-five more on the next, and on and on until your eyes blur. Conservatively speaking, each molecule is a week's bench work for a graduate chemist. On each page, therefore, you are looking at a man-year including French holidays and sick leave. Which you are going to need sooner rather than later, since on this page only *one* molecule smelled of sandalwood! I can think of few more discouraging ways to spend a year than to be charged with producing a sandalwood, only to go home week after week after week, as Vaillant painstakingly records, with peach, cedarwood, lemongrass, rosewood camphor and cut-grass, all from this one page.

Eventually, through sheer hard work and persistence, a vast arsenal of sandalwoods was built up. At this point (between

OBSERVATIONS

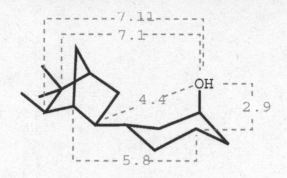

1981 and 1995) theories sprang up to account for what had and had not worked. Unsurprisingly, considering the number of chemical words that were by then known to say 'sandalwood', a pretty good photofit of the sandalwood suspect could be put together. As a matter of fact, many models were proposed, making broadly similar predictions. A summary of several of them is shown. Distances shown are in Ångstroms.* Note that the sandalwood molecule used to make these models does not have the wiggly tail of Bacdanol and its brothers. This is because wiggly bits move around through thermal motion and therefore make these measurements meaningless. In other words, chemists (a) find that some wiggly molecules smell of sandalwood, then (b) look for stiff ones that do so as well and (c) measure the stiff ones to deduce which features of the wiggly ones matter. If this seems slightly illogical, it is.

* The Ångstrom, named after Swedish physicist Anders Ångstrom, is one of those beautifully natural units, like the atmosphere or the gauss, that suffer persecution at the hands of 'rational' unit systems. A carbon-carbon bond is about one Å long, so the unit makes good sense. Its 'official' rival, the nanometre (nm), is ten times larger and perfectly useless.

Unfortunately, though the gods do not object to hard work, they seem to regard theories as *hubris*, and when it comes to fragrance chemistry they always throw carefully crafted spanners in the works. This particular one had already appeared in 1973, in the form of a molecule called Osyrol (opposite below) which Rahman Ansari and his colleagues accidentally discovered at Bush Boake Allen.* Osyrol breaks all the sandalwood rules, yet smells of sandalwood. It is shaped not unlike a spanner.

As for ambers, the gods not only had a sense of humour, but something of a cruel streak as well. The hugely distinguished fragrance chemist Guenther Ohloff worked for many years on ambers, which tend to be rather rigid molecules, braced and counterbraced by bridges and rings. In 1971 he proposed the 'Triaxial Rule' to account for amber odour. The Rule says that an amber must have a structure called a decalin, like two joined-up deckchairs, and that three groups in the one, two and four positions must be axial – that is to say, point heavenward or downward from the deck. This fitted a vast amount of data. Within a few years, however, there appeared several compounds that smelled of amber, among which was the superb and extraordinarily intense amber Karanal, named after Karen Rossiter, the Quest chemist who discovered

* Bush Boake Allen, or BBA, was in its heyday a sort of Xerox of fragrance chemistry — a fairly dull company with an amazingly creative research lab under the leadership of John Janes. Sadly, it is now defunct.

it.* Karanal drives a coach and horses through the Triaxial Rules.

❧ A bit of biology ☙

Smell, like colour, is a biological phenomenon. It is not an intrinsic property of a molecule – it is what our cells feel when they touch it. In other words, it is a problem of molecular recognition. Molecular recognition is everywhere in biology. Type 'molecular recognition' into one of the online search engines and the web will show you over 23,600 pages that refer to it.

Consider first how life makes its own molecules. Coumarin comes from the tonka bean, also called *kumarù* in the Tupi language of French Guyana. Fermentation shrivels the beans and liberates the coumarin, which is so abundant and pure that it spontaneously forms white crystals on the surface of the bean. It tastes sweet when very dilute and bitter otherwise. One bean can make a rather good (if somewhat carcinogenic)

* She also discovered an excellent rose compound called Rossitol. She is therefore probably the only fragrance chemist alive to have materials named after both halves of her name.

kilo of ice cream. All its life, the bean of the tonka tree quietly makes coumarin at ambient temperature without the least fuss: no strong acids, weird solvents, no sodium bicarbonate. How it does so is by using tools that the present-day organic chemist can only dream of.*

Almost every chemical reaction in living organisms is facilitated by a special catalyst or enzyme, itself a molecule. How does that work? In the case of coumarin, for example, step five of the bean's way of making it involves bending the loose end of the molecule in such a way that it can more easily find the bit that it needs to connect to. This is done by an enzyme called an isomerase, which attaches to the molecule in such a way that it causes the bond to 'pop' from one orientation to another like donking a biscuit tin.

To bind molecules, enzymes must have pockets big enough for the molecule to fit in. Consequently, enzymes tend to be a great deal larger than the things they bind to. One such isomerase is shown below, together with the much smaller

coumarin that it binds. Though this is a small enzyme by biological standards, it is still a very large molecule for a

* Science is about making dreams come true. Chemists, chief among them Nobel Prize winner Jean-Marie Lehn, are taking a leaf from nature's book and making synthetic enzymes every bit as good as, and a good bit smaller than, the natural ones. Some day all chemistry will be done this way.

chemist: forty-four carbons, sixty-nine hydrogens, twelve oxygens, one nitrogen. Proteins are big: a simple (fictitious) protein made up of just one each of the twenty available building blocks would read like this in SMILES notation:

OC(=O)CC[C@](n:c(=O)[C@@](n:c(=O)[C@@](n:c(=O)[
C@@](n:c(=O)[C@@](n:c(=O)[C@@](n:c(=O)[C@@](n:c(
=O)[C@@](n:c(=O)[C@@](n:c(=O)[C@@](n:c(=O)[C@@]
(n:c(=O) [C@@](n:c(=O)[C@@](n:c(=O)[C@@](n:c(=O)
CN)C)C(C)C)CC(C)C)[C@@](C)CC)CO)[C@](O)C)CS)C
CSC)Cc1ccccc1)Cc2c

Enzymes like isomerase are a class of protein. If you could pick it apart, this enzyme, like all proteins, would turn out to be a bundled-up necklace, made of small, coumarin-sized building blocks all chained together. Different proteins are simply made of different building blocks and the chain can be shorter or longer. Life consists mostly of these two kinds of molecule: small ones like coumarin and large ones like proteins. Some proteins are the tools that make and break the small molecules, but other types are also sensors that tell you a small molecule is there. For example, when you take Valium (a small molecule), the Valium binds to a receptor (a large molecule, or protein) which acts as a switch and turns the protein on or off. What is amazing in all this is that when proteins (the big guys) bind molecules (the small guys), they do it with complete accuracy: the one that's meant for coumarin doesn't bind Valium and vice versa. As you might expect, though, the world isn't just made of coumarin and Valium, far from it. There are in fact tens of thousands of small molecules and tens of thousands of proteins (enzymes or sensors) making, breaking or just feeling up the small guys. How do the receptors know which molecule to bind?

The answer is all about locks and keys. The proteins are the locks, and the small molecules are the keys. The ultimate lock-and-key mechanism, which we have all heard of, is antibodies. Inject (vaccinate) someone with a key (small molecule) that is foreign to the body, and the body will in due course produce locks (antibodies). These attach to the foreign molecule and prevent it from doing harm. How do they bind to it? Not with strong two-electron bonds as between the atoms within a molecule. What happens instead is a mutual stickiness between the antibody and the molecule, a sort of flirtation as distinct from the real marriage of proper bonds. The reason this works at all is that molecules have small sticky patches on them. For example, a nitrogen in the small molecule might attach to an OH group on the big one, two benzene rings may stick to each other like stacked dishes or a positive charge on the small molecule might attach itself to a negative one on the big one. In every case, the force is ultimately electrostatic, but they are subtly different from each other in their range and strength. Each of these forces is rather choosy about distance and direction. Things must be oriented *just so*, otherwise the molecules won't bind. The way they work is a bit like magnets, i.e. at short range, and only if the magnet is properly oriented.

The molecular recognition problem, then, boils down to having the correct arrangement of magnets in the proper place and properly oriented in both the lock and the key. The more magnets that connect up properly, the stronger the force between the big and the small molecule. The stronger the force, the tighter the binding will be. What does tight binding mean? Several things: for a start, it means the key won't fall off the lock. Remember that heat is constantly trying to shake things

to pieces. All the time, every single atom of every single molecule is moving around every which way and banging into its neighbours. At room or body temperature, the shaking is not strong enough to break proper bonds within a molecule, but it'll certainly shake loose the magnets that are holding two molecules together. What will happen is that they'll get knocked off by the shaking, then try to attach again when the heat motion brings their sticky bits back within reach; they will hang on for a brief interval and then get knocked off again. It stands to reason that if several magnets are working together to glue a key to a lock, it will fall off less often, not least because they all have to be knocked off at the same time for the key to be shaken loose. What this means is that the key will spend a greater proportion of the time attached to the lock and less time wandering around trying to find it again.

In other words, the tighter the binding, the less of the stuff you need to get a key in every lock. Drugs like the painkiller etorphine, the psychedelic LSD and the nerve blocker tetrodotoxin act in tiny amounts because they are firmly stuck to the proteins, or receptors, they bind to. Incidentally, you don't want the binding to be too tight, because this would means the stuff will never fall off. This happens: the vitamin biotin is a key that fits snugly into a protein lock called avidin, found in egg white. The fit between biotin and avidin is so perfect, all the magnets line up so nicely, that on average at room temperature the biotin key will fall off the avidin lock once every nineteen years. This would make it useless as a messenger, or for that matter as a taste or smell molecule. Imagine biotin was a sweet molecule and the sweet receptor on your tongue was avidin. One sip of the stuff, and you would get a sweet taste night and day until your retirement.

The ultimate aim of a molecule binding to a receptor is to turn the receptor on. From what we know about receptors, this involves a subtle but widespread change in the receptor's structure, a small rearrangement of its constituent amino acids called a 'conformational change'. When that change occurs, the receptor, through other lock-and-key mechanisms, can turn on other things and trigger the cell's response to the initial small molecule signal. But this still does not answer the next, harder question. After all, getting a key into the lock is all very well, but once it's in there what actually turns the key and causes this conformational change? The surprising answer turns out to be nothing. The reason is that neither the key nor the lock is powered. When we turn a key with our hand, our arm muscles overcome the springs and friction inside the lock. No such motor is available to a molecule in the receptor. Instead, what happens is that the lock jiggles around so much, from heat, that it opens spontaneously for a brief instant every once in a while. In fact, life's tiny machines have a jiggly life of their own. In this jiggly world, what the key does is stick to the lock when it's open, and therefore makes it stay open longer. Perhaps a better analogy is a jumpy door-latch in an earthquake. The latch spontaneously jumps up and down all the time. Attach a little magnet to the door near where the latch ends up in the 'open' position, and the magnet will stick to the latch when it opens. If the magnet is very powerful the latch will be permanently open and no jiggle will ever release it again. The door stays open all the time. That's biotin, or our lifetime sugar pill.

If the magnet is just right, the latch will stay mostly open and only jiggle shut again once in a while. In the jiggly microscopic world the entire home is always jumping about, and

you can actually use the magnet as a key: stick it to the door, and the latch opens long enough for the door to open. But of course the magnet itself will jiggle off, so the exact strength of magnet you need will be determined by the weight of the latch and how long you want it open. Armed with this understanding, we are now ready to tackle the first mystery of smell.

But first, one more word about receptors in general. As I said earlier, receptors are proteins, that is to say, large molecules made by living organisms to perform all the really difficult tasks, such as breaking down molecules, making molecules, replicating DNA, moving, responding to light and countless others. Almost every single chemical reaction in every cell of our bodies is aided, controlled, indeed made at all possible, by proteins. Proteins are the devices that make life possible. In a sense, as biologists and others crack open the mysteries of living organisms, it is as if they have discovered a whole civilization with extraordinarily advanced technology. What makes the whole thing odd is that the living organisms of this mysterious civilization are the very cells of our bodies. Biologists are, properly speaking, like engineers in reverse who stumbled upon an alien spaceship in good condition and are trying to figure out how it works. Often things are useful even when you don't understand them: vaccines were used in the 1770s, antibiotics (mouldy bread) and painkillers (morphine) since time immemorial, a long time before we figured out how any of them worked.

∾ *Membrane receptors* ∾

The story of receptors, and of smell receptors in particular, goes back to a question that first came up in the 1950s: how does adrenalin work? Adrenalin, as everyone knows, tells your body to get ready for action, and among other things it

makes sure there is enough sugar in the blood to keep things going. Like oxygen and water, sugar is good for you only within a narrow band of operating parameters. Go over the limit, and you feel terrible, piss all night and day while thirsting continuously, and given time, go blind and die of kidney failure, as my grandfather did at the age of forty-four. Let it drop too much, and you have epileptic fits. When it was found that adrenalin told liver cells (where the sugar is stored) to release their sugar, a mystery remained. The sugar was *inside* the liver cells, of course, but the adrenalin attached itself to the *outside* of the cells. How did the message get across the cell membrane?

The answer is that the membrane is an oily layer two molecules thick, not unlike a soap bubble, except of course that it's stable in water. It forms an unbroken sheet around every cell. Floating in the membrane are proteins specially designed for the purpose, that is to say, proteins which like having their midriff in oil but their heads and feet in the watery bits respectively outside and inside the cell. Once you have these proteins, this is how you make them work as receptors. The receptor protein grabs something in its hands on the outside, and moves its feet on the inside to tell the cell that a message has arrived. The cell responds by doing what it's supposed to do: stop releasing sugar.

Now, as mentioned before, all proteins, including of course receptors, are actually chemical bead necklaces scrunched together. The beads on the necklaces come in twenty different colours, and the necklaces are produced by a little protein-making device, itself a protein, that starts at one end and squeezes out bead after bead. Each type of protein has a unique sequence of beads. To those of us who are used to machines made of separate parts, this way of building things is a bit strange. It is as if all the parts in your car were threaded on to a single clothes line. But proteins are built this way

because the blueprint for each protein is a chemical ticker tape called RNA which says red, blue, yellow, white and sixteen other colours. The ticker tape in turn is taken from the great ticker tape registry, namely our genome. One gene, one bit of ticker tape, one protein.

∾ *Fishing for receptors* ∾

When the gene message used by cells to make adrenalin receptors became known twenty years ago, people started looking for other such receptors. This is done by making short artificial bits of gene and 'fishing' for complementary bits in the genome. It works because our genes are made up of two complementary strands, so that when a cell divides each gets one strand and then makes up the other strand for an exact match. It soon became clear that parts of the adrenalin receptor message appeared in other receptors' ticker tapes. In fact, bits of the adrenalin receptor ticker tape were found in all sorts of other receptors and also more distantly related stuff like the protein rhodopsin, the red protein that catches the light in our retinas. The way you figure out whether things are related is by comparing the texts on the bits of ticker tape that make up the receptors. As Matt Ridley elegantly put it, evolution is like a game of Chinese whispers. Every time the text on the ticker tape gets repeated, some errors are made in translation. Like Chinese whispers, this sometimes makes it more interesting, or at least more appropriate to whatever situation the gene finds itself in. At other times the mangled sentence is meaningless or harmful rather than effective, and the animal dies or fails to mate.

Reading the ticker tapes is now easy, and computer programmes can compare them with each other to figure out how

close they are, and for that matter which came first in the whispers game. For example, if you have three examples of a poem, two of which differ by one word and one by two words, you can try to arrange them in a time sequence if you have other clues (say, one is in a primitive organism and the other in a modern one). You can build evolutionary family trees from ticker-tape messages alone, which is handy because it means you don't need to painstakingly count the legs on shrimp, or look at the beaks of finches – your computer does it for you. But a major problem is that the ticker-tape messages do not tell you how the bits of the protein sit in relation to each other when the protein is made and scrunched up. To figure out the structure of the finished product, you actually need to measure it, and this is far from easy: it involves making crystals of the protein itself.

⟅ *Seeing atoms* ⟆

Crystallography is probably the least intuitive of all the disciplines that make up biology, and its practitioners are privy to some of the most arcane knowledge required in any branch of science. It is a mixture of inspired empirical recipes (rubbing your beard over a dish to make crystal growth start is a typical trick) and deep mathematical theorems. My uncle is a distinguished crystallographer, and the blackboard in his austere office is invariably covered in triple integrals, an unusual sight in the life sciences. While the methods are abstruse, the results are sensationally clear. What crystallographers deliver is, quite simply, pictures of proteins in which you can see the atoms.*

* Since these maps were for the most part paid for by taxpayers and charities, it is fitting that they should be available to all for free. They can be downloaded from *www.rcsb.org/pdb/* and viewed with any one of several free viewers. They are beautiful. If you find them hard to make sense of, rest assured: you are in good company.

We can't simply look at these proteins in the microscope because light waves are just too big to see such tiny things. Imagine, for example, that you are watching waves coming towards a beach. You would not expect a small inflatable bobbing up and down on the sea to affect wave behaviour much, whereas a big boat will make a dent in the surf. In fact, the boat's size has to be comparable with that of the waves before it begins to affect them. It's the same with light, which is why the microscope does not readily see things smaller that the wavelength of visible light, say 0.5 microns.

The wavelengths that *would* be small enough belong to X-rays, but unfortunately X-rays go through things largely unaffected, which is what makes them so useful in medicine. This is why one needs to use crystals. The basic principle of crystallography is not that difficult to understand: it is called diffraction. Imagine light waves striking an opaque object with two slits cut in it. Each slit becomes the focal point for

circular ripples that spread out from it. Because a given wave coming from the left hits the two slits at the same time, the ripples that come out of the slits will be in synch. Look at the pattern the ripples make: if two peaks or two troughs meet, they add up; if a peak meets a trough, they cancel each other

out. What you end up with further downfield – on the beach, so to speak – is a regular pattern where waves and calm alternate every few metres.

How do we go from this to proteins? First of all, imagine the slit experiment in 3-D rather than 2-D: waves hit a card with regular holes drilled in it, and you record the pattern of the waves on a target card parallel to the first and some distance away. Suppose that the holes are all of the same size arranged in a square pattern. Then you will get a square pattern of waves on the target card. What is interesting is that the closer the holes are to each other in the first card, the bigger the pattern on the second card will be. Putting the holes closer together is tantamount to putting the target further away.* Now imagine that the holes, instead of being circular, have a more complex shape, for example the letter G. Then the spots on the target, called the 'diffraction pattern', will no longer be the same. Other, weaker spots will have appeared because each part of the letter G sends waves off independently, and forms an array with the corresponding part of the G next door and all the other Gs in the card.

Now imagine that each hole in the original card is replaced not by a single letter, but by a paragraph of text like the one above. In fact, imagine that the original card is now made up of, say, postage-stamp-sized copies of the paragraph of text tiled next to one another. The diffraction pattern from this will be very complex: each letter, and each part of each letter, will be contributing to the pattern of waves. The job of the crystallographer, believe it or not, is to read the paragraph of text starting from the dots. The method only works if you can make 3-D crystals of proteins. You slowly remove the water and as the proteins get dry they spontaneously form nice big

* To get a feel for the strange and wonderful way these patterns work, put '2-D diffraction pattern applet' in your search engine and play with the simulations you find.

crystals (a millimetre or so is sufficient, as long as the crystal is nice and regular). But the proteins we are interested in, the receptors, are membrane proteins and they do not easily form 3-D crystals because they live in a flat, nearly 2-D environment, the membrane. So crystallographers are stuck with flat crystals, which are not as good. What this means is that, in the paragraph of text, you can read only the capital letters and have to guess at the rest of the words.

What helps enormously in the guessing is that you know what the words should be from the ticker tape. As long as you can figure out in the crystal pictures how the protein has been scrunched up – that is, follow the clothes line through the structure – you can arrive at a decently accurate picture of the 3-D structure of an adrenalin-type membrane receptor. Actually, this is a lie: what we have today is an accurate 3-D picture of a protein *related* to a membrane receptor, but quite different in detail, i.e. several stages earlier in the evolutionary Chinese whispers. But it's the best we can do so far.

∽ *Evolution as the Great Locksmith* ∽

What does the structure of a typical receptor look like? The distinguishing feature of many is that the clothes line goes back and forth across the membrane seven times. These transmembrane (TM, hence the receptors are collectively called 7-TM receptors) segments are rod-like, though if you look more closely the rods are actually helices. Helices are a common structure inside proteins, and they hang together because the beads of the helix connect up with one another on successive turns, thereby making the whole thing quite strong. Where does adrenalin fit? Well, that is less clear. Again, by analogy with other proteins such as rhodopsin, it is thought to fit deep inside the protein. How does it get there? Not really known, but

remember that the whole thing is wriggling about quite a bit because of thermal motion, and the adrenalin molecule could take advantage of a small opening to slip in and eventually progress to its rightful place.

What happens when it gets there? Again, not known. To answer that question you would need accurate 3-D pictures of both states of the receptor, the On state and the Off state. Since we find it hard to get either, things do not look good. But actually it's even worse than that. As we shall soon see, it is not sufficient to get a picture of the receptor with and without the adrenalin stuck in it. Think of the lock and key analogy. You're trying to figure out how a lock works and you get two pictures, one with the key inserted, the other one without. This could be entirely useless if the lock is shut in both cases. What we need is an accurate picture of the receptor in the On state, and we just don't have it. Just how accurate does it have to be? Hard to say. If what happens when the receptor is turned on is a *minor* change in structure, then we're in trouble. This would make sense because the thing that turns it on (adrenalin, smells, etc.) is so small compared with the big protein. If the change in the protein were catastrophically large, it would be darned unlikely to reverse rapidly in time for the next message to come along. In lock-and-key terms, putting the key into the door raises the latch, but does not cause the entire door to fall apart into its component panels. In a nutshell, we do not really know exactly what happens to a receptor when the key attaches to it, and we are left with only an indirect understanding of what goes on, by hitting it with all sorts of different keys and seeing what happens.

How many different types of 7-TM receptor are there?* There are hundreds, and more are being described every day. They fall into different families, but most contain only a few

* To find out the latest story, USE <<GPCR>> or try *www.gpcr.org*, a forum for the vast amount of research in the field.

members. Except, that is, for the human smell receptor family, which contains 347 members. This is a large number, though not as large as was originally thought (more than a thousand – most turned out to be 'pseudogenes', unused ones). I have them on a chart on my wall, all neatly arranged one below the other in register, one ticker tape per line so that the differences and similarities between one and the other can be seen, as well as the constant bits. Some bits of the ticker tapes, or 'sequences' as they are known, haven't been tinkered with at all by evolution. Other bits are wildly variable, even within this receptor class, and still more so between classes. Biologists like to think that everything they can measure is interesting, so they account for the bits that didn't change by saying they are essential to function, and for the bits that did change by saying that they are the parts that bind to all the different smell molecules and are therefore also essential to function. In fact, things can be highly variable when they don't matter to function *at all*, since in such cases the evolutionary pressure is nil. It's as if a watch mechanism contained many idle wheels – how many, and how many teeth they bear, is irrelevant.

The discovery of smell receptors owes almost everything to the tenacity and intuition of a single scientist, Linda Buck. Her work, published in 1991, caused the hitherto largely stagnant field of smell research to burst into renewed life. Science is largely made from these single seeds of knowledge growing into mighty trees. But the bottom line, as far as human smell receptors are concerned, is now known from the Human Genome Project. We – or more exactly the human who had his or her genome sequenced – have 347 different smell receptors. This immediately raises a seemingly simple question: is each receptor *specific for a particular smell?*

Think of smell molecules as words in an unknown language, and the number of receptors as matching the number of signs in the language. If this were a palaeography problem,

you'd know from experience that there are two extreme types of notation. In the alphabetical notation, sounds are broken down into their elements (consonants, vowels) and each element is given a letter. In the ideographic notation each word is given a symbol. Given that you know how many object-words are needed for people to put together a useful language – about a thousand – you proceed as follows. First you collect all the examples of known writing in a given language. If you only have one tablet, you wait till someone digs up more. Then you count all the different signs. If the answer is less than fifty, you know it's alphabetic. If it's much more than 500 you know it's ideographic. If it's 347, you've got a problem, and that is what stumped the decipherers of dead languages like Egyptian and Mayan. Eventually, both languages turned to be syllabic, i.e. languages in which each sign represents a combination of sounds, often consonant-vowel. Amharic in Ethiopia is another fine and living example, with 247 beautiful signs for consonant-vowel combinations.

～ *The smell alphabet* ～

What about smells? The parallel is actually pretty good. Suppose there were only a thousand smells to be recognized. If you were inventing smell receptors, you could go two ways. If the thousand were known and invariable, and you wanted high sensitivity, you'd certainly go for the thousand receptors, each of which came equipped with a nifty little pocket shaped just right for a particular odorant, like the dimples in the chocolate box. Every receptor would fit one of the smell molecules snugly, and therefore tightly. You could then pick up small amounts of stuff from the air and know it's there. Downsides? For a start, the wiring is going to be horrendously complex, because you've got a thousand different wires – but

by the standards of the brain, that may be no big problem. A more serious drawback, if you don't believe in Chief Designers, is that evolution will take a long time making this, because the evolutionary pressure favouring the individuals who smell 501 instead of 500 molecules out of the thousand will be slight. Another, more serious problem is that you can't stop the smells themselves evolving! Some new fruit comes along with different chemistry, especially if, as humans did, you move from place to place on earth. A new species of cat comes up with a whole new wrinkle on piss, and you don't know about it because your sense of smell, like Noah's Ark, has closed the doors to the beasts that didn't make it by departure time.

Another approach might be to go the alphabet way. Again, look at the thousand odorant molecules and see whether they have features in common. Pick a few (say twenty-six) features, such that every odorant has at least two of them and no two of the thousand odorants have exactly the same set. Design a receptor to bind to each one of those features *and ignore the rest of the molecule*. Wire them up in parallel to the brain so that each receptor type sends its own signal. Then sniff one of the odorants and watch what happens. Suppose a molecule has features R, O, S and E. Four receptors get turned on, and the word 'ROSE' lights up in the brain. Allow for a bit of slack in the binding, so that if the fit isn't perfect a receptor still sends a signal, albeit a weaker one. Try a different compound with those features and you will get roSe or RosE, but you can arrange it so that the reading is, so to speak, case-insensitive.

What you have now is a system that will recognize a lot of smells. Even if you limit it to four-letter words, just the combinations of molecules bearing any four of the twenty-six features in combination will add up to 358,800. Better than that, it is open ended. New smells can come along with a novel combination of these features, and you will neatly file them in

your memory as a new chemical word. Everything seems fine, except that there are several technical problems. One is the magnet problem:* each molecule will be weakly held, one magnet at a time, by the receptors, because only one part at a time is being used for binding. That means you will find it hard to smell low concentrations. The other is that it is going to be devilishly hard to ignore the rest of the molecule and only focus on the feature that the receptor is interested in. To understand this, imagine that you are trying to fit a piece into a jigsaw puzzle, except that the piece always comes with other pieces attached to it. The only way you can succeed is by making a hole in the puzzle big enough for the whole thing to fit into. You then have to make sure that (a) the place for the missing piece is on the rim of the hole, and (b) the piece you are testing is on the rim of whatever weird thing you're trying to fit. But you can't make big holes in receptors since a vacuum is out of the question, and there appear to be no water pockets. The odorant with the significant feature exposed to the outside will just have to snuggle in like all the others, and be jostled about by all the bits of the receptors that touch it. This is not like a crowded bus full of civilized commuters, where you can kiss your boyfriend without everyone else kissing you too. Furthermore, if the rest of the receptor were made of Teflon, or at any rate very slippery stuff, and the only sticky bit were the feature detector, then it might work. But every bit of the receptor will on average be as sticky or pushy as the bit the receptor is supposed to be interested in, so it'll be hard to arrange for feature detection unaffected by the rest of the molecule. Yet, as we shall soon see, this is precisely what our noses can do.

* This problem has been properly (and very readably) treated by Lancet et al in Vol 90, pages 3715–19 (1993) of *Proceedings of the US Academy of Sciences*, available free of charge as a pdf on *www.pnas.org*.

∽ *The primary smells* ∽

Another, more subtle consequence of this system is that since each receptor feels the smell molecules one feature at a time, the twenty-six features will in essence be smell primaries, the smell analogue of primary colours. In other words, suppose that twenty-six molecules are chosen, each carrying just one of the features. Just as the three primaries corresponding to the three colour receptors in the retina combine to give us every colour we see, a mixture of smell primaries should be able to reproduce any smell. Many primaries for smell have been proposed, and the search began long before the receptors were known. In 1916 the philosopher Hans Henning introduced a geometric construction he called the 'smell prism', in which six odour primaries were distinguished: fragrant

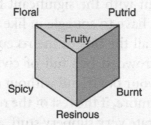

Hennings's Smell Prism

(a.k.a. floral), putrid, fruity, spicy, burnt and resinous. Though not bad as descriptors, these, like all descriptors, have an arbitrary quality to them. But right or wrong, there remains an inescapable fact: if primaries existed, the world should be full of smell illusions.

These illusions should take the following form: mix A and B and you get the smell of C, with A, B and C being single molecules. This sort of thing happens all the time in perfumery, where for example mixing a few pure molecules gives you a striking approximation to, say, a flower's smell.

This resemblance does not count as an illusion, however, because when you analyse the flower you find that it contains the component molecules rather than a single sum-of-the-parts molecule. In fact, to my knowledge, despite 150 years of synthetic chemistry and almost as many of perfumery, not a single smell illusion has come up. One could argue that there is less interest in smell than in vision, and that smells are harder to handle. But considering how much perfumery and chemistry, not to mention cooking, go on, it still seems odd.

A related mystery is that if the detectors feel only the part of the molecule that interests them and ignore the rest, then a fair few molecules should smell identical to each other. Imagine, for example, that we denote by the symbol ∧ the features that are ignored by all receptors. Then a molecule written as ∧∧∧R∧OS∧∧E or R∧∧∧∧O∧S∧E should still smell of ROSE. But – and this is probably the single most important empirical fact in olfaction – *no two molecules differing in structure have ever been found to smell identical.*

When one talks of a 'bitter almonds' smell, for example, one is talking about a resemblance, not an identity. Benzaldehyde, nitrobenzene, benzonitrile, hydrogen cyanide and trans–2-hexenal all smell of bitter almonds, but anyone, even a naïve observer, can easily tell them apart by smell after just one showing. Benzaldehyde is the proper bitter-almonds smell (contained in bitter almonds), whereas nitrobenzene smells like a mixture of amaretto and shoe polish, and benzonitrile smells like metallic almonds, and hexenal like cut-grass and almonds. My experience of smelling HCN is limited, or I would be dictating this book to sessions of the Spiritualist Society, but my recollection is that it has a clean, woody-almondy smell, again different from all the others. The same applies to all other odour categories: every musk, amber, wood, etc. smells different from its related molecules, though some are pretty close. Woody ambers, for example, can be hard to tell apart.

Let us sum up how far we've got. We can exclude the ideogram idea of one receptor, one smell because there are vast numbers of smells, probably hundreds of thousands made by the fragrance companies alone, and only 347 receptors. The alphabetical approach doesn't seem to work very well either, because you should be able to make smell words from smell letters and you can't. What's left? Well, the syllabic alphabet is currently the most favoured shape-based theory. It is technically known as the *odotope* theory, and it posits that receptors feel parts of the molecule larger than a simple one- or two-atom 'functional group' but smaller than the whole molecule. This theory has, on the face of it, much to recommend it. First, it accounts for the syllabic number of receptors (347). Second, it gets one out of the tight spot of the absence of smell illusions, because they become a great deal harder to put together if each receptor recognizes not one but several letters. Imagine playing Scrabble with the letters stuck to each other in threes and fours!

Things look good, then, for a syllabic theory, despite our ignorance of what the syllables may be. But just when you thought you could safely work it out syllable by syllable, there comes another nasty snag: the problem of mirror image molecules. To understand how this works, look at the two molecules below. There is no way you could rotate the one

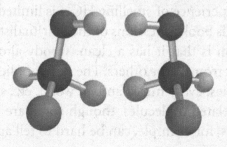

on the left to make it overlap, atom for atom, with the one on the right. Clearly, the right-hand one is the mirror image of the left-hand one, and you stand no more chance of super-imposing them than of wearing a right-hand glove over your left hand. Now look at a model of the receptor binding site for

the molecule. The left-hand molecule will sit happily in its colour-coded sockets if you rested it on the stand. However, the right-hand molecule would not.

What this means is that the moment you start having binding sites that involve more than two attachment points, you run into the problem that these sites are *chiral*, which is to say they have handedness. If you have 347 receptors, chances are that all the binding sites will be chiral, in so far as they are made of chiral molecules in a complex geo-metric arrangement. In a syllabic model, if a molecule binds to two receptors – for example, RO and SE – to give a smell of ROSE, then the mirror-image ESOR molecule will find it impossible to bind to those receptors. Instead, it will bind to OR and ES. It should therefore not smell of rose. The trouble is, it usually does. Mirror-image versions of many known odorant molecules have been made. How do they smell? There are by now pretty good statistics on this, and the answer is that *usually* they smell the same (ESOR=ROSE), though many cases are known where they do

not.* These can further be subdivided into two categories that look to be about equal in number at the time of writing. There are those where the odour character is changed (ESOR ≠ ROSE) and those where the character is the same but the intensity is decreased (ESOR = rose). The ESOR ≠ ROSE scenario is the only one that fits a syllabic model, and it is a minority. Most of the evidence, in other words, is against recognition by chiral, syllabic sites.

It is not impossible, of course, for OR and ES receptors to exist, but how does the brain know that ESOR is the same as ROSE, and similarly for all other chemical words? This would be like making a mould of your left hand, cutting it into pieces and expecting the pieces to fit your right hand. I've done this just for fun, and of course it doesn't work (though it looks nice). There would have to be two complete mirror-image sets of receptors wired in such a way that any combination of stimulations of one set should give the same effect as stimulating the corresponding receptors of the mirror set.

This could be achieved trivially if you could just make a mirror image of the whole receptor, in which each molecular bead on the scrunched-up necklace was replaced with its mirror image. Alas, the very *beads* on the necklace themselves have handedness. When you go to the health store and pay good money for largely useless amino acids, you will notice that the label says L-leucine. The L stands for left. There is no R-leucine for sale, and if there were, it would do you even less good than the L flavour because the enzymes that use it to make things have chiral binding sites. In fact, R-leucine, like all R amino acids, is likely to be either toxic or even more useless. Amino acids are the beads making up the receptors, and we only use L forms. Making an exact mirror-image OR site to match the

* John Leffingwell and his company (*www.leffingwell.com*) maintain what is probably the most comprehensive smell site on the web. The data says that 64 per cent of enantiomers smell similar or identical, 17 per cent smell different and the rest are not known.

RO is therefore extremely difficult, and making several hundred of them seems altogether impossible.

By contrast, in other fields involving receptors, such as drugs used to fight disease, it is almost always the case that the mirror-image molecule has a different effect to that of the correct enantiomer, or mirror-image molecule. This has led to a great deal of *re*discovery in pharmaceuticals, because most drugs are sold as a near fifty-fifty mixture of mirror-image molecules, easier to make than single ones. In some cases it has turned out, amazingly, that the desirable effect of the drug was due to one enantiomer and the undesirable side-effects were due to the other! Consider also the fact that the Patent Office will in some cases allow you to re-patent a drug if you now sell only one enantiomer, and you have a winning formula.

A closer look at the comparison between drugs and smell molecules also reveals disturbing differences that call into question the very existence of a conventional lock-and-key mechanism for smell. When drugs bind to receptors, they can do two things: turn them on or turn them off. How does that work? Go back to our magnet model and consider that the receptor has two states, On and Off, and can click from one to the other when kicked by thermal motion. Now picture a drug that binds more tightly to the Off state of the receptor. If such a molecule is bound, the receptor finds it harder to turn on. This is because in order to do so, it has to kick off the molecule, but the molecule is tightly bound. Therefore the receptor will spend more time in the Off position. Conversely, a molecule that binds to the On form will turn the receptor on. The Off drugs are called antagonists, the On drugs agonists.

We've all experienced antagonists at work. When the dentist comes up with her cute little syringe and injects you with a colourless solution that makes your mouth numb for three hours, what she's doing is using a molecule (xylocaine) that prevents sodium channels (a receptor-like molecule in nerves)

from opening. When you're in serious pain, they give you mor-
phine, an opiate receptor agonist. If they give you a little too
much morphine and you forget to breathe, they will give you
naloxone, an opiate receptor antagonist which binds to the re-
ceptor and does not turn it on. Same for codeine, which binds
to some sort of cough receptor. Same for the beta blockers you
can take before your exams so you don't feel your engine room
getting flustered by stress. Same for atropine, which dilates
your pupils (acetylcholine antagonist), and so forth.

The point about agonists and antagonists is that they are
similar molecules with different effects. The reason they are
similar ultimately lies in the small difference in structure
between an On receptor and an Off receptor. Like Roger
Moore lifting one eyebrow to signal the highest degree of sat-
isfaction, receptors barely move when fully turned on. The
binding site for drugs will also barely move between one state
and the other, and therefore the drugs that bind specifically or
preferentially to one or the other will be similar in shape. The
art of medicinal chemistry has consisted in tailoring the exact
shape of the molecule to one or the other state. For a long time
this was done empirically, but now as our knowledge of recep-
tors increases, *rational* methods are apparently being used to
design new drugs. A classic example of an on-off pair obtained
by the empirical approach is the beta-adrenergic agonist iso-
proterenol (left) and its antagonist dichloro derivative DCI
(right). Here the construction-kit atoms are not shown and

what you see is the outer envelope of the molecule, the boundary of the smooth cloud of electrons that envelops it. The thing at the front that looks like an inedible variety of squash is the benzene ring. On the left molecule it has two OHs hanging from it at four and six o'clock, and on the right the two OHs are replaced by two chlorines. It is striking, in this case as in many others, how little difference in structure exists between a strong On and a strong Off drug. Bear in mind that on this scale the receptor would be the size of the page.

Now to smells. Much as with drugs, research in smell chemistry has tended to focus on making seemingly endless variations on a molecular theme. For example, the skeleton of beta-santalol has been subjected to chemical surgery thousands of times in the search for a better, sweeter, creamier, more powerful sandalwood. Chemists have devoted hundreds of man-years to this, and dozens of their very best discoveries are sold as raw materials for sandalwood perfume. Not a single sandalwood antagonist has ever been found. That is to say, no chemist has ever come up with a molecule that (a) looks like a sandalwood, (b) has little or no smell of its own and (c) prevents you from smelling another sandalwood. This, by the way, is true of all smell categories. One hundred and fifty years of perfume chemistry have failed to come up with a single receptor blocker! Not that this is through lack of interest. Imagine coming up with a malodour counteractant, i.e. something that makes you insensitive to, for example, the indole contained in shit. That would make a highly desirable product. Instead of that, we're left sitting on the pot looking at the label on a spray can, all bucolic alpine scenes and high-gloss flowers. Spray the stuff, and it works the way a coat of paint works: it doesn't erase, it only covers up.

It has been said,* correctly in my opinion, that theories define facts as much as the other way around. Nowhere is this more true than in structure-odour relations, where all knowledge is anecdotal. Anecdotal evidence has a sort of slippery, jelly-like quality to it, and theories are needed to congeal the stuff together into single, solid facts. 'Anecdotal' is often used as a pejorative term in scientific circles, meaning unreliable. In practice it often means isolated, and therefore hard to assess. Think of a new field of science as a large jigsaw puzzle. Pieces are discovered one by one, and at first they are unlikely to fit together to make a picture. Things can look distinctly unpromising, sometimes for decades. But if you can bear the pain of feeling stupid and the humiliation of being wrong, anecdotal evidence is the call of the wild, the surest sign of the undiscovered. Columbus set sail on the basis of anecdotal evidence. The Mayan hieroglyphs were deciphered using anecdotal evidence. Life-saving remedies based on plants, such as aspirin and digitalis, were found by scientists who paid attention to anecdotal evidence.

Scientific problems typically go through three phases. In the first phase, a few bold explorers discover a new land and map out its basic features. In the second phase, boatloads of immigrant scientists arrive and colonize the land. In the third phase, statues are erected on town squares, sometimes to the original discoverers, more often to the able administrators who built the roads and railways. Smell, as it happens, did not follow this pattern. Scientific colonies never thrived on this particular island. Every few years, a new set of scientists claims

* Paul Feyerabend, among others, convincingly argued this view in *Against Method*, required reading for those who believe the scientific method is something which can be written down and followed like a recipe.

to have cleared the jungle, but their cities are eventually overgrown and get lost in the weeds.

In smell, the difficulty is compounded by two additional factors, one obvious, the other more subtle. The first is the supposed untrustworthiness of the smell sensation I've mentioned earlier which makes strong men and women doubt their own noses. The second is that when facts, especially anecdotal ones, remain unexplained for long enough, a kind of question fatigue sets in, and they become accepted without being understood. The situation brings to mind a quintessentially British cartoon I saw once where a dinosaur strides past a terraced house, and a couple see it from their living room. Wife: 'What was that?' Husband: 'Oh, just one of those Things.' The fact that we can smell functional groups is just such a Thing.

Functional groups, as we have seen, are the specific structures of one or more atoms that are responsible for the chemical behaviour of a substance. Examples are thiols (-SH), nitriles (-CN) and aldehydes (-C(=O)H). The little hyphen indicates that these groups are, of course, attached to something and that the Something varies hugely. But the remarkable thing is that the Something matters little to the smell of the molecules. What gives the game away, especially to the casual observer, is the fact that types of smell are named after chemical groups: sulphuraceous, nitrilic, aldehydic, corresponding respectively to -SH, -CN, -(H)C=O. This is particularly clear in the case of -SH. All molecules which contain an -SH group smell (a) strong and (b) reminiscent of rotten eggs.

A word about the description 'rotten eggs', since only a tiny minority of readers will be old enough to remember them. Eggs nowadays come with time stamps and serial numbers, so they seldom get a chance to rot. The rotten eggs smell is today more likely to be experienced in an oriental market (the durian fruit), by opening the gas tap on the stove (a small

amount of an –SH compound is added to make sure we notice it), or best of all by going to an Indian store and asking for *kala namak* or 'black salt'. Black salt, as its name does not indicate, is actually pink and is a type of rock salt that must come from Hell, as it contains ample amounts of Hell's Kitchen smell, namely the HSH molecule. HSH is –SH repeated and smells bad twice over. Put some *kala namak* on your tongue and you will see what I mean. The first thing you will notice is that it reminds you mostly of a very intense hard-boiled egg smell. Clearly, eggs, even when fresh, are itching to fall apart. If you've done any chemistry at school, you will also recall the classroom when the teacher was making one of those stinks for which chemistry is famous. Beware though, the culinary satanism of *kala namak* is beguiling: a tiny amount in blackcurrant ice cream, strawberry daiquiris, coffee and chocolate does wonders, as long as you don't let anyone know you did it.

Do all –SH compounds smell identical then, i.e. of rotten eggs? Not a bit, actually: they smell of all manner of things, from grapefruit to garlic *via* blackcurrants, but they all have this sulphuraceous (i.e. from Hell) character. The grapefruit compound is particularly instructive. It is called pinanethiol. Thiol means –SH, so pinanethiol means pinane-SH, or

Remove the –SH and the rest of the molecule (pinane) smells like pine needles, as it should, since pinane is a major component of turpentine oil, itself extracted from pine. Add the SH back and, having smelled the pinane by itself and familiarized yourself with *kala namak,* you can clearly smell the parts of the molecule. That is to say you smell both the pine

needles and the sulphur. Smell another very strong SH compound like H_3C-SH, or methanethiol, for a few seconds till the nose (mercifully) tires of the hideous –SH smell, then go back to pinane-SH. Surprise! The sulphur note is now almost gone and the molecule no longer smells of pinane-SH, but instead smells of pinane *tout court*. This means that this molecule smells like the sum of its parts. In other words, -SH *is* a primary, though the other smells are not. But how does that work? How do we know what parts it's made of? This, as we shall see, is the greatest mystery of smell. Looking for an answer will take us amazingly far afield.

But let us first convince ourselves that this sum-of-parts effect is really true. Can we do this experiment with other molecules? What we need is a part with a distinctive odour, preferably not as unpleasant as –SH but still detectable. –CN, the nitrile group, is a nice one, because when attached to a compound it invariably imparts to it a character best described as

aldehyde = nitrite

'oily-metallic'. This felicitous phrase was coined by the great fragrance chemist Paul Z. Bedoukian, founder of a firm that still bears his name. Many nitriles are known, and soon after they began to be studied systematically someone noticed that they smelled much like the corresponding aldehydes. In chemical word notation –CN smells like –C=O(H). This property has been used extensively in fragrance chemistry, because the wonderful-smelling aldehydes (think Chanel No. 5) are chemically unstable and rather reactive, whereas nitriles, though coarser in smell, are peaceable creatures. For example, lemon-scented household cleaners contain the –CN equivalent of what is perhaps the best-known aldehyde of all (at least by smell): citral. The nitrile equivalent is called Agrunitrile® and

citral, *lemon* Agrunitrile®, *oily-metallic lemon*

smells, well, like an oily-metallic lemon. Remarkably, this trick can be done with many aldehydes, giving metallic-oily cucumbers and metallic-oily cumin. Once again, the smell of a molecule is the sum of its parts.

Why is all this amazing? Let us go back to –SH for a minute. If you look at the periodic table of the elements you will find that S (sulphur) sits immdiately below O (oxygen). This says that they have the same number of electrons in their outer shell, and since chemistry is essentially the study of the mating habits of outer-shell electrons, these two should have something in common. And indeed they do: for example, there is an –OH version of every thiol (-SH) compound. The –OHs are known as alcohols. Ethyl alcohol CH_3CH_2-OH is the one that makes you drunk, and CH_3-OH is the one that makes amateur distillers go blind and die. The reader will know from experience that the smell of ethyl alcohol (good-quality vodka) is never, and indeed should never be, reminiscent of rotten eggs. As a matter of fact, no alcohol ever smells of rotten eggs. To hammer the point home, we can *always* distinguish alcohols from thiols at *any* concentration. And therein lies the rub, because they are not that different in shape – in fact, they are quite similar.

Look at the molecular models of pinanethiol (grapefruit from Hell), above, and pinanol (pine needles), below. They are

identical, apart from the different functional groups. The O and S atoms are definitely going to be the magnets in this molecule, because the remainder are just slippery little CH groups that do not bind to much of anything. If our magnet model of molecular recognition is correct, given that everything is jiggling around all the time, how can we be so sure that we are not mistaking the slightly larger S for the smaller O and vice versa? Imagine yourself feeling the two molecules inside canvas bags. It would then be hard to tell them apart, unless you had some precise callipers to measure the O and S with. But remember, in the jiggly microcosm, because of heat the callipers will jump about all the time by an amount comparable to the difference in size between O and S. Nevertheless, our noses unfailingly tell these apart just by feeling the outer electron layer, the anonymous lumps of electrons under the receptor's hands.

But assume for the moment our receptors can, somehow, reliably detect this small change in shape. Then the converse question applies to the aldehyde-nitrile pair: why do they smell so similar? After all, as magnets go, they are more different from each other than SH and OH!

And this phenomenon does not stop with these groups: in fact, all manner of chemical groups, such as oximes (-NOH), nitro ($-NO_2$), isonitrile (-NC) and phosphine ($-PH2$), can be detected with perfect reliability by the human nose. The first to point out this well-known fact (an oxymoron, but a common one in science) was a scientist called Klopping, but his brilliant 1971 paper did not make much of an impression on the field. Klopping pointed out that, roughly speaking, the larger a molecule was, and the more chemical groups (magnets) it had for molecular recognition, the more secure its molecular identification should be, and therefore the more specific its odour. This is like saying that the safest keys are the most complex ones, which makes sense. Conversely, of course, tiny molecules, such as gases like HCN, H_2S and NH_3 that have only one magnet, are like cupboard keys, which can be replaced by a piece of bent wire. They can rely on only a single variable for recognition and should therefore smell similar at some concentration or other. But of course, they do *not*. HCN famously smells of bitter almonds, not of rotten eggs, and ammonia smells of rotten fish etc. Klopping concluded that there must be something wrong with the assumptions, but could not say what.

∿ *Malcolm Dyson* ∿

Dyson was born early enough in the twentieth century to fight in the Great War and survive a gas attack that left him in fragile health to the end of his days. Even in his diminished state he worked eighteen-hour days and kept a large team of bright young people on their toes well into his sixties. Soon after the Great War, he developed methods for the synthesis of thiophosgene, which he then used to synthesize what were then called 'mustard oils' and are today known as isothiocyanates,

i.e. compounds containing the chemical group -N=C=S. It may be no coincidence that thiophosgene and mustard oils are close relatives of phosgene and mustard gas respectively, two compounds that Dyson may have experienced in the trenches. His interest in smell may also have developed in those terrifying times: the nose alone gives warning to the poor soldier that his hour has come. This explains why, aside from fragrance-chemistry textbooks, treatises on war gases are the only chemistry texts where smell is systematically described.[*]

Whatever the reasons for his interest in these odd compounds, he developed methods for the synthesis of many isomers of chlorinated phenyl mustards. Doing this involved punching in the chlorine atoms in all the different positions that the benzene ring would allow and must have been fairly dull, particularly since he repeated it with chlorine's heavier relatives one and two floors below in the periodic table, bromine and iodine. None of these materials stood a chance of ending up as a fragrance or flavour, so Dyson's study[†] belongs to the surprisingly small body of chemical work done solely with a view to understanding smell without commercial motive.

He made some remarkable observations. When only a single chlorine was added to the mustard molecule, it could go in one of three positions: four, two or six o'clock if the -NCS is at noon (left-hand column overleaf). Dyson found that the two and four o'clock compounds were mustard-like, but that the six o'clock smelled of aniseed, shaded. Dyson found that when he replaced the chlorine with its heavier brothers bromine and iodine, the anisic smell came more easily. The

[*] One such, Mario Sartori's *The War Gases* (1939) makes fascinating reading, and contains much information on the smell, often pleasant, of molecules one hopes never to encounter.
[†] In *The Perfumery and Essential Oil Record* of March 1928. His article is curiously framed by unattributed one-paragraph notices entitled 'Odoriferous Principle of Castoreum' and 'Luxury Taxes Referred to in the House of Commons'.

darker the shading, the more anisic. Two out of the three bromine compounds were anisic, and all three iodine ones. What this table says is that (a) molecules with nearly the same shape can smell very different (first row), (b) that molecules with rather different shapes can smell very similar (third column) and that as you make an atom heavier, the smell gradually changes from one type to another. Dyson concluded from this, his first foray into the area, that some sort of molecular vibration might be at work, and he talks repeatedly of 'osmic [i.e. smell] frequencies'.

His words must be seen in the context of the time. Theories of smell had hitherto been rather vague, many of them involving action at a distance, some form of remote communication between the smelling object and our sense. This notion took some effort to dispel even in the late 1920s. Indeed, Dyson returns time and time again in his early papers to the fact that smell appears to require the substance to evaporate and is therefore due to molecules of it entering our nose. Vibrations of molecules were known to occur but had yet to be measured.

So his primary reason for entertaining the notion of vibrations seems essentially aesthetic: 'If it be assumed that osmic perception is due to the intramolecular vibrations of the molecules concerned, then there is a very sound parallel between the three senses of sight, hearing and smell.' This is clearly an extra-scientific argument, which appeals to a metaphysical sense of elegance. The hold of such concepts is greater than one might suppose. Physicists in particular prize 'simplicity' and 'beauty' in a theory. In biology, by contrast, there are more examples of what can only be described as 'contraptions' and this sort of argument has less currency.

Dyson returns to the vibration theory in another article later in 1928, in which he goes over some of the same ground, spending a full two pages explaining to perfume chemists that smell can neither be action at a distance nor chemical reaction of the odorant with the cells in our nose. The first point is clear because only things which evaporate have a smell, and the second because molecules like paraffins (strings of $-CH_2-$ capped by CH_3s) do have a smell and are otherwise quite inert chemically. In a mock apology that endears him to all who have had occasion to propose new scientific ideas, he says of his vibration theory: 'It may of course be argued that these ideas, too, are speculative, but on the whole speculations based on known phenomena are to be preferred to those which have their origin purely in fantasy.' Soon after, like Ruzicka, he also synthesized the complete series of macrocyclic musks from six to twenty carbons and reported that only the fourteen and fifteen-carbon rings smelled musky. These are very flexible molecules of roughly similar shape and rather different odours. Over the following three years, Dyson completed his studies of mustard oils, giving his many papers the same title and a sequential numbering, as was often the case in those years when the pace of scientific life was less frantic than now.

Then comes a six-year gap, after which Dyson bursts into life again, using his trusted mouthpiece *The Perfumery and Essential Oil Record*, with a paper triumphantly entitled 'Raman Effect and the Concept of Odour'. Even the size and striking appearance of the typeface used for the title help to give this piece of work the feel of front-page news. To understand his excitement, we must go back and witness a revolution in chemistry that had happened in the intervening years. In 1921 the Indian physicist Chandrasekhara V. Raman went on a long trip to Europe. As he recalled in his Nobel lecture seventeen years later: 'A voyage to Europe in the summer of 1921 gave me the first opportunity of observing the wonderful blue opalescence of the Mediterranean Sea.' This seems like a promising opening line to a romantic paragraph. But Raman's intellect shuts like a steel trap on such frivolous thoughts: 'It seemed not unlikely that the phenomenon owed its origin to the scattering of sunlight by the molecules of the water.' Raman got back to Calcutta in September, and began to study this phenomenon systematically. However, as often happens in research, 'it soon became evident [...] that the subject possessed a significance extending far beyond the special purpose for which the work was undertaken'. This subject was to keep Raman busy for the rest of his scientific life.

In his Nobel lecture, Raman goes out of his way to give credit to his collaborators. It was one of them, Venkateswaran, who had made the crucial observation: when glycerine rather than water was used as the liquid, the opalescence was a brilliant green colour, whereas the incident light was blue. In other words, the light was not merely scattered by the solution – as by a dilute solution of milk in water, which

would not change the colour. Raman and his colleagues needed more intense light sources to see the scattered light, so they built a special telescope seven inches in diameter. This instrument did what telescope users are taught never to do, namely look directly at the sun. With this they discovered that the colour of the scattered light 'followed' the colour of the incident light, but always at the same distance, like a chorister singing a melodic line a major third below the soloist. Raman and his colleagues soon found out that the interval between the two varied according to substance and therefore must be a property of the stuff itself, not of the incident sunlight. They then made use of the newly invented mercury lamp, which, unlike hot bodies (such as the sun) that broadcast a large range of frequencies, emits light only at sharply defined wavelengths.* And they saw something amazing.

When they managed to photograph the first spectra of the scattered light, they realized that it was made up of different 'lines' and that the position and intensity of each line depended on what liquid was used. Furthermore, the lines always did what the opalescence had done, namely sing in fixed harmony with the incident light. Raman soon figured out what this was all about: *each line was a vibration of the molecule.* So far we have drawn molecules as if the bonds connecting the atoms were rigid. But the electron glue that holds molecules together is not all that stiff. If you were to pull one of the atoms away and release it, it would go *boing* and vibrate a few times before settling down to its original position. In fact, it behaves like an elastic spring. The pitch depends on the spring and the atom. The stiffer the spring, and the lighter the atom, the higher the pitch. The weights

* So do yellow street lights, which use sodium rather than mercury. So narrow is their spectrum that red things such as tongues and Ferraris look almost black.

of the atoms are set by their position on the periodic table, and the stiffness of the springs depends on how strong the bond is between the pair of atoms it connects – although not very much on what else is around. You could learn to recognize what *boings* different pairs of atoms make when plucked. You could then ask someone in the room next door to pluck the different atoms in a molecular model unseen by you. Provided you have perfect pitch, you would know what atom pairs it was made of.

∾ *Molecular chords* ∾

Each vibration of a molecule can contribute a line to the Raman spectrum. The fundamental thing is this: every chemical compound is defined by a set of atoms with their connections to each other. Molecular vibrations are like dance movements: some of them involve only a part of the molecule (think head movements in Indian dance), others involve flexing motions of the entire molecule (think the embarrassing 1970s). When you add up all the different ways a molecule has of vibrating, it turns out to be in a simple proportion to how many atoms it has. A molecule with N atoms has three times N ways of moving: a typical smelly molecule with, say, twenty atoms would have sixty dance steps or vibrational modes. The spectrum of vibrations is like a keyboard, with the lower half (the 1970s) taken up by the vibrations involving most of the atoms of the molecule. The upper half (Indian dance) is where all the signatures of chemical groups live. It makes sense that the exact list of vibrations will depend on the exact structure of the molecule. By definition, the pattern of connected atoms is unique. It is hardly surprising, therefore, that the pattern of vibrations is also unique. In fact, this is true to such an extent that accurate measurements

of molecular vibrations provide a 'fingerprint' of a molecule. If you've seen it before and know its structure, you can identify it instantly. There are libraries of thousands of spectra to assist in comparison. Incidentally, while you can figure out the vibrations from the structure, you cannot yet solve the reverse problem, i.e. figure out the structure from the vibrations.

When Dyson read Raman's work, he immediately saw the direct relevance of this to smell: we can detect chemical groups, and so can the spectroscope. Ergo, since shape is *not* a good predictor of smell (remember his mustards of a few years earlier), *the nose may be a spectroscope*. In a breathtaking seven pages, Dyson stakes out so much ground that smell science is still catching up today. But the centrepiece of his demonstration comes first. With typical panache, he says, 'Let us commence the inquiry with a simple case – selecting some group of substances with an indisputably characteristic odour which is unlike that of the vast majority [...] I have selected the mercaptans (-SH) as the most suitable; once their powerful and clinging odour has been observed it forms a most vivid impression and most chemists would recognize it again. [...] Is there any corresponding characteristic feature in their Raman spectra? The answer is that there is indubitably a *unique* feature in the Raman Spectrum of all alkyl mercaptans, a line with [...] frequency 2567–2580. *No other compound has such a line.*' (My emphasis.)

∾ *The smell of rocket fuel in the morning* ∾

Most of this was true: SH compounds do stink memorably and distinctively, and nothing else has exactly the same smell. Crucially, however, the last statement was wrong. There is in

fact another type of compound with just such a vibration: the only other covalent bond in nature that vibrates at anywhere near 2500 wave numbers. It is the boron-hydrogen bond, B-H, and compounds which contain it are known as boranes. Had Dyson known this, he would have been within reach of a formidable piece of evidence in support of his theory, a veritable Rosetta Stone of smell. Picture this: if the vibration idea is right, then boranes should smell of sulphur, no ifs, no buts. Do they?

Francis Jones (see opposite) was the first person to make and, bravely, smell a borane, in 1878. He found that it had a 'disagreeable* odour', which we now know to be common to all boranes.

Volatile, spontaneously flammable, unpleasant-smelling, highly toxic – the boranes clearly required special handling. The techniques for holding these ferocious beasts on a suitably long leash were worked out in the early years of the twentieth century by Alfred Stock. His great invention was the vacuum line, essentially a collection of vessels connected by glass piping interrupted in suitable places by stopcocks, and from which air has been pumped out. Gases travel fast in a near-vacuum, and boranes can be shifted from one part to the other of a vacuum line merely by cooling the part in which one wants the borane to condense, closing the stopcocks on either side and warming it again. Armed with this, Stock was able to study boranes properly. A fellow chemist said of his work, 'All statements about boranes earlier than 1912, when Stock began to work on them, are untrue.' All, that is, except the *smell*. 1912 is the date of Stock's first paper on the subject, a long article in *Berichte*, the journal of the German Chemical Society. He makes B_4H_{10} and describes it as a 'colourless gas with a characteristic, repulsive odour, when very dilute reminiscent of

* 'Disagreeable' is virtually synonymous with sulphuraceous in the language of chemists.

The next paper was "*A Preliminary Notice on a Hydride of Boron,*" by FRANCIS JONES. After an unsuccessful attempt to prepare the above substance, by treating a product (magnesium boride), obtained by the action of sodium on a mixture of magnesium chloride and potassium borofluoride with hydrochloric acid, the author succeeded in preparing a spontaneously inflammable gas, which is doubtless hydride of boron, by first strongly heating a mixture of magnesium dust and boron trioxide,—

$$B_2O_3 + 6Mg = 3MgO + B_2Mg_3,$$

and, secondly, treating the grey friable mass thus obtained with hydrochloric or nitric acid. The gas is colourless, burns with a bright green flame, and has a disagreeable odour. By using $3Mg$ instead of 6 in the above equation and treating the product with hydrochloric acid, amorphous boron is obtained as a brown powder.

The Society adjourned to December 5, when the following papers will be read :—" The Processes and their Comparative Value for Determining the Quality of Organic Matter in Potable Water," by Dr. Tidy ; " Researches on the Action of the Copper-Zinc Couple on Organic Compounds," by Dr. Gladstone and Mr. Tribe ; "On a New Gravimetric Method for the Estimation of Minute Quantities of Carbon," by Drs. Dupré and Hake.

The discovery of the first borane, recounted in *Chemical News* of 29 November 1878. Note that Jones *from the very first* reports on the 'disagreeable odour,' of his boron hydride. In a later paper he promotes the odour to 'extremely disagreeable' and states that it 'produces nausea and headache even when inhaled in moderate quantity'. Indeed, all boranes are very toxic. The green flame of boron is characteristic, and can be seen at the start of the Lockheed SR-71's engines, which do not have a starter motor and rely on a dollop of borane fuel to fire up. This highlights a further unpleasant habit of boranes, their tendency to burst into flames. The strange title above the text refers to the article that follows it, in which two scientists envisage a future science of 'moving colours and shapes' which would rival dance in its attractiveness, possibly a premonition of Grateful Dead concerts.

chocolate'. This chocolate idea was to have unintended conse-
quences, as we shall soon see. A few pages later, Stock is more
precise. He describes the smell of another borane, B_6H_{12}, as
'extremely repulsive, recalling that of B_4H_{10}, but also some-
what reminiscent of hydrogen sulphide'. Here is the piece of
evidence Dyson needed. Totally different shape, no chemical
properties in common, but same vibration – and, by God,
same smell!

But in 1912, no one knew what the vibrations of B-H bonds
were. Furthermore, as time went on, chemists got better and
better at *not* smelling the lethal boranes. Stock's description of
B_4H_{10}'s smell in dilution as 'chocolate' may be true for all I
know, but a lazy chemist with a head cold thoughtlessly ap-
plied it to another molecule, decaborane $(B_{10}H_{14})$. This is the
only solid borane anyone not equipped with a vacuum line
can get hold of, and the only one that does not burst into
flames. It is a white, crystalline solid with a strong, sweetish
smell of boiled onion or leek, in other words of -SH. But
scientists can be reluctant to let mere facts get in the way of
well-established opinion, and to this day decaborane is de-
scribed in all the hazardous substances databases as having
an 'intense, bitter, chocolate-like odour'. This single error
probably set vibration theories back by three decades.

The late 1930s brought a lot of progress in optics and infra-
red detectors, and in 1941 Stitt worked out the vibrations of
boranes using infra-red absorption. This was then a new tech-
nique, different in principle from Raman's method and more
accurate. Instead of intense visible light, infra-red light con-
taining a range of frequencies is shone at the sample, which
absorbs the light whenever its vibrations correspond to the
frequency of the light. How does this work? By a phenomenon
familiar to us as resonance.

Here's a simple experiment you can do with an upright
piano instead of practising your scales. Open the lid of the

piano, and stand up while holding down the loud pedal with your foot. That frees up all the strings. Sing a note quite loudly for a brief instant, then stop and listen. The piano will carry on your singing, because the sound waves from your throat have set in motion the strings that match the pitch of the note you sang. Same with atomic vibrations, except that you use light.

And when the borane spectra were published for all to see, there it was, the intense vibration of the B-H bond just above* 2,500 cm–1, smack in the middle of the S-H range . . . But, in

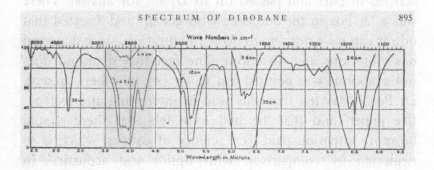

the first of many missed opportunities that recur in this story, Dyson never made the connection, and neither did anyone else until 1995 when, discovering the similarity in vibrations, I checked the odour of boranes. But more about that later. As it was, deprived of this gem of evidence, Dyson moved on to point out other interesting correspondences between chemical groups, such as $C=O$ and the triply bonded carbons of acetylenes. Raman spectroscopy was young, some of his frequency assignments are wrong, but he managed to put together a table for the upper half of the vibrational keyboard that is still mostly true.

* An unfortunate habit of the spectroscopy literature is to display the graphs with the *horizontal* as increasing wavelength, which means decreasing energy. Wave numbers, the inverse of wavelength, go in the right direction.

What was the reaction of his contemporaries? Remarkably, we have some direct responses in print in the form of a discussion following a presentation at the Society for Chemical Industry in 1938. Dyson could not attend, and the paper was read on his behalf by another person. It goes over much of the ground of his previous papers, and is boldly entitled 'The Scientific Basis of Odour'. By this time, Dyson was at Loughborough College, the institution which was to be his home until his retirement. The reading of the paper was followed by a discussion, which was transcribed in part and passed on to Dyson for answer. There was a Dr Fox in the audience who got up and asserted that odour can have nothing to do with vibration, since diamond has vibrations and no odour. The fact that diamond does not evaporate was pointed out to Dr Fox by others present. Dr Percy May felt that 'this was an interesting and instructive paper' and that 'he had long felt that there should be more attention paid to a science of osmics, which is so neglected by comparison with optics and acoustics'. In other words, positive but lukewarm. Reading between the lines, though, we can see that some of the appeal of Dyson's theory was in the philosophical unity of colour, sound and molecular vibration. This was to be Dyson's last article on the subject.

∾ Robert H. Wright ∾

Things went quiet on the vibration front until 1954, when the theory suddenly reappeared under new management, that of a Canadian chemist called Robert H. Wright. The intervening years had been eventful for lock-and-key theories. First, thanks to X-ray crystallography, a great deal more was by then known about the shape of molecules. Second, spurred on by a

1946 article by Linus Pauling,* there was by then an emerging consensus that shape was responsible for molecular interactions, and that the recognition of smell molecules was just one example among many. An influential and authoritative article by R. W. Moncrieff had appeared in 1949 in *American Perfumer*, setting out 'What is odor: a new theory'. The idea was that the shape of the molecule was responsible for its odour. Pauling and Moncrieff were distinguished chemists, and Moncrieff in particular had a great deal of experience of fragrance chemistry. His belief that shape must be responsible for smell carried a great deal of weight, and influenced other chemists such as Beets, who did much fundamental work on musks and went on to publish many theory articles based on shape.

Another emerging figure in the field was John Amoore, a British-born chemist living in the US who took a first-principles approach to the problem. He started by supposing that there were only a limited number of shape-based receptors, and that all odours would be based on combinations of binding more or less well to several receptors, the pattern of binding determining the smell. In essence, the set of basic receptors is tantamount to a set of smell 'primaries', just like the primary colours from which any colour can be produced. Amoore tried to identify these primaries by an ingenious method. He scoured the literature for words used to describe smells and ranked them in order of decreasing frequency. The list which follows is what he came up with. Amoore's idea was that things which fitted to one receptor are likely to be more common than things which fitted to two or more, therefore the most common descriptors are likely to be those of primaries. Amoore chose the top seven as

* *Chem. Eng. News*, 24, 1375 (1946). Linus Pauling, winner of two Nobel Prizes (Chemistry 1954, Peace 1962), brought quantum mechanics into chemistry. He also maintained side-interests in a host of problems, among them smell, the mechanism of general anaesthesia and, most famously, vitamin C.

Camphoraceous	106
Pungent	95
Ethereal	53
Floral	71
Pepperminty	77
Musky	69
Putrid	49
Almond	30
Aromatic	27
Aniseed	12
Lemon	7
Cedar	7
Garlic	7
Rancid	6

primaries.* The chief merit of this approach, in retrospect, seems to have been the lack of alternatives. The descriptors were in themselves, as Amoore freely admitted, highly arbitrary. Part of the problem was the database. Ask a sulphur chemist, and garlic will come up 50 per cent of the time. Ask a fragrance chemist, and 'putrid' will almost never come up. 'Putrid' refers to compounds produced during putrefaction, chiefly sulphides and amines, and therefore should properly be split into 'rotten eggs' and 'fishy'. Further, we now know that 'pungent' has to do with the olfactory equivalent of pain, trigeminal stimulation, and is therefore not to be considered a smell character. 'Floral', as we have seen earlier, is meaningless, because flowers come in many smells. The high incidence of 'musky' suggests that Amoore was reading fragrance chemistry papers, but in that case 'woody' should be just as frequent, and so on. In spite of Amoore's earnest

* The number seven has a certain ring to it when one is looking for primaries, not least because Newton was fond of it, and reputedly added 'indigo' to the list of six obvious colours of the rainbow to achieve it. What may have stopped Amoore from going one better on Newton was that the eighth on the list was almonds, which he knew to be a huge problem for shape because of the puzzle of hydrogen cyanide.

efforts,* the list reads a bit like Borges's celebrated classification of animals:† '1. those that belong to the Emperor 2. embalmed ones 3. those that are trained 4. suckling pigs 5. mermaids etc.' Amoore made one major prediction, which we have encountered before, and which is not borne out by experience. It *should* be possible to produce any smell by a combination of the primaries, and it clearly is not. Amoore's theory of odour primaries no doubt still haunts the dreams of accountants working for fragrance companies, who would love to reduce their inventory of materials from two thousand to seven. One enduring consequence of Amoore's classification, however, was the idea of a structure-odour relation for the camphor category. Amoore postulated a hemispherical socket as a receptor site in which camphor and a number of other camphoraceous odorants such as cyclooctane, chloretone and naphthalene fit snugly. Though it fitted the facts known at the time rather well, this idea had little influence

* John Amoore, whom I never met but spoke to on the telephone, was, it seems, a man of courtly manners and total intellectual honesty, the first to admit to any deficiencies in his theory.

† 'The Analytical Language of *John Wilkins*' in Jorge Luis Borges, *Other inquisitions 1937–1952* (University of Texas Press, 1993).

outside 'academic' structure-odour studies and did not, for example, overly excite fragrance chemists, for whom camphoraceous is an uninteresting odour category. The idea is still quoted today, despite evidence to the contrary – about which, more later.

∾ *The revival of vibration* ∾

To be fair, in 1954 vibration theory was not doing all that well either, and R. H. Wright needed plenty of pluck if he intended to revive it. But this he had in abundant supply. All in all, he seems to have been the sort of scientist and science teacher everyone dreams of meeting. Wright trained as a chemist at the University of British Columbia. He then married and moved to New Brunswick for several years, after which he returned to Vancouver and worked for the BC Research Corporation, an applied research institute. His main interests were in chemistry applied to pest control: insect repellents, lures, etc. His connection with smell came from this work: insects can be trapped or kept at a distance by the appropriate molecules now known collectively as pheromones. Like many chemists, Wright was unimpressed by the relationship between molecular shape and smell; he had read Dyson's work and thought there might be something in it. But Dyson had taken several hits below the waterline in the intervening years.

The first was that, as we had seen, some of Dyson's frequency assignments were wrong, and critics seized upon this to dismiss his theory. The spectacular borane-sulphur prediction would have nailed that one squarely, but no one knew of it. Some claimed that the theory must be wrong since methyl nitrile (CH_3-CN) and methyl isonitrile (CH_3-NC) had 'quite different' odours and rather similar vibrations (see table opposite). This claim is worth examining, because it illustrates

the less than solid nature of facts in the field of olfaction. First, the smell. The presence of a nitrile group invariably imparts a metallic-oily smell, which most people find fairly unpleasant. The smaller the molecule, the larger the contribution of the nitrile group to the overall smell. The only vibration which could account for the constancy of nitrile character whatever the molecule must be the stretch vibration of CN itself. Similarly for isonitriles, since the -NC group imparts a distinctive smell to every molecule it inhabits. Isonitriles, it must be said, are quite something. The smell of the pure stuff was described by Klopping as 'indescribably vile' and few would disagree. But what is remarkable about their smell is not so much its character, but its prodigious intensity. At high dilutions, by contrast, isonitriles have a metallic smell which is actually quite close to that of nitrile, and I wager many people would misidentify it. Second, the vibrations. The relevant CN and NC stretch frequencies differ by as much as 100 wave numbers. Who was to say that this was a small difference when the 'pitch' resolution of our nose was unknown? After all, to a spectroscope these are miles apart. I suspect Dyson would have made short work of this, had he retained an interest in the matter.

CH3CN	CH3NC
3009	3014
2965	2965
2267	2166
1454	1459
1400	1410
1041	1130
919	944

By contrast, in his book *The Science of Smell** Wright puts up a strikingly weak defence against these objections, which

* NYC: Basic Books, 1964 (Library of Congress catalog no 64–20274).

is surprising given his knowledge of physics and chemistry. But the reason soon becomes clear. It is not because Wright is dispirited about vibrational theories, but because he feels that Dyson has made a crucial mistake in defining the *range* of vibrations that are essential to smell. Recall that Dyson had emphasized the range between 1,400 and 4,000 wave numbers. This was (a) because he felt that the functional group smells (-SH, -CN, etc.) must be detectable, and they all vibrate in this range, and (b) because of the limitations of Raman spectroscopy which at that time could not see things clearly below 1,000 wave numbers. Dyson, in other words, was not wedded to this range at all. He simply felt a theory that excluded it would sacrifice a great deal of explanatory power.

～ *Searching for the way it works* ～

Sacrificing the range above 1000 wavenumbers was just what R. H. Wright now proposed to do, for reasons that seemed compelling at the time. Wright was trying to overcome another, far stronger objection to any vibrational theory: *there was simply no conceivable means by which a living organism could perform spectroscopy*. A spectroscope designed to measure molecular vibrations by optical means must include (a) a light source, (b) some sort of device (prism, grating) to separate either incident light or emitted light into different wavelengths and (c) a detector. In the case of Raman, the light source had to be visible and intense. Now living organisms do produce light, but not of sufficient intensity (try reading by the light of mushrooms) to get Raman spectra. If the newer type of spectroscopy, infra-red absorption, is to be performed, then a reasonably strong infra-red light source containing a broad range of frequencies must be used. There are several

good reasons why this is impossible in biology. The simplest intense infra-red source is a hot object. The filaments of ordinary light bulbs, for instance, emit far more infra-red than visible light. But a hot object is impossible in a living system because it would toast its surroundings. A chemical infra-red source, a sort of stealth firefly light, is not inconceivable, but is quite difficult to implement because the efficiency of chemical light sources decreases sharply as wavelength increases and becomes almost nil at infra-red wavelengths.* Even were this possible, one would need several such inefficient lamps to cover the vibrational spectrum.

Light sources are not the only problem. There is also the question of water. As we all know from idly reading the labels of French mineral waters, 75 per cent of our bodies are made of Evian. The problem is that water molecules are attached to each other by weak bonds, which give water (at the molecular level) a jelly-like consistency which is supremely good at absorbing infra-red. In practice, water is absolutely black to infra-red and would soak up all the energy, leaving none for the smelly molecules to absorb. It could be argued that if a biological spectroscope existed, then it must be of microscopic size, since peering up one's nose reveals nothing suspicious, and therefore the light would not have to travel far.

No, Wright felt, optical spectroscopy must be out of the question. But that only left mechanical means with which to detect vibrations. In other words, some receptor would actually feel the molecule buzz. But why should the molecule be buzzing in the first place? Wright argued that the only source of energy would be thermal motion. It was at this point that he took the turn which, I believe, doomed his theory thereafter.

* For those who care, this has to do with the fact that when the energy level of an electronic excited state becomes comparable to thermal energy, decay mechanisms other than emission of radiation predominate.

The problem with thermal motion is that the energy involved, whether at room or body temperature, is small, of the order of 250 wave numbers, which is around 10 per cent of the SH stretch energy. One might think that the effect of a 250 bump on a 2,500 vibration would be to play it *pianissimo*. That would be the case if things weren't quantum. In the quantum world things work like flutes, not like pianos.* When you blow into a flute (or a beer bottle) very softly you get no sound. It is only when you get beyond a threshold intensity of blowing that the flute emits a sound. Blow harder still, and the sound jumps an octave higher. Same with Brownian motion: a 250 wave number bump is tantamount to the gentlest puff of air, and stands almost no chance of exciting a 2,500 wave number vibration. What this boils down to is simply that if the nose is going to feel vibrations mechanically, then only vibrations below 1,000 wave numbers need concern us.

This new notion, which Wright introduced in a 1954 article, radically changed the whole picture and gave vibrational theories a new, albeit temporary, lease on life. Wright felt that it made a biological spectroscope more plausible. But another consequence was that, when looking for correlations between spectra and smells, Wright said one had to look in the far infra-red, a region different from that explored by Dyson. Wright then found himself in an unusual position, because far-infrared spectroscopes were few and far between, and he happened to have one. The reason why they were rare he amusingly terms a 'sordid detail': these machines cost €35,000, five times the price of a near-infrared spectroscope – a lot of money in 1961. So the good news was that he could do the experiments. The bad news was that virtually no one else could repeat them. Given the perceived outlandish nature of

* Pianos are called pianofortes or fortepianos for precisely that reason. From the standpoint of this physical analogy, they are the ultimate *classical* instrument in more ways than one.

Wright's theory, this was a severe impediment. If you propose something really different, you had better make sure other people can replicate the experiment. Otherwise, if they don't like your idea but can't say why, they simply won't believe your data. I say this partly because for years I reacted to Wright's work in just this way.

∾ *New problems* ∾

Having scaled this peak, Wright must have had a sinking feeling when he saw a veritable Hindu Kush of further problems come into view. The first was that some molecules with strong and distinctive smells simply have no vibrations in that range. The reason is very simple: much in the way that on a xylophone the shorter bars give higher notes, short little molecules like H_2S can only make high pitches. H_2S has only three vibrations: two S-H stretches in which the Hs move either together or alternately (around 2,600) and an H-S-H 'bending' vibration around 1,290. And that's it. Nothing below 1,000. Had Wright known about the boranes, he would have realized the error of his ways. But he didn't and he bravely went on. He lists three such molecules: H_2S, HCN and NH_3. He then does a bit of special pleading to get rid of them. He assumes that H_2S undergoes a chemical reaction in the nose which turns it into a larger molecule, i.e. one possessing vibrations below 1,000.

$$4H_2S + O_2 = 2H_2S_2$$
$$2H_2S_2 = H_2S + H_2S_3$$

These chemical reactions were plausible. There is nothing wrong in principle with exceptions, and Wright faces up to this one with exemplary candour (he calls it 'a somewhat

embarrassing question'). But scientists have a word for this sort of stuff: 'epicycles', named after the celestial wheels needed to make Ptolemy's wrong theories of planetary motions work. Add a few too many, and things start to creak badly. Wright had not yet reached that stage, and between 1954 and 1975, armed with his infra-red spectroscope and some clever graphical methods, he attacked several of the major odour classes. As is usual in this field, his first attempt was on bitter almonds. Note that he had neatly disposed of the intractable problem of HCN when dealing with the 'three exceptions'. H_2S, as we have seen, reacted with water and with itself. NH_3 (ammonia) was not a smell but a pain sensation, and 'as for HCN it also is a

FIGURE 1. The far infrared absorption spectrum of nitrobenzene and the vibrational assignments or kinds of oscillation believed to produce each kind of absorption.

A representative figure from one of Wright's bitter-almond studies. When checked against accurate quantum-mechanical calculations, both the frequencies and the motions tally exactly.

reactive gas, and quite toxic, and the fact that some people can't smell it points to the possibility that they lack the special chemical point of attachment it needs to generate an osmic frequency'. Epicycles again: the toxicity is irrelevant, and in any event H_2S is vastly worse. HCN is really rather unreactive, and the fact that some people can't smell it is irrelevant. On that logic, smell as a whole could be deemed not to exist because some people have a blocked-up nose.

Having thus tried to swat HCN as if it were an irksome gnat, Wright goes on to measure the infra-red frequencies of a host of *other* bitter-almond chemicals. Many people, myself among them, had private and occasionally public reservations about his vibrational frequencies. Fortunately, it is now possible without any sort of measuring instrument to calculate vibrational frequencies to virtually any degree of precision, provided one has a fast computer or is prepared to wait. I have recalculated some of his frequencies using sophisticated quantum-chemistry software,* and have found them to be correct not only in value, but also in the far trickier job of assigning which type of motion, or mode, is responsible for each frequency. The problem, then, was definitely not with the data. This is clearly state-of-the-art spectroscopy, and Wright's critics – assuming there are still any around – had better think again.

∾ *The fall of vibration* ∾

Actually, they need not have worried about his data, because as it happened it provided little support for his theories. For a start, the molecules tended to have hosts of modes in the region below 1,000 wave numbers, and even had there been some sort of pattern it would have been hard to see. Wright

* I inhabit a Mac-only household, so it had to be MacSpartan from *www.wavefun.com*

resorted to some clever graphical display methods which showed where the density, i.e. the number of modes per energy interval, went up or down. Despite this, the correlations were still not that convincing, and epicycles soon started to make ugly grinding noises again. In a remarkable paper in *Nature* in 1964, Wright resorts to adding imaginary frequencies at the *difference* frequency between two measured ones, after which some sort of pattern does reluctantly emerge. There is no question of him misrepresenting the data, since he does this in full view of the reader, so to speak, in a clearly written figure-legend plain for all to see. But the bungee suspending disbelief was by then fully stretched. Two huge additional weights were about to make it snap.

The first was the problem of isotopes. As Wright knew very well, and as other chemists never tired of pointing out, isotopes provided a crucial test of his theory. Isotopes bring up the thought of radioactivity, and indeed they are the very stuff of nuclear physics, but in this instance they serve another purpose than to emit particles and rays, lethal or otherwise. Elements, as we have seen earlier, differ from each other in the number of electrons they have in their onion-like electronic layers, and these electrons have to be countervailed by an identical number of protons in the nucleus to make sure the atom is neutral.* There is, however, a third type of particle that is quite happy to live in the nucleus and, unlike electrons and protons, carries no charge. Appropriately, it is called the neutron. Though neutral, the neutron can have a disrupting effect on the nucleus, because it interferes with the force that holds protons together. For example, the stable and unstable isotopes of uranium differ only by a handful of neutrons in their nuclei. The simplest of all elements, hydrogen, has one proton and one electron. Add a

* Were this not so, elemental solids would explode like TNT, propelled by the repulsive forces between like charges. When more than one element is involved, and the charges on the component atoms are equal and opposite, you get well-behaved solids like Na+ Cl-, table salt.

neutron to the nucleus, and you get deuterium. Burn deuterium in air, and instead of common water, H_2O, you get heavy water, D_2O. Heavy water really is heavy: a flask of it in the hand sloshes differently from the ordinary stuff. But in most respects, heavy water behaves exactly like water. It does have a slightly higher boiling point, to be sure, but you could grow bacteria in it (a bit more slowly), water the plants, indeed drink the stuff (in moderation) without any ill effects.

The reason why it behaves so much like water is that most of chemistry, as we have seen earlier, follows from the mating habits of electrons and the nuclei just tag along to make up the charge. What this means is that the electron bonds made by different isotopes will be, to a high approximation, identical to each other.* In other words, the bond between deuterium (heavy hydrogen) and carbon will have the same strength (i.e. stiffness) as that between ordinary hydrogen and carbon. But – and this is where it gets interesting for the science of smell – heavy hydrogen is twice as heavy. So that the *boing* you get when you stretch the C-D bond and release it is a fifth lower, a contralto to C-H's soprano. In other words, isotopes change the masses, not the springs, so all the vibrations of a molecule are changed to a greater or lesser extent by isotope substitution while the shape is unchanged.

So there we have the perfect test of whether our smell receptors are reading shapes or vibrations: two molecules with identical shapes and different vibrations. As usual though, the devil is in the details. Which molecule to choose, and which elements to replace with their heavier isotopes? As one might expect, the lighter elements are most affected by the addition of neutrons, none more so than the lightest, hydrogen itself. Heavier beasts like carbon and oxygen do come in different isotopic flavours, but adding a neutron to the twelve nuclear

* Remarkably, electrons spend a small fraction of their time inside the nucleus while whizzing round an atom, so they are dimly aware of the neutron's presence.

particles of normal carbon will give it a mass of thirteen, only an 8 per cent change. Hydrogen it is, then. But then one also has to be careful about the choice of which hydrogens in which molecules to replace with deuterium. Many hydrogens are loosely bound to the next atom, and they constantly jump off and back on like circus horsemen. Take for example D_2S, the heavy analogue of H_2S. You can certainly make it, and it will most definitely have completely different vibrations from H_2S, but if you smell it, the D will be replaced by an H taken from the surrounding water in your nose, and this within nano-seconds. This is because, unless you have been drinking a lot of heavy water, almost all the hydrogens in your body will be light ones, and when the D jumps off a far more common H takes its place. Result: no experiment.

Nevertheless, there are many stable hydrogens in molecules, and Wright could get hold of suitable isotope-substituted odorants. He did so, and the result is described in one of the chapters of his book. He asked people to smell normal and deuterated napthalene, and cheerfully reports that they smell different. Looks like good news then? Well, not really. The difference was not striking, and precisely no conclusion can be drawn from this experiment. The reason is the bugbear of all smell experiments: purity. Even a tiny amount of some molecule unrelated to the main component could affect the smell of the whole thing. This happens in the lab when two successive batches of the same odorant, prepared under 'identical' conditions, have slightly different smells because of slightly different synthesis impurities. Deuterated compounds are frequently prepared by completely different methods from the normal ones because of the restricted availability of deuterium building blocks, so one would expect them to be contaminated with different impurities and to smell different anyway. The nose is just too good a measuring instrument for the theory to be tested in this fashion.

What should Wright have done? The only way to do this properly is to put both molecules in a gas chromatograph and smell the molecule peaks pure as they come out. This requires (a) a smelling gas chromatograph, uncommon then as now outside the fragrance world, (b) training to learn to smell the peak rapidly and memorize its properties (ten seconds is all you've got) and (c) learning to store the properties in one's mind until the next experiment, when the peak of the other molecule comes along. Aside from the gear involved, this is far less easy than A-B comparisons with smelling strips held in the hand and moved back and forth under one's nose. It's also hard to scale up smelling gas chromatography to the large groups of untrained observers beloved of experimental psychologists.* Nothing impossible, but given the circumstances, Wright's experiments on isotopes failed to convince anyone even of the need to do them better.

◌ *Mirrors again* ◌

The second piece of bad news concerned enantiomers, the mirror-image molecules discussed earlier. It took a surprisingly long time to get to the bottom of the question of whether enantiomers did or did not smell different. The reason is simply that, by their very nature, enantiomers are likely to have very similar properties, and getting one or the other in pure form is far from easy. The trusty gas chromatograph is of little use in separating enantiomers, because their boiling points, molecular weight and so on will by definition be identical. Inject a mixture of enantiomers into a gas chromatograph, and they will come out

* Partly no doubt to atone for the slipperiness of their subject matter, experimental psychologists are fanatical about experiment design and statistical analysis, and often take a dim view of simple observation. Faced with a levitating yogi, they would call in a coach party to fill in a questionnaire (Height above carpet: B — between 15 and 30 cm; C — more than 30 cm).

at the other end smiling and holding hands like identical twins, at exactly the same time.* One way of separating them is to crystallize them. If you crystallize a mixture of enantiomers and keep the crystals small, you sometimes find that the crystals contain only one or the other form. This is because once you have started a lattice of the left-handed one, the right-handed one won't fit. This discovery was what made the young Louis Pasteur famous, but it involves separating out little crystals one by one with tweezers. Synthesizing enantiomers pure is no easier in principle, because you start from enantiomeric building blocks, and they have to be pure, and so on.

Be that as it may, it became increasingly clear during the 1970s that the two enantiomers of carvone, a common flavour molecule, did possess different smell characteristics. That is to say, no matter how pure you got them, how finicky you were, how many people you asked, what concentration you used, what choice of words you preferred, one of the two carvones (S) smelled of mint and the other (R) of caraway. This is an easy test to do, and the two are non-toxic, so there is no living on the edge as with boranes. When this fact slowly hove into view, it was greeted with delight by critics of vibrational theories. And indeed, on the face of it, it looked like Wright's ideas would never survive it. Here's why: as we have seen before, if you put any asymmetrical moving object in front of the mirror (your hand, for example), you will see that whatever you do the guy in the mirror copies faithfully. In other words, enantiomers have *identical vibrations*. This has nothing to do with range, whether below or above 1,000 wave numbers, or any such folderol. Every single vibration is identical. Not surprisingly, if you put *liquid* enantiomers into an ordinary spectroscope working with *unpolarized* light (the reason for these italicized caveats will soon become clear), you get identical spectra.

* So-called 'chiral' GC columns are now available to do this, but they are a recent development.

142

Wright, typically, took this in his stride, though he was by then looking a little beleaguered. He simply pointed out that 'given that the living molecular-receptor sites are almost certainly chiral, the frequency-pattern of [one enantiomer] can be different from that of its isomer *at the moment of interaction.*'* True, true, absolutely true. In simple language, this means that if each receptor holds a single carvone molecule in its little mitt while measuring its vibrations, and if the receptor also has handedness (everything does), then it is hardly surprising that the response to the two enantiomers will be different. This is not an arcane phenomenon. If you do spectroscopy of a solid crystal of one or the other enantiomer, and you give the measuring system a sort of handedness by using polarized light vibrating only in a particular plane, then your spectrum will change completely when you go from one crystal to the other. But Wright's critics were by then no longer paying attention. The only thing that could have saved him at this point was to come up with a mechanism, and he couldn't.

Wright carried on working on vibration and smell until his death in 1985. The consensus of his close collaborators seems to be that, while he was productive during that time, no major facts emerged that would have reversed his by then marginal position in the world of smell.

❧ *Physics to the rescue* ❧

By the time Robert Wright died in 1985, the general consensus was that (a) isotopes smelled the same as normal compounds, (b) the different smells of the carvone enantiomers disproved all vibrational theories and (c) in any event no spectroscope could ever be made with biological building blocks. Deprived of his persuasive advocacy, Wright's work sank without much

* The emphasis is his.

trace in the field of smell, and his collaborators dispersed or set to work on other things. Tragically, Wright died without ever realizing that the solution to the problems that had beset him for the previous twenty years beckoned to him from the library shelves. Not in an obscure publication, mark you, but probably within reach of his hand, in the most famous of all physics journals, *Physical Review Letters*.

It was contained in an article published from the labs of the Ford Motor Company in Dearborn, Michigan. Today, the names Ford and Dearborn do not necessarily conjure up visions of exciting basic research, but in the late 1950s, together with a handful of other large companies like IBM, General Electric and RCA, Ford had decided to emulate Bell Labs. Bell Labs' amazing string of successes* (the transistor, the laser, etc.) had planted in the normally saturnine minds of large-company executives the idea that you could do basic research, invent new devices, change the world, garner a few Nobel Prizes and still make a bundle in the process. Ford therefore set up a proper lab built on Bell Lab rules: modest pay, great facilities, total freedom and flexible teams.

~ *Jaklevic and Lambe* ~

Within two years of each other, John Lambe and Robert Jaklevic joined Ford from the universities in which they had done their doctorates. Lambe already had something of a reputation as a brilliant experimentalist, having been the first to operate a solid-state maser (the microwave equivalent of a laser) as far back as 1957. Jaklevic, fresh from his studies at Indiana's Notre

* Bell has a special place in nerds' hearts. My friend, the physicist and chemist Walter W. Stewart, when cold-called by upstart phone companies to ask whether he wants to switch from AT&T Bell, invariably asks, 'Did you guys invent the transistor? No? The laser then? Neither? Then I'll stick with the company that did!'

Dame University, was a specialist in surface science, the chemistry and physics of what happens in the thin layers at the edge of things. Surface science had proved to be the key to solid-state electronics, because all the phenomena that make devices like transistors and diodes work happen at the interfaces between different kinds of semiconductor materials. Surface scientists had created a whole technology to keep things clean and deposit thin, controlled layers of stuff on them, which continues today in the giant chip-manufacturing factories that make the electronics our lives depend on. But in 1961, all the tools of the trade were home-built, looked like a plumber's pipe dream and could only be operated safely by the person who built them. Jaklevic and Lambe, after casting about for interesting ideas, decided to start work on a phenomenon called 'electron tunnelling' which, after languishing for years in the wilderness, had suddenly become an exciting area to work in.

Here's how and why: connect two metal wires to a battery and touch them together, and current will flow. The current is 'of course'* carried by electrons within the wires. But how does current flow at the point of contact? Metals are, so to speak, *wet* with electrons and touching metal to metal causes the wetness of one to overlap with the wetness of the other. But *why* are metals wet with electrons? Why are the electrons not safely corralled by the serried ranks of metal nuclei? Why do they extend a little into space? Very simply, because electrons are slightly fuzzy. If you could take a high-magnification picture of a small piece of metal and its electrons you would find a very shallow electron aura around the metal lump. If you could increase the magnification further you would see that every electron skipping back and forth inside the metal tries to jump out when it gets to the edge, goes a little distance into the surrounding space and then gets harpooned back into the metal.

* Every such 'of course' is the result of large numbers of human lives spent elucidating facts and getting used to ideas.

This is a proper quantum phenomenon, ultimately due to the fact that in order to 'know' that it cannot jump out of the metal, the electron has to give it a try. The cloud is where all the escaping electrons are caught scampering out and are hauled back into the lump. What all this means is that if you take two lumps of metal, touch them together and then separate them gently, electrons will flow until the lumps have moved further apart than the combined depths of their two electron auras. We are talking small distances here, of the order of one-millionth the width of a hair. It also works if you coat the metal with an appropriately thin layer of some insulator. If the insulator layer is thin enough, the outside of it will be just as wet with electrons as the naked metal. These electrons are said to have tunnelled through the layer.

Every time you throw a switch, electrons tunnel through the thin layer of oxide, grime and whatnot on the switch surfaces: the current flows. The reason this phenomenon waited until the late 1950s to be studied properly was this: how do you know there aren't little islands at the point of contact between the metals where the two wires have actually become welded together in one continuous piece? In other words, how do you tell the difference between an electron that has tunnelled and an electron that has simply gone through the weld without ever leaving the comfort of the metal interior? The answer is that until 1959, you couldn't. Every experiment purporting to show tunnelling currents was doomed by the same question from the back of the room: 'How do you know there are no welds?'

∽ *Giaever's leap* ∾

That was until Ivar Giaever came along. As a graduate student at Rensselaer Polytechnic, using surface-science equipment, he had been making metal-insulator-metal devices with the

insulator thin enough for the current to flow. He then had a brilliant idea: cool the metals in liquid helium. At normal temperatures a lump of metal is like an office block, with the floors filled by electrons, starting from the bottom and going up. Each floor is an energy level, and each floor can house exactly one electron. A one-inch square piece of metal has a vast number of these levels, about as numerous as there are atoms in the lump.

Take two pieces of metal, and connect them to opposite poles of a battery, and here is what you see. The energy levels in the metal connected to the negative pole are all shifted up by a certain amount equivalent to the voltage of the battery. It's as if every electron at that end went up a set number of floors. When you bring the pieces of metal close enough for electrons to tunnel, the electrons in the filled floors of the negative metal face empty floors across the gap, and fly across. Those further down the building that face filled floors cannot fly, because there is no space for them to fly to. The current flowing from left to right will simply be proportional to the number of filled floors facing empty ones, and that will in turn depend directly on the voltage of the battery. In other words, the current will be proportional to battery voltage. This is why the early studies of tunnelling were so difficult. The current of electrons flowing in a tiny welded contact is also proportional to voltage, though for entirely different reasons. Hence the difficulty in telling the two types of current apart.

Giaever's interest was in superconductivity, an amazing phenomenon that happens when you cool metals to liquid helium temperatures. At the time, it had been proposed that the underlying cause of superconductivity was that the energy floors filled in a different kind of pattern: filled floors up to a certain level, then a gap, and then a fixed number of filled floors again. Giaever saw that he could test this by electrical experiments. Shift the voltage and the whole pattern, gap and

Current flow by tunnelling between normal metals (top) and superconducting metals (bottom). In normal metals, tunnelling current (right graph) is proportional to voltage) and thus indistinguishable from normal flow. In superconducting metals the banded energy levels give characteristic stepped currents when voltage is varied.

floors, shifts together. Put superconducting metals opposite another one with this weird floor occupancy, and shift the voltage, and you should see all manner of bumps and troughs in the current as the filled floors shift past each other, then the gap, then the upper filled floors again. And to his surprise, delight and everlasting fame, that was precisely what Ivar Giaever saw. He published this effect in 1959 and was awarded the Nobel for it in 1973. What Giaever was interested in was the weird behaviour of electrons at low temperatures, but an unintended side-effect of his work was also that people for the first time believed in tunnelling currents. If at any time in an

experiment you suspected that the two pieces of metal were in direct contact, all you needed to do was dip them in liquid helium. If the currents got weird, you were looking at tunnelling.

∾ *The search for ripples* ∾

Jaklevic and Lambe decided to see whether they could observe smaller ripples in the current even in normal metals above helium temperature. These had been predicted to exist by some theorists, and both Jaklevic and Lambe believed that theorists' predictions should always be taken with a large pinch of salt. Physics is unusual in that people either do theory or experiment, seldom both. Experimentalists laugh at the armchair generals who send them on fruitless missions or declare impossible something which turns out to be easy. Conversely, theorists frequently deride the glorified radio hams who, when faced with a brilliant idea, have the audacity to ask whether it is worth spending years testing it. Mostly, though, they can't live without each other.

In order to test the notion that small but significant ripples were present in the linear current curve, Jaklevic and Lambe had to build better 'junctions' as these metal-insulator-metal devices were by now called. They needed to get the tunnelling current just right by adjusting insulator thickness. Too much current and you fry the insulating layer, too little and the signal gets crackly like a bad telephone line and you can't see a thing. Jaklevic did the junctions, Lambe built the highly sophisticated electronics needed to measure the current and change the voltage. Then they started doing experiments, and their better, cleaner, quieter gear enabled them to go to much higher voltages. Everyone so far had stayed close to the edge of the pond, pushing only a few millivolts (1,000 millivolts =1 volt) on either side, for fear of damaging things. They boldly

turned up the juice until the thin junctions were just bearing up under as much as a full 1,000 millivolts.

And then they saw something amazing. Ripples there were, and plenty of them. But they did not sit in the places predicted by theoreticians. They modified their methods to see the ripples more clearly against a flat background.* And then they stared at the pattern of ripples for some time, until they had a brainwave. The pattern looked exactly like a vibrational spectrum! But of what? Jaklevic soon realized that the ripple spectrum was pretty close to the vibrational spectrum of a solvent he used to dissolve a varnish called Formvar while making the junctions. That still left the big question of how the ripples had ended up on their current curves, which was a bit like seeing CNN appear in your cup of tea. But he and Lambe soon figured out how this worked.

Since the spectrum was like that of the evaporating solvent, they assumed that somehow a small amount of it must have ended up in the insulating layer of the junction sandwich. The solvent molecule was now caught in the crossfire of tunnelling electrons zipping past it on all sides within the insulator. Some of the electrons hit the molecules and the shock made the molecules ring like a gong. But this being a quantum gong, things were at once unfamiliar and simple, once you had figured it out. Picture the electrons flying to an empty floor across the gap. Most of them make it across without hitting anything, but some hit a lone molecule. The shock transfers energy from the electron to the molecule, and the electron drops a few energy floors before continuing to the other side.

This is where the quantum bit comes in. The electron's fly-drop-fly stunt only works if everything is nicely lined up. First of all, the electron can't just drop *any* number of floors,

* For this they used a lock-in amplifier, one of the cleverest electronic devices ever invented. Its operation is clearly described in the magnificent book *The Art of Electronics* by Horowitz and Hill (ISBN 0521370957).

the drop must equal in energy a vibration of the molecule (remember, flutes not pianos). This is because the molecule can only soak up energy in amounts that match one of its own vibrations. (That energy, by the way, just like the sound of a gong, eventually ends up as heat.*) Secondly, after the drop it must find itself opposite an empty floor, otherwise it back-pedals furiously and goes back up to the floor from which it jumped. What's more, the vibration never happens.

So that's where the ripples come from: as you raise the voltage, first the electrons do their normal, horizontal flights, because you need to reach a certain minimum energy to play one of the molecule's vibrations. Then, when the voltage difference reaches the energy of the lowest molecular vibration, some electrons start the fly-drop-fly routine. When the voltage difference rises to the energy of the second vibration, some more electrons do the fly-drop-fly. All these currents add up, and by the time you're at half a volt, which corresponds to 4,000 wave numbers, the poor solvent molecules in the gap, like Woody Allen in the Orgasmotron, are being tickled to death, every single one of their vibrations helping electrons to get across. The total current is bigger than if there were no solvent molecules in the gap, of course, because with the molecule as a stepping stone there are effectively many more ways of going from one metal to the other, and electrons take all the opportunities they're given.

∾ A close brush with smell ∾

By the time they figured this out, Jaklevic and Lambe were well pleased with themselves, and rightly so. At one stroke, they had discovered a new interaction mechanism of electrons: the

* It is said that owing to the efficiency of musical instruments, a full symphony orchestra only produces about 100 watts of heat, less than your brain as you read this.

fly-drop-fly thing ended up being called 'inelastic electron tunnelling'. As a bonus, they had also figured out an entirely new way to measure molecular vibrations, which did not suffer from the drawbacks of Raman and infra-red spectroscopy, namely a selective blindness of the optical techniques to some of the molecule's vibrations. Not bad for a couple of years' work. Interestingly, and perhaps not without a little malice, the rumour spread that their first ripple pattern had been due to oil from the vacuum pump that had contaminated their junctions. This tenacious story probably tallied with expectations of the Ford Motor Company being an oily sort of place, but as Jaklevic ruefully told me, it was entirely untrue. In fact, as a lark they tried to get pump oil contamination on purpose and could not manage it, because vacuum oils are designed, as one might expect, not to create any vapours at all.

Jaklevic recalls that they had high hopes for this new technique as a tool for analytical chemists, but this was not to be. Metal-insulator-metal devices were, and still are, hard to fabricate, and it is probably easier for a chemist to buy a Raman *and* an infra-red spectroscope than to start building a tunnelling one. When I spoke to Jaklevic about those days, he inquired why I, a biologist, was interested in this, and I explained a possible connection with smell. 'Oh!' he said, 'We'd wondered about that!' – at which point, feeling slightly miffed that he made it sound so easy, I admitted my amazement at the news. Jaklevic charmingly replied, 'We were quite smart, you know, and the idea just came up in discussion.' What happened then? Jaklevic recalls, 'Ford had three chemistry departments, and we often talked to the chemists down the hall. We brought the subject up with them, and one said that it was supposed to be the shape of a molecule that determined its smell.'

They had a go, nevertheless, and they ordered some deuterated acetic acid to see if it smelled different from the normal

one. Maybe it did, maybe it didn't, and they dropped the idea, which was in any event not central to their pursuits and not useful to Ford. They discussed the smell story with other scientists at the first international conference on tunnelling in 1969. But they never heard about Wright, nor he about them, though both had published in the most widely read scientific journals on earth, *Nature* and *Physical Review*! Jaklevic and Lambe were amazed to hear from me that their insight might after all have been right. Had Wright known, he would have immediately seen (a) that this was a mechanism made for nanoscale devices, such as proteins, since tunnelling only operates at distances comparable to, say, the size of an odorant molecule and (b) that cells were awash with electron currents and enzymes designed to carry them, and therefore that a biological spectroscope had just gone from impossible to plausible at one stroke. All that remained was to fill in the (by now manageable, as we shall see) gaps. I'm only sorry I was ten years too late to break the news to him.

∾ *Clifton Meloan* ∾

I became aware of Clifton Meloan's work only a few years ago, while reading a review on the biological effects of isotopes written by a true scholar,* who had taken the trouble to ferret out all manner of obscure references (and, incidentally, found a glaring error in one of my papers). Meloan is a now-retired analytical chemist who spent his entire professional life in Manhattan, Kansas, a town that engagingly styles itself 'the small apple'. It sits atop a range of low flinty hills in central Kansas, and is the home of Kansas State University. Having arrived at KSU in 1959, Meloan rose to the rank of Professor

* Wade, ref *Chem. Biol. Interact.* 1999 Feb 12; 117(3): 191–217.

of Analytical Chemistry, and always had a large group of graduate students working in his lab. One day in the early 1970s, a graduate student asked him in the course of a conversation what the ultimate dream of an analytical chemist might be. Meloan thought this one over, and replied that detecting the presence of a single molecule in a single living cell without damaging either might be it. At the time, the most sensitive detector of molecules was the Hall detector,* which goes down to 10^{-15} moles, or approximately 100 million molecules. Analytical chemists clearly still had some way to go. As it happened, soon after this exchange, Meloan and his students went to hear a lecture by CalTech on the mating habits of the gypsy moth. Meloan was bowled over: here was a small insect capable of detecting far smaller amounts of stuff. Meloan conservatively put the sensitivity of the gypsy moth to the homing hormone at 10^{-21} moles, or 100 molecules, a million times better than he or any of his colleagues could pull off.

Meloan amusingly recalls feeling humiliated by the moth's abilities, and at a weekly lab meeting he set his group of research students the task of coming up with experiments to tackle this amazing phenomenon. The students were unenthusiastic: Meloan's main line of work was straight-up analytical chemistry, and they were naturally more inclined to work on mainstream projects. The first to break ranks was Susan Albrecht, and together they went to see Charlie Pitts, an entomologist friend also at KSU. Pitts told Meloan that it was fruitless to embark on a study of moth pheromones, since 'dozens of people with more money, better gear and smarter students were already on it'. Instead, he offered his own

* The Hall detector is named after Randy Hall, its inventor. It detects molecules containing halogens such as chlorine. As they come out of the GC column, they are swept into a nickel reaction tube, heated to 850–900°C and stripped of their halogen atoms, which are carried into a conductivity cell. As the halogen concentration changes in this cell, the conductivity of a solution in the cell changes proportionally.

unsolved insect-homing problem of local provenance: face flies. Face flies are the nasty ones that look like house flies and constantly settle on the eyes, nose and mouth of cattle, driving them crazy. In bad cases of face-fly infestation, the cattle are so disturbed in their grazing that they lose 30 per cent of their body weight. In farming Kansas, this is tantamount to a declaration of war.

The flies were attracted by cowpats, and thence on to the nearby animals. Pitts showed Meloan the results of a striking experiment. He had collected the vapours above an attractive cowpat in a vessel cooled by liquid nitrogen, redissolved them in a solvent and sprayed the result on half of an old cowpat that no longer attracted face flies. The result was plain: all but one fly were on the sprayed side of the cowpat. Meloan was fired up by this experiment, and decided to isolate the attractant. He wryly recalls, however, that 'Charlie Pitts had neglected to tell me one thing: this was the only experiment that had worked in eight years!' They needed cows fed on a standard diet, so they went to a government farm near by, and learned how to get the cows to relieve themselves in a large Waring blender which was then rushed back to the lab. The blended cowpat was then gently heated, the volatile fraction collected and put through a gas chromatograph. It turned out to contain fifty-two different molecules!

Undaunted, Meloan and his group proceeded to split this fraction in half, checking which half was attractive to face flies by using a Y-shaped glass tube with a blotter of the stuff in each arm of the Y. Let a face fly in and see where it goes, then take that fraction, split it in half again and try with the fly once more. After weeks of work, they narrowed it down to four compounds. They then collected vast amounts of manure and did the last thing that analytical chemists like to do. They put hundreds of small samples of the stuff through the GC and collected the suspected peaks, a tiny amount at a time so as not

to choke the GC. Eventually they had a milligram or so of the stuff, and they rushed it to the Nuclear Magnetic Resonance spectrometer, which churned away overnight to build up a clean spectrum from a million noisy traces. The next morning, there it was: *m*-xylene. The *m* stands for 'meta-', which means the two carbons sticking out of the ring are at noon and four o'clock. Two and six o'clock are called 'ortho-' and 'para-', *o*- and *p*- for short. They promptly tried the *o*- and *p*-xylenes on the face flies: the flies ignored them, and only paid attention to the *m*- isomer.

This was baffling: Meloan had been reading all the theories of smell, shape and otherwise (there were many others of various degrees of implausibility). The shape-based theory required the molecules to carry chemical groups capable of interacting with receptors, the 'magnets' we have encountered before. Xylene had no good magnets: the benzene ring was unchanged, and the methyls were slippery, featureless lumps which would not readily make bonds to anything. Nevertheless, Meloan tried a host of variants, adding carbons here and there. Some attracted flies, some didn't, but no clear pattern was emerging of why this was so.

At this point Meloan and another student, John Blaha, were diverted into a different direction. Meloan wanted to know which part of the face-fly antenna was sensitive to xylene. Under the microscope, insect antennae reveal themselves to be formidably complex machines with orifices in the cuticle leading to caverns lined with receptor cells, the interior of the antenna being taken up by all manner of wiring and

accessory cells. The entomologists had made some headway in understanding which bit did what by plugging the apertures with tiny dollops of wax and watching whether the flies could still smell. Meloan wanted to go further and actually find out how far into the antenna itself the xylene travelled. At that time the National Bureau of Standards (NBS) had developed a combination microscope-Raman spectroscope, which used a laser to shine intense light on a point and report back on what molecules were vibrating at the microscope focus.

∾ *John Blaha's observation* ∾

Blaha took the flies and the compounds to the NBS and started the measurements. Sure enough, he could detect the xylene and the other molecules in the antenna by their vibrations, but there was no clear difference between the compounds in their ability to enter the antennae. Then Blaha excitedly called Meloan to report an odd observation. He had been looking at the Raman spectra of compounds in the antennae, and something had caught his attention. The compounds that attracted flies *did* have something in common: an intense vibration just below 1,000 wave numbers. Meloan's mind, primed by his readings, immediately saw the relevance of this: Wright's theory!* Meloan claims to have been completely agnostic up to this point, but the pattern was sufficiently striking that he decided to pursue it. Over the next twenty years until his retirement in 1993, Meloan was to maintain smell research as a stop-go sideline, waiting for the occasional student who wanted to pursue this eccentric line of work.

* Though Wright gave Dyson full credit, the latter's work was by then overshadowed by Wright's more numerous and more recent publications, and the theory had become associated with his name.

Meloan wanted to put Wright's theory to the test and began casting about for ideas. A colleague suggested isotopes as an elegant means of changing vibrations without changing shape, but Meloan felt that using isotope attractants might turn out inconclusive, because of the perennial impurity problem. Repellents were more common than attractants, and if a small amount of a repellent impurity sneaked its way into an iso tope-substituted attractant, the experiment would give a confusing result. Instead, he decided to turn the problem upside down and work on repellents. He knew that cockroaches were repelled by bay leaves, and decided to analyse a bay leaf extract to see which chemical was responsible for this. It turned out that several were, but 1,8-cineole, a common molecule with a camphoraceous odour, was the best among them.

He devised a clever method for testing repellency. He put cockroaches into a large glass box, at the bottom of which lay two upended bowls like igloos, with little doors cut in the rim. Dangling from the igloo ceiling, out of reach of the roaches, was a swab of gauze dipped in the molecule being tested. The other had the swab with nothing in it. The light was switched off and the cockroaches were allowed to scurry at will in darkness and to familiarize themselves with the smell of both igloos. Then the lights were turned on, whereupon the roaches ran for cover. Having figured out which igloo stank of repellent and which didn't, the smart little creatures tended to congregate in the igloo without repellent. When the molecule had no repellent effect, both igloos were equally crowded. Meloan did this with cineole, and almost all the roaches avoided it like the plague. He then put in deuterated cineole, and they ignored it completely: both igloos were equally full.

This was an amazing result, and a hard one to account for on the basis of an attractant impurity, since Meloan was using the lowest concentration of cineole capable of giving the full repellency. To explain this as an impurity effect, one would have to

assume (a) the simultaneous presence of a very powerful attractant (none were known of sufficient potency), and (b) a fortuitously exact cancellation of the repellent effect by this unknown molecule. Meloan began to feel they were really on to something, and tried to publish the results, whereupon he encountered the fiercely sceptical reaction which by then greeted anything resembling Wright's theory. This was understandable: Meloan's work did nothing to address the two fundamental questions of mechanism and the different smells of enantiomers. Furthermore, he had no track record in the field of smell. Add to that a pinch of snobbery at the agricultural flavour of some of his work, and the result was never in doubt: rejection.

Meloan took this in his stride, and felt that his position as tenured professor allowed him to get off the publication rat race. He published what he could in entomology journals, and once went to a fragrance chemistry conference in Greece to talk about his isotope work. Mostly, though, the work remained unpublished in the sense that only the microfilms of his students' PhD theses, held in the library at KSU, bore witness to two decades of effort. Theses are not referenced in any of the big scientific databases and most of his work remained unread and unmentioned by others. Meloan himself felt that only a conclusive experiment would settle it. He took as a given that Wright was essentially correct in his selection of the vibrational range (below 1,000 wave numbers) and his idea that a pattern of *several* vibrations was required to do the job, and kept searching for it unsuccessfully until his retirement.

∾ *Where I come in: the polarograph* ∾

It will be apparent from the story so far that by the time of Robert Wright's retirement in 1985, most of the pieces of the

puzzle were available to anyone lucky or persistent enough to find them. When Linda Buck discovered the receptors for smell in 1991, another huge piece fell into place. The piece that was still missing was the translation of tunnelling spectroscopy into the biological realm. That is what I supplied, so the time has come for me to make an appearance. A book has been written about this part of the story,* so I shall as far as possible avoid repeating any of its content.

My involvement in smell came about in the most unlikely manner. I was working at the Marine Station in Villefranche sur Mer near Nice, a heavenly place. One day in, I think, 1986, in the Station's lovely old-fashioned library I came across a book in two volumes entitled *Polarography*. Polarography is a technique of chemical analysis now rarely used but which in its heyday revolutionized analytical chemistry and earned its inventor, Czech chemist Jaroslav Heyrovsky, the 1959 Nobel Prize for Chemistry. Part of the success of polarography was due to its simplicity. Anyone could assemble a simple polarograph in a week at reasonable cost and do interesting things with it.

Here's how you do it. Ask your local glassblower to weld a sturdy, thin-bore, thermometer-like glass tube to a glass reservoir. Clamp this on an upright, fill the upper reservoir with mercury and put the tip of the tube in a beaker of dilute salt solution in water. If you look closely, you will find that tiny droplets of mercury fall through the water and collect into one large drop at the bottom of the beaker. When mercury has collected at the bottom, connect the top mercury reservoir to the minus pole of a battery, and the lower one to the plus pole via some device that allows you to control the voltage difference between the two mercury pools. Insert a current-measuring device such as a galvanometer in the circuit, and you are ready to roll.

* *The Emperor of Scent* by Chandler Burr (Random House, 2003) (ISBN 0375507973).

Start with a small voltage. What you see is almost no current, and that's because in the wires and in the mercury the current is carried by *electrons* and in the water by *ions*, elements in which there is a permanent charge imbalance, either positive or negative. An example might be table salt, sodium chloride, which in water dissociates to Na+ and Cl- ions. Electrons get to where the mercury ends, and have nowhere to jump to in the water, so they stay put: no current. Conversely, the ions can't jump into mercury. Push the voltage a little higher, however, and current begins to flow. What you actually see on your galvanometer is not a steady current, but a sawtooth trace which rises from zero as each mercury drop forms on the end of the tube, grows, reaches maximum size and falls off. When that happens, the current falls to zero and starts another cycle. If current flows, something in the solution must be accepting electrons. It can't be the sodium ions dissolved in it, because they hate electrons. Turning them from Na^+ to Na^o (sodium ion to sodium metal) requires a hell of a shove. That is why the opposite reaction is so easy – sodium metal reacts violently with water. It can't be the water taking up electrons either, because that famously causes the release of gases at both electrodes (hydrogen and oxygen) and you don't see any. But if it isn't sodium and it isn't water, what is it?

The answer is weird: oxygen. The air we breathe contains 20 per cent oxygen and some of it dissolves in water, which is how fishes stay alive. The way you prove that oxygen is responsible for the current is simply by bubbling nitrogen through the solution, which drives off the oxygen: no current. Oxygen is not alone, of course, in accepting electrons – all sorts of other things do so as well. More to the point, the voltage at which they begin to accept electrons is typical of the substance, which means you can both detect its presence and determine its amount in the solution. What is brilliant about

the use of mercury is that no matter what chemical reactions are taking place at the electrode, you start with a fresh, clean, ultra-smooth metal surface at each drop. Nifty device. But as I kept on reading about polarography, I found a peculiar phenomenon, called polarographic maxima, mentioned again and again.

In principle, if you have a mixture of different things dissolved in the water that accept electrons at different voltages, the curve of current* versus voltage should be like a rising series of rounded-off steps going up and up as you reach more and more negative voltages. The levelling-off at each step is due to the fact that whatever the electrons are jumping on needs to diffuse from the bulk solution to the mercury surface in order to accept electrons. When the amount attacked by electrons exactly matches the amount replenished by diffusion, the current ceases to grow. This is true for most things, but some of them show a pesky behaviour that greatly puzzled early practitioners of polarography. Oxygen is the best example. As you go negative from zero, the current curve rises very steeply. At a still more negative voltage, at the point where you'd expect it to level off if this were a well-behaved compound, from one drop to the next, it suddenly jumps back down to a much lower level and carries on. Go back down a notch in voltage, and it jumps back to the higher level again.

This is mildly interesting, but it's also a pain in the neck if you like nice clean traces, and polarographers soon found that adding a bit of soap or egg-white protein to the solution made it go away. A few polarographers remained interested in what was happening during maxima. It soon emerged that the reason the current got so much bigger was that the mercury in

* Where you measure the current during the sawtooth is up to you, as long as you do it consistently. Modern polarographs do it just before the drop falls off, and give you a single reading of current per drop, with a couple of drops every second. The drops are tiny, and the mercury lasts a long time.

the drop rotated vigorously, thereby stirring the solution around it, which meant more oxygen could come and be jumped on by the electrons. At a more negative voltage, the mercury ceased to rotate, and the current fell back to its diffusion-limited level. Why this stirring occurred, and above all what made it stop, had never become clear. For some reason this phenomenon, despite its negligible importance and seemingly zero interest, began to bug me. I wanted to find out how it worked.

At the time I was spending summers working in Moscow and paying regular visits to the huge bookstore Dom Knigi. On the right-hand side of the ground floor was the section dedicated to translations of Russian science books into foreign languages. Perhaps the best aspect of the Soviet command economy was its colossal misallocation of resources in the field of education. In practice, this meant translating hundreds of science textbooks into dozens of strange languages and selling them absurdly cheaply. The downside of the command economy was that a given book would appear without warning one morning in a vast pile, and be gone by evening. I was under strict instructions from my mathematician colleague Edouard Yeramian to buy everything. This I did, partly to be able from time to time to send him huge parcels covered in stamps, partly to put together my own collection.

This gave me an opportunity to test what I call the Paragraph Rule. In almost every science textbook, there is one point, usually of paragraph length, where the style of the author matches exactly one's style of understanding, and which we then grasp properly and permanently.* The trick is then to read hundreds of books, so that the paragraphs gradually come to cover one's field of interest, like fliers strewn

* Some, like Horowitz and Hill's *The Art of Electronics* or Atkins's *Physical Chemistry*, seem to be composed entirely of such paragraphs, and to surf a tsunami of expository power from beginning to end.

on a football pitch. This, over a period of about ten years, is what I tried to do with undergraduate solid-state physics.

From this intellectual collage, I had at long last gained a rudimentary understanding of electron behaviour in metals and in semiconductors, and I tried to apply it to the maxima problem. I felt that it must have something to do with the electrons in the metal. As we have seen above, electrons in metals sit in their energy levels like a liquid in a vessel, filling each one of them up to a definite energy. But at all temperatures above absolute zero, there is an additional wrinkle to the story: the liquid bears, so to speak, a head of foam, where the electrons jump up and down from one level to another under the influence of thermal agitation in the metal. The hotter the metal, the deeper the head of electron foam. This foam blurs the boundary between filled and empty levels in the metal, and is the reason why the tunnelling spectroscopy of Jaklevic and Lambe is carried out in liquid helium.

One night in 1989 I suddenly had a brainwave: the reason the electrons in the foam were jumping up and down was because they took with them a quantum of heat from the metal. Suppose one of these electrons jumped into the solution immediately after absorbing the heat. It would carry with it a quantum of heat energy from the metal, and therefore the mercury would cool. By contrast, if you imagined one of the deeper electrons in the metal doing this, it would take no heat with it and therefore its transfer to the solution would *not* cool the metal. I remember getting up at three a.m. to write this down. This explained all the features of polarographic maxima: as you sweep the voltage up in the negative direction, the first electrons to jump to the oxygen are the hot ones, and this causes temperature differences in the mercury drop, which in turn cause changes in surface tension,* which in turn

* Via the Marangoni effect, named after Carlo Giuseppe Matteo Marangoni (1840–1925), who taught physics at the Liceo Dante in Florence.

cause rotation. As the voltage gets more negative, you reach past the electron foam into the liquid stuff and the cooling effect, rotation and current cease. Using the prestige of the Pasteur Institute, in which I was supposed to be working on completely different things, I parlayed Roucaire Instruments, a French supplier of polarographs, into lending me a machine to try this out. In a couple of weeks I had done the experiments, which consisted in wrapping a few turns of resistance wire around the glass tube near the drop and gently heating it: the maxima disappeared.

I thought it would be nice to publish this, and since most of what I knew about physics came from Russia, I submitted it to the journal *Elektrokhimiya* in Moscow, where it was accepted as a short note. I had written the article in English, of course, and it was translated into Russian. Another reason for my going to a Russian journal was that I knew there was an English translation of the journal, and I was curious to see what two successive translations (by Russian scientists, working for a pittance) would do to my article. They greatly improved it.

∾ *Protein semiconductors* ∾

During this study of maxima, I noticed – as everyone who did the same thing must have noticed sooner or later – that when you put protein in the solution, the drops of mercury at the bottom failed to coalesce into one large mass but instead sat at the bottom of the beaker like metallic caviar. Soon after this I came across a remarkable and obscure paper by a Japanese electrochemist, Shinagawa, which suggested that when you coated the mercury droplets with protein, the electrons went through the protein on the way to the solution. Shinagawa described the transfer of electrons through the

protein as 'semiconduction', literally electrifying words for a biophysicist like myself. I knew that great minds like Albert Szent-Györgyi, Nobel Prize winner, discoverer of Vitamin C and archetypal maverick, had searched all his life for experimental tests of protein semiconduction and never found a proper one.

The solution presented itself to me immediately: since mercury drops (a) were coated with a layer of protein and (b) refused to coalesce, why not put two of these drops in contact with each other in a tube, stick some wires behind them and see whether current flowed? Initial attempts were a bit frustrating. A little bit of current flowed around zero voltage, but on either side the thing would not conduct. Shinagawa had suggested dissolving a little bit of another metal in the mercury to make current flow more easily, so I dissolved 1 per cent of zinc in one of the two droplets and *presto*: the thing behaved like an electronic component known as a Schottky diode. The device was promptly patented* by the institute I worked in at the time. It is almost certainly of little practical use, but like Dr Johnson's dog, what's amazing is that it does it at all. This experience convinced me that if proteins were indeed semiconductors, then evolution might have made use of this property in the nose. At the time, everyone was very excited by 'electronic noses' which detect odorants with thin strips of semiconductors. I felt what biologists usually feel: that if we can do it, evolution did it a billion years ago.

In order to solve the structure-odour problem, which as we have seen is a biological one, you need to know at least three things: (1) biology, (2) structure and (3) odour. Each of these things taken individually is not particularly difficult.† A

* US Patent 5, 258, 627
† My friend Walter W. Stewart says that, outside mathematics, the only truly difficult thing is Quantum Field Theory.

biology degree takes three years, reading all that matters in structure-odour relations takes a few months, and sniffing all you ever need to sniff in a perfumery lab takes a matter of days. The problem is that few people did both 1 and 2, and few of those ever got a chance to do 3. How 3 came about for me was a bit of an accident. In those days, and to some extent even now, the notion that perfume was a serious art form was considered eccentric and, in a man, indicative of effete tendencies.

∾ *The perfume guide* ∾

In 1992, between jobs and at a bit of a loose end, I decided to write a guide to perfumes. This was prompted by my friend David Armstrong, who, no doubt tired of my lyrical ramblings about perfume, suggested that I get it all out of my system and down on paper. I sat down in my mother's flat in Paris and wrote a few reviews, after which I started going around the publishing houses to see who would be interested. The only publisher who showed an interest was a small outfit that had started a series of pleasantly arcane guides (on whisky, luxury, etc.) and needed to keep it going. They paid me peanuts and made a mess of the cover, but they printed it and sold it.

Little did I know at the time that this ugly little book would open so many doors. What happened was that the perfumers started reading it and, never having heard of me, assumed my name was a pseudonym for one of their own. After all, who else would take perfume so seriously? This misunderstanding cleared when I was invited by perfumer Gilles Romey of Quest International to come meet the artists. We had a great time: they were glad to talk to someone who liked their work and I was like a kid in a candy store. When they foolishly asked what they could do for me, I said, 'Can I spend a week in the lab?'

I soon had the run of the place. A perfumery lab is an odd sort of place, a kind of pharmacy of smell. At Quest, five or six women in lab coats sit at work stations with a dropper and electronic scales. In front of each, a large, ugly metal contraption rotates a series of shelves on an electrically-driven chain mechanism to bring one of three thousand or so small bottles within reach. Telephones wait at each station, on which the perfumer calls in his requirements. These take the form of long lists of raw materials, each with their weight in the formula. At the back of the lab, a cold room holds the stores of all the materials: shelf after shelf of vials, cans, bottles. In the chill air there hangs that peculiar smell towards which all perfumery companies seem to converge, a sort of nondescript chemical tutti-frutti that smells colourful rather than good. During a week's 'work', aside from hearing all the gossip about the perfumers, I gave myself a crash course in smell categories and descriptors. When I had doubts, I asked around. I came away feeling a lucky man.

By 1992 the smell receptors had been discovered, but there was still no direct proof that they did sense molecules. I felt there was plenty of room for speculation, and while still at Pasteur had put together a project to study the flow of electrons through proteins and whether it was affected by the presence of smelly molecules. This was a properly biophysical project. Many big decisions in our lives are guided by aesthetic, even sentimental reasons. I loved biophysics as a sociological as well as a scientific phenomenon. For a start, it was big in Russia, and I spent a lot of time there. Until the end of the USSR, Warsaw Pact countries had almost cornered this market. They had a surfeit of highly trained experts in the physical sciences, and in the 1960s many of them ended up in biology departments. The chief requirement for the existence of biophysics appeared to be a plentiful supply of under-employed physicists who for one reason or another found the atmosphere of pure physics

uncongenial, and who followed Schrodinger's lead* in hoping to colonize the rich lands of biology.

Looking around, they correctly observed that most biologists were woefully ignorant of the hard sciences and incorrectly concluded that this was the reason for biology's slow progress. In reality, though, it was true that biologists were never the pick of the intellectual crop. I should know – I'm one of them. The fact is that Life is *the* most formidably complex phenomenon there is. Reverse-engineering life is a daunting task, even for Landau Institute graduates. The fall of the USSR had a dual effect, first causing a massed exodus of Eastern-bloc biophysicists and then a temporary reduction in defence budgets in the West that suddenly made biomedicine look very attractive. In truth, until we sort out cancer, degenerative diseases or death, biomedicine is where the money is, and Science grows lusher near funding.

∾ *Funding from the Blue* ∾

Anyway, there I was, looking for biophysics money. Where to go? An American colleague mentioned that the US Office of Naval Research had a programme on smell and funded projects worldwide. Readers unfamiliar with the way science works will not appreciate how rare this is. Most funding agencies fund projects only within their own countries.† The reason usually given is that it would be hard to keep track of what happens to projects in other countries, but considering

* Erwin Schrodinger, one of the fathers of quantum mechanics, wrote an extraordinary book entitled *What is Life?* (1933), which provided a mental road map for generations of biophysicists.
† The great French chemist Jean-Marie Lehn was once asked how 'French chemistry' was doing. He replied that he knew what France was, and what chemistry was, but that he had no idea of what 'French chemistry' might be.

(a) that funding agencies are crap at keeping track of projects right under their own noses and (b) that it's cheaper to fly from London to the US than to Edinburgh, the argument does not hold water. The main reason is, of course, that with money comes patronage, and the feudal system of science likes to do favours where they can be returned.

I had come across the Office of Naval Research (ONR) some years earlier at a congress. I was standing in a deserted hall next to a large poster describing my work, feeling like a prostitute past his career peak, when this handsome, forty-five-year-old guy in a dark suit turns up, looks at my poster for a while, then turns to me. In that strange clenched-jaw diction typical of educated Russians speaking American, he asks me whether I would object to his agency funding my work. Naturally, we got talking. His name was Igor Vodyanoy, and he was a Russian-born biophysicist who had ended up in charge of a funding programme at ONR. He was still in charge by the time I applied to work on smell. True to its military origins, ONR was, and still is, a splendidly undemocratic outfit where decisions are taken by skippers, not committees. Now that neither Igor Vodyanoy nor I have any connection to academic olfaction research, I relish the opportunity to speak freely: he probably had more influence on the field of olfaction than any single scientist actually doing the work. Basically, what Igor Vodyanoy liked got funded, and what he liked turned out to be the most interesting research in the field. An added perk was that every year the Funded Ones got together in Marineland, that weird 1950s prefiguration of all amphibious dreams to come. I applied for a modest sum and got it.

Early in 1993 I moved to London and rejoined my old department, then run by the best department head I ever met, Geoffrey Burnstock. His unusual point of view was that diversity was the source of all joy, and that his (huge) anatomy department was big enough to reach out to the tail of the

Gaussian curve and accommodate a few people who did weird things for little money. It must be understood that universities are non-profit only in the narrow sense that they spend every-

thing they get. The opportunity cost of having someone who does research on the cheap is simply this: the space could be given to someone who does it expensively, and brings lots more moolah into the system.* Burnstock was unimpressed by my funding, but otherwise pleased.

I started tinkering, putting together a nice setup to make protein diodes and carrying out rather frustrating experiments. On many occasions matters got sufficiently difficult that I would retreat to the library to read and get my mind off things. One day late in 1993 I came across a paper entitled 'Easily realized inelastic electron tunneling spectrometer',† which explained in accessible engineer-language how to build a Jaklevic-Lambe machine. I had never heard about non-optical spectrometers before, and was fascinated. As I read how the thing worked, an amazing series of thoughts went through my mind:

1. You could do spectroscopy with electrons.

2. But proteins could do electrons too.

* I once jokingly said to the Dean of my faculty that if someone walked into his office and said he could solve the Secret of Life for £5,000, his first question would be, 'Can you do it for £5 million?' He agreed.
† Y. Wang, R.R. Mallik and P.N. Henriksen, 'Easily realized inelastic electron tunneling spectrometer', *Review of Scientific Instruments* 64 (1993).

3. The smell receptors were proteins.

4. Didn't some people say the nose worked like a spectroscope?

5. Maybe they were right.

I knew from the start there was something big in this, and I set to work right away. It soon turned out that this was far more interesting than making mercury-protein-mercury sandwiches. But I had the problem of convincing the Navy that this, rather than the original project, needed pursuing. In May the following year, at Marineland, I presented a little paper whose abstract read: 'I have developed a simple computer-controlled instrument which allows the study [. . .] of protein mono-layers sandwiched between mercury drops in an aqueous solution. I shall describe preliminary data obtained with it and discuss their relevance to theories of olfactory reception, with particular reference to the novel possibility of identification of odorants by inelastic electron tunnelling spectroscopy.' Note the elegantly stealthy way of changing the subject. The keynote speaker was Linda Buck, and her sensational discovery of the receptors was having a huge impact on the field. My musings about vibration went unnoticed – nobody seemed to mind one way or the other – so I came back from Florida and decided to do this full time.

❧ Revelation in Portugal ❧

I spent the next six months looking for a simple clue that would settle once and for all in my mind whether a vibrational mechanism for smell was even plausible. Like Dyson before me, I had noticed the strange coincidence between the SH stretch vibration and the rotten-egg smell. Like Dyson, I knew nothing

172

about boranes. Unlike Dyson, however, I soon found out about them in a book I picked up on the bottom shelf of an old and dusty Lisbon bookshop. The book explained how to calculate vibrations from masses and bond stiffness, and gave the stiffness of the C-H and B-H bonds. The B-H bond was less stiff, and this made me wonder whether this would be sufficient to shift the 3,000 wave number vibration of the C-H into the 2,500 range of S-H. I programmed the formula into my little calculator, plugged in the values and there it was: 2,550. When I got back to London, I tried to get hold of boranes, but they all seemed to be lethal and unstable. Then I found decaborane, which alone among them is stable in air at room temperature. Sigma, the biologist's favourite supplier, stocks it and it was delivered overnight. It smelled of rotten eggs, of course, as Stock had noticed all those years ago. That did it for me.

I needed a few days to recover from the exhilaration of smelling decaborane for the first time. I then started thinking about enantiomers. Since the carvones had by then acquired celebrity status, I ordered a sample of each and started smelling them in earnest. They are often described as smelling of mint and caraway, but a more appropriate description might be MINT-caraway for one and mint-CARAWAY for the other. At the same time I was reading as much tunnelling-spectroscopy literature as I could find and soon came across something interesting. C. John Adkins, who ran low-temperature physics at the Cavendish Laboratory in Cambridge, had published a series of articles in which the mechanism of tunnelling spectroscopy was dissected and calculated accurately. He also reported experiments in which certain vibrations which should have been visible were not and speculated that this was a geometric factor, due to the electrons being scattered in the wrong direction.

The way it works is easy to understand. As we have seen, the electrons fly across the gap, collide with a molecule, set

it vibrating and fall in energy. The collision changes their momentum as well as their energy; in other words, deflects them as well as slows them down. If it should happen to deflect them at ninety degrees to their path, they never make it across: no current, no vibration. This was of great interest to me, because it said that some vibrations could be invisible to the spectroscope in the nose. With enantiomers, one could always imagine the two molecules binding in such a way that a group on one or the other molecule would become invisible. But which one? Looking at carvones, an answer suggested itself. The main feature of the carvones, the thumb of these handed molecules, is the C=O group. Its two atoms carry the biggest charges, and its nice strong stretch vibration always sticks out in spectra like, well, a sore thumb. Suppose that you can smell the C=O in one but not in the other, and that is what makes the difference between mint and caraway. How could you test this?

The first thing I did was to get some acetone, whose spectrum consists almost entirely of C=O stretch. This will seem strange to the reader unless he does the test, but if one smells acetone, mint carvone and caraway carvone in rotation a few times, one soon gets the definite impression that acetone represents the *difference* between the two carvones, just as yellow is the 'difference' between blue and green. Asking other people to go in for this state-sponsored solvent abuse seemed a bit much, however, and a better experiment was needed. I decided to mix the acetone and the mint carvone to get a caraway mixture. It worked fine for a few seconds, but the acetone would evaporate so quickly that the effect was fleeting. I tried the heavier analogues of acetone, propanone and butanone, which evaporate a bit more slowly and still smell very 'ketonic'.*

* The very term, like sulphuraceous, nitrilic and ethereal, denotes a deep connection between smell and chemical groups. On some planet where boranes are common and sulphur rare, some scientist is probably noticing the strange similarity between boranic and sulphuraceous smells.

Pretty soon I had convinced myself that a 3 : 2 mixture of mint carvone and butanone smelled nicely of caraway.

❧ *Experiments in a locked room* ❧

Far more serious was the question of isotopes. Although I couldn't find anyone who had gone on record stating that isotopes smelled identical, everyone I spoke to just seemed to assume that this was the case. There seemed to be no data on humans showing that isotopes smelled different. The only exception was people who said that H_2S and D_2S smelled the same, which meant precisely nothing because of the rapid isotope exchange as soon as the stuff hit the nose. At the time I started on this, in early 1995, I was unaware of Clifton Meloan's work on insects. I was feeling cocky, though, and thought I would go and have a smell for myself. My job was made easier by the large numbers of isotopes which had recently become available to chemists to help them in chemical analysis, chiefly nuclear magnetic resonance. If you have a compound dissolved in the solvent and you want to determine its structure by hydrogen NMR without interference from the solvent, all you need to do is make sure the solvent contains only deuterium atoms, whereupon it becomes invisible to the machine.

I started looking through suppliers' catalogues to find a fully deuterated version of a common perfumery raw material. I soon hit upon acetophenone, described in Arctander's 'Bible' as possessing a 'pungent-sweet odor, in dilution resembling that of hawthorn or a harsh orange-blossom type'. It was available from Aldrich in fully deuterated or 'd_8' form. I ordered a gram of it, and a hundred grams of the vastly cheaper normal one. They came the next day. I locked the door so as not to be disturbed. If this was to be the moment

when I found out I was completely wrong, I wanted no witnesses. I gingerly cracked open the glass vial of the d_8, dipped a smelling strip into it and another into the normal one and gave it a go. My first impression was electrifying: they smelled *different*, the deuterated one less sweet, more solvent-like. On further smelling of the strips, though, the smells became more similar – it seemed very hard to tell. I called my colleague, fragrance chemist Charles Sell, and told him about this, and he dryly, and quite reasonably, replied, 'Impurities'. He offered to let me use his smelling gas chromatograph, and I made an appointment to do so. A week or so later I went to Ashford with my samples, and was sent to the GC room in the basement in the company of Charles Sell's chief technician Ken Palmer. Ken put the d_8 sample into the machine, waited for fifteen minutes or so and then the puff of pure d_8 came out at the other end. Ken immediately said, 'That's different! I've been smelling the stuff for years, and that's not acetophenone.' We put in the normal sample and it came out smelling normal. I was overjoyed, and we rushed up the stairs to bring the news to Charles and his colleagues. To my surprise, they showed little interest, so I headed back to London. On the train, two young girls across the aisle were smelling perfumes on each other's wrists and I thought to myself: *I know how that works.*

I started hunting down facts, doing calculations and slowly putting together the ideas needed to write a Big Vibration Paper. Immediately, I noticed something odd: everyone was really interested in what I was doing. This was a novel sensation. Every single thing I had done before in science had been of interest only to me or at best to a small number of people specialized in the field. My previous research topics had been the pH sensitivity of intercellular low-resistance junctions, the stability of membrane perfused with fluoride, the movement of lipid-soluble ions across tight membrane junctions, etc.

None of these had ever proved particularly electrifying as a topic of conversation. Smell was different: everyone perked up when I explained what I was up to. This buzz seemed to propagate by unseen channels. When my turn came on 1 March 1995 to give my first departmental seminar on the work, I did something strange: instead of just booking the seminar room, which held about forty people and was usually amply sufficient, I also booked a nearby lecture theatre holding over 150. There was no reason for doing so, but some instinct told me it would be needed. In the event, it was. Ten minutes before one p.m., when the talk was due to start, the seminar room was overflowing and we moved to the lecture theatre. By one p.m., that too was nearly full. I started nervously, then got under way. The talk went well, and half an hour later a very smart and humorous colleague, Candy Hassall, came to see me and told me how relieved she was that I hadn't made an ass of myself, because 'many people hoped I would'. This was news to me, and probably an irritated reaction to the mysterious buzz.

In science there are three kinds of problem: the ones only specialists care about (99 per cent of the total), the ones everyone cares about (cancer, the next flu vaccine, a better antimalarial, etc.) and a third, most mysterious category: the questions everyone would like answered but nobody dares ask. Here's an example: when I was a kid I always wanted to know where different languages came from, how language had started. Was there an *Ursprache* that began it all? I remember asking my mother about this, and she got me a little book on linguistics explained to the layman. The book was dull, all about sentence structures and phonetic transformations. Nowhere was the question of the origin of language even mentioned, even though it was literally the first thing a kid would think of. Forty years later (April 1991, to be exact) I came across an article in the *Atlantic Monthly* entitled 'The Quest for the Mother Tongue', which described how a small

group of brave linguists had dared ask the child-like question and, even worse, had dared answer it. I got goosebumps (buzz alert!) the moment I started reading it. The article explained how several Russian linguists and one American one had used a combination of classical (phonetics) and modern (word list comparisons) methods to reconstruct the words of languages extinct for 15,000 years. What was remarkable was the seething fury their quest had unleashed among their colleagues. This seemed quite unwarranted. If these daring explorers were so manifestly and completely wrong, after all, it should then be easy to demolish their argument. As it turns out, the issue is probably impossible to decide, because languages become unrecognizably different after 10,000 years or so, and so peering further into the murk will not allow much to emerge. I told my friend Walter Stewart about this, and his comment has remained with me ever since. He said there were three kinds of answers corresponding to the three kinds of questions I listed above. Those that are boring if true (99 per cent), those that are interesting if true (cancer etc.) and the last category, which he characteristically put above all others, of things which are *interesting even if not true*. I was to find out a great deal more about this over the following ten years. If someone had revealed the future to me in 1995 (at least until 2005) I think I would have taken a long holiday in preparation.

The buzz continued apace. My department head, Geoff Burnstock, had felt sufficiently good after my talk to go and ask the president of my college (University College London) to extend my contract for a further two years. This duly happened, partly thanks to a stroke of luck. The president (or Provost, as he is locally known), Derek Roberts, had worked on tunnel-effect devices many years earlier at GEC and was thrilled to find that some physics and engineering he was intimately familiar with had an unexpected application to smell. He asked me to come to his office a few days later. I

arrived, thinking that this would be a private conversation, and found him at a huge round table with a dozen other people seated. The scene, to my eyes, looked a bit like the War Room in *Dr Strangelove*, minus Ambassador Kissoff and the big screens. The Provost pleasantly asked me to explain my work in a few minutes, which I did as best I could. By this time I had recovered some of my wits and had figured out that the other participants were all the professors of physics, chemistry and bioengineering. He then thanked me and with a slow, circular motion of his index finger, asked each person in turn whether they had any major objections. No one said much, except a professor of physics, Marshall Stoneham, who opined that the idea was attractive and plausible. I hadn't even had a chance to talk to any physicists until then, so I was hugely relieved. The Provost dismissed me, and remained a steadfast supporter until his retirement a few years later.

The next thing that happened was even more remarkable. A former student, Alison Baum, who now worked as an ideas scout at the BBC, called me. She asked whether I would object to *Horizon*, the corporation's flagship science programme, making a documentary about my work. This, mind you, was at a time when my article wasn't even written, never mind published. More buzz. I asked for a day to think it over, and went home. Sitting on my couch in my empty flat in Clapham, I thought: *Why not?* I hadn't much idea what the programme entailed, and it felt like jumping off a cliff, but I decided to say yes for the simplest of reasons: if I said no I would never find out what happened when you jumped off a cliff, and would for ever regret not having at least tried. I had a couple of meetings with the director, Isabelle Rosin, and the filming got under way. It was an amazing experience. TV journalists and their technical staff have something in common with doctors and nurses: they are trying to make you do something unfamiliar as quickly as possible and with minimum fuss. To that

end they are elaborately polite, call you by your first name all the time and fuss over you in every way imaginable. Until you get used to it (I never did), this feels so good that I am not surprised a lot of people get hooked. The other thing that is special about TV is that they decide in advance what everyone is going to say, and then get them to say it. Never, ever work with a hostile TV journalist, or you will regret it. I did not have to worry about this – the atmosphere was very friendly and the usual BBC fairness prevailed.

When Alison heard about my carvones experiment, she suggested we put it to the perfumers at Quest in Paris, to see whether they agreed with my assessment that mint plus nail-varnish remover equals caraway. They were supposed to smell a series of 'chromatic' mixtures with different proportions of butanone mixed with the mint-carvone to find out whether any smelled of caraway. To my huge relief – since I hadn't tested the resemblance on anyone – with the cameras rolling they agreed that a mixture close to the one I reckoned best produced a very good caraway illusion. The shot was kept and broadcast on the programme. Thus at one stroke the supposedly invincible objection that had destroyed Wright's theory was revealed as insubstantial. In fact, the boot was on the other foot! Now the believers in shape have to explain why fully two-thirds of all reported enantiomer pairs smell similar.

At the same time, I had finished the first version of my paper and submitted it to *Nature*. The premier scientific journal in the world, *Nature* could definitely make, and probably unmake, a career. Since I hope that not every reader of this book will be a professional scientist, a few words of explanation are in order. Nearly every scientific journal has a declared field. *Nature* is one of the few that cover all science. A scientific journal is largely a clearing house for manuscripts. Scientists send in articles; the articles are read by junior editors and sent out to referees who (one hopes) read the article,

think it over and write a fair review. The referee's report says whether the article is good or bad, recommends rejection, revision or acceptance and gives reasons. Reviewing papers is unremunerated and a bit of a drag. Why do people do it then? First, it's nice to be asked, and it makes you feel like your opinion matters. Second, and this is what Don Braben calls 'peer preview', you get to know what your colleagues are up to before anyone else does. This 'Peeping Tom' thing is great. The naïve reader may wonder whether any ideas get stolen at this stage. The answer is yes, but relatively rarely and only in truly cut-throat fields. But why send the papers to people who may have a conflict of interest? Very simply, because they are the most able to judge the work on its technical merits. This is the single most important thing wrong with contemporary science: when a field is specialized enough, only people who have a conflict of interest can fully judge your work. The ideal referee would be an honest broker who (a) knows enough to figure out for herself what the story is about while (b) not caring passionately enough about the outcome to find her judgement affected. The last twenty years have seen the disappearance of honest brokers, because science has become more specialized and people do not have the time to read outside their field unless they want to forgo their careers.

But if you think submitting a specialist paper is difficult, try submitting an interdisciplinary one. That really gums up the works, like asking the figure-skating jury to referee hockey. Worse still, make it a hypothesis, which mine was. In physics, it is OK to call yourself a theoretician. In biology, that's considered a perversion, like preferring erotic literature to real sex. Biological received wisdom says 'ideas are cheap' (bad ones are, of course) and hypotheses are usually relegated to weird (and wonderful) journals like the *Journal of Theoretical Biology* or *Medical Hypotheses*. To prime things, I called up the biology editor at *Nature*, Nick Short, and explained to him

what the paper was about. I had waited for days to get pumped up enough to make the call, and must have sounded manic. He probably got five such calls a day, but was utterly charming; he declared the whole thing interesting and encouraged me to submit. This I did a few days later, with predictable results. Each of the referees hated the part that pertained to his or her specialty, hated not being able to judge the rest and therefore assumed everything else must be worth hating too. The back-and-forth, which involved seven referees and four revisions, lasted eleven months and ended in the manuscript (much improved, it must be said) being accepted by Nick Short and rejected by his boss Philip Campbell a day later. In the meantime, fortunately, the BBC programme had been broadcast and the situation had changed considerably: I had been contacted by the editor of another journal, *Chemical Senses*, who, having seen the referees' reports from *Nature* and my revisions, decided to publish the article. The broadcast itself was a weird occasion. It took place at a party for crew and friends of the director, and I drank so much I couldn't stand up but felt stone-cold sober. It was like a firing squad in reverse: the bullets come out, your shirt is white again and you get to smoke a cigarette before they set you free. The programme went on to win a prize for Best Science Programme of 1995: again, the buzz was at work.

I expected immediate reactions to the publication of the paper, which took place in 1996. In fact, nothing much happened. I got a few e-mails. I tried to interest the fragrance firms in testing my theory. An attempt with Quest led nowhere, another with Givaudan ended unpleasantly. Disappointed, and concerned that I might spend the rest of my days waiting for some random person to express the faintest interest in my smell work, I started working on another project which had interested me long before I even worried about smell, namely an experimental test of the existence of solitons in proteins. I

got some funding and moved on, though I kept thinking and adding bits and pieces to the smell story if I came across any. In 1998 I had the good fortune to meet a freelance journalist, Chandler Burr, on the train from Paris to London. He seemed an interesting guy, so we got talking and I eventually explained what I did. He was fired up by the notion that the sense of smell was such a mystery, and asked me whether he could write a short article for *US News and World Report*. I said yes, and pretty soon the article had grown to a size suitable for the *Atlantic Monthly*, in which he had previously published. The *Atlantic* dithered for months over when to publish, by which time Chandler's agent had lost patience and sold the idea as a book to Random House, a large US publisher. In the meantime Chandler and I went to a scientific meeting in India together. This was the only time I have been invited to a conference on smell, and part of the reason must have been that from the vantage point of India a published paper is a published paper, and the gossip as to who's in and who's out does not reach that far. Be that as it may, the meeting was great fun. I was hugely impressed with the quality of the young Indian scientists and I got a chance to show my stuff to specialists from all over the world.

By the time I gave my lecture, everyone expected the fur to fly, and they were not disappointed. The atmosphere was openly hostile, and a lot of my colleagues peppered me with questions as I went along with my talk. This is OK in small doses, but can be irritating if the barrage is continuous and the intent is to nitpick at all costs. In the front row, very close to me, was a brilliant young scientist from NYU. She was visibly straining to find fault with my talk, and threw me several curve balls which I fielded adequately. I might add that the whole idea of spotting a huge gap in someone's thinking in a few minutes when they've been mulling things over for years has something fatuous about it, but why not? At one point she

thought she had me nailed and stuck her hand up like an eager kid at school. I stopped to let her ask her question, which she did with the glee of someone who knows they are about to land a knockout blow. The question was: since serotonin contains an indole nucleus, why doesn't serotonin smell of indole? As it turned out, she had made a trivial mistake, which I pointed out. Serotonin is nonvolatile. Her reaction was extraordinary: she crossed her arms against her body in a caricature of a childish sulk. By this time things were so heated that everyone laughed, whether at her gesture or at her failure to land the punch I do not know. She looked even more upset, understandably.

After the meeting in India, things resumed their deathly quiet, and I busied myself in switching departments. Geoff Burnstock, my guardian angel till then, had retired and been replaced by a young developmental biologist called Nigel Holder, who tragically died a couple of years later. For reasons I never ascertained, Holder took an instant dislike to me and made it clear that he would veto any extension to my contract. I applied for a job in the Physiology Dept where I had spent three miserable years as an undergraduate. To my surprise, I got it and moved. The next two years were spent trying to make the soliton experiments work. I felt increasingly like the man in Poe's *The Pit and The Pendulum*: the walls were closing in on me and there was a hole in the middle of the floor. Why? Very simple: universities are businesses these days, and every square metre of lab space must be made to sweat cash. This is never said openly, of course, and every college has a mission statement of toe-curling banality containing the words 'scholarship', 'excellence' and 'vision' in all possible permutations. But, like the Constitution of the Soviet Union, in its day the most liberal on earth but mercifully never applied, these fine principles seldom percolate down to actual reality. At long last I decided to take a year off to begin writing this

book. My wife Desa generously agreed to support me, and I moved out of college. The department had initially promised to give me some lab space, but later reneged on the promise. Physics professor Marshall Stoneham came to my rescue and offered me space in an outlying building belonging to physics – space which I have to this day.

Six months into the 'sabbatical', opportunity knocked in the form of a request from some of the technical staff at Guinness for a one-day consultancy on smell as applied to flavours. Consultancy must be the most dismal of all professions, because you sell assets of unpredictable value at a fixed price: for £500 a morning you can either impart information which helps a large firm make millions, in which case you feel screwed, or you can tell them things equally clever but which turn out to be useless, in which case they feel screwed. Be that as it may, I did my best to be useful. At the close of the meeting, they asked me whether I thought one could make an acid-stable lemon.

Who cares about acid-stable lemon? Very simply, when you make lemonade by squeezing lemons, you mix two things which nature has carefully kept separate, namely the citral in the oily vesicles in the skin and the citric acid in the flesh. Citral is an unsaturated aldehyde, and as such pretty reactive. Under acid conditions, the molecule bites its tail and turns into various other things which unfortunately smell pretty awful, like burning bakelite. What this means is that if you put artificial lemon flavour (chiefly citral) into lemonade (acid water), the thing starts smelling of blown fuses in a few weeks at most, and your shelf life is short, which costs money. Acid-stable lemon? Having heard this a few times before, and being aware that only citral smelled of lemon and that people had been trying to do this for many years, I said no.

Then I went home and started thinking about it, and pretty soon I could see that I had been rash in saying it couldn't be

done. By this time I had developed a primitive algorithm for the calculation and comparison of molecular vibrations, was writing a paper on it and had just finished the section on sandalwoods. One of the sandalwoods was a beautiful product from Givaudan named Javanol®. Javanol was derived from a sandalwood molecule called Brahmanol simply by replacing two double bonds in the molecule with three-membered carbon rings called cyclopropanes. This is quite a big shape-change, and is far from easy to do, but the odour remained that of sandalwood. Givaudan had kindly made a sample available to me, and I had been able to check for myself the similarity of Javanol to the parent compound. I had then calculated the vibrations of Javanol and Brahmanol and found them extraordinarily similar. At this point I had a brainwave: why not do the same thing to citral? The extra carbon would prevent the molecule biting its tail and *voilà* – an acid-stable lemon.

I was mulling over this possibility when Jacqui Grant, a US businesswoman and family friend, came over for dinner. She asked what I was doing and I told her about this lemon idea, and her reaction was immediate: 'There may be a business in this.' We there and then decided to spend a little money having the lemon molecule made, found a contract-chemistry lab, and a few weeks later the molecule came in the post. It smelled of lemon. I dissolved a small amount in a solution of hydrochloric acid, did the same for citral and came back half an hour later to find that the citral stank and our stuff still smelled great. Jacqui was back in the US, and I told her the news. Memorably, she asked me whether I minded her looking for investors to start a company around this product. I agreed, of course. She found the money and we both started a new life in the real world of fragrance chemistry.

The company was christened Flexitral, and we soon had a website going. The next year was spent learning the ropes,

figuring out what to make and how to make it and, for me at least, getting what our chief chemist pleasantly calls 'the most expensive high-school chemistry education in history'. By this time the web was everywhere, and the notion of having a virtual company made from bits and pieces scattered all over the world was in all MBA course notes. What made a difference to beginners like us was, of course, search engines that could find anything for you anywhere in a hundred milliseconds. Soon we had Googled two chemistry labs, one in Loughborough and the other in Moscow, and they were working on our products. In short order we had another molecule called Lioral, a lily-of-the valley material.

By the time we were ready to start showing our wares to the fragrance and flavour companies, Chandler Burr's book came out (January 2003). The reaction was extraordinary and completely black and white. First, the white: everyone in the industry read it and many people thought it was a great yarn. Also, the book set out, far more clearly than any scientific paper could, the fact that there was something deeply wrong with shape-based theories of smell. This everyone knew, but instead of being the elephant in the corner of the room it was now out in the open. I imagine some of the chemists must have been angry, but so what? Also, Flexitral showed up at presentation meetings not with ideas, but with 10 ml bottles of products. These were not infrequently molecules that had been sought but not found by years of shape-based research. A sniff is worth a thousand words. Some took the view that it did not matter how we found them, as long as we did. Some must have reckoned we got lucky, though after the second or third visit this hypothesis was taking on water. The curious thing for me was being invited to lecture as part of a business visit: the chemists in the audience frequently smouldered during the talk, but virtually never expressed any open criticism. Their colleagues and the heads of R&D must have drawn

their own conclusions: as the French saying goes, '*Qui ne dit mot consent.*'

Now the black. The first thing that happened, which still hurts to think about two and a half years later, is that I broke up with a close friend. He objected to being portrayed negatively (under a pseudonym) in the book, and blamed me for not editing that part out. Truth was, I wasn't paying attention, and I thought in any event that the description was factually true. Then anger started coming out from the scientific side. *Nature* ran a review by Avery Gilbert, a psychologist active in the field of fragrance perception. The review was quite something: 'Vibrational theory lay dormant for the past three decades because it lacks a plausible biological mechanism for converting intramolecular vibrations into neuronal activation. Recently, however, it was resuscitated by a physiologist and perfume critic named Luca Turin. While implausible, Turin's proposal is certainly a delightful potpourri of creativity, conjecture, extrapolation and isolated observations. And it's brazen: a universal theory of smell based on one man's olfactory observations.'

Then, a year or so later, came the *pièce de résistance*. *Nature Neuroscience* published a paper by Leslie Vosshall and her colleague, Andreas Keller, purporting to show that my theory was wrong because naïve subjects exposed to one particular concentration of an isotope pair failed to smell the difference. The paper was well executed and cautiously worded, and is a valuable data point in a continuing debate where other groups have weighed in on both sides of the argument. There is no question that isotope effects, though present (in my estimation), are subtle, and that finding an isotope pair (same shape, different vibrations) with a radically different smell would be great. *Nature Neuroscience*, however, believes the issue resolved. In an extraordinary editorial accompanying the paper, an anonymous writer thunders in the Grand Manner:

'The paper by Keller and Vosshall on page 337 of this issue is unusual; it describes a refutation of a scientific theory that, while provocative, has almost no credence in scientific circles. The only reason for the authors to do the study, or for *Nature Neuroscience* to publish it, is the extraordinary – and inappropriate – degree of publicity that the theory has received from uncritical journalists.' Interestingly, the author turned out to be Charles Jennings, founding editor of *Nature Neuroscience*, who at the time of my submission to *Nature* in 1995 was junior editor in charge of accepting or rejecting neuroscience manuscripts. The effect of this editorial was perhaps not what *Nature* and Charles Jennings had intended. I began to get e-mails from graduate students and postdocs all over the world who, having read it, immediately suspected something was amiss and went to the primary literature to check what was going on, and came out interested. One of them, then a graduate student at MIT, got his boss interested, and now a team led by Professor Shuguang Zhang is planning to test my theory directly on reconstituted receptors. On balance, of course, publicity is what every interesting theory should get, because that will hasten its confirmation or disproof. To declare the debate closed after one article, as *Nature* did, seems like undue haste.

Recently at Flexitral we did an audit of all the chemistry done in the past three years. It turned out that our success rate was one product in ten molecules synthesized, two orders of magnitude better than the industry standard of one in a thousand. I guess I'll just carry on using my theory, credence or not.

∾ *The future of fragrance* ∾

The rise of perfumery parallels that of fragrance chemistry. As the great perfumer René Laruelle put it, 'Synthetics are the

bones of fragrance, naturals the flesh.' Too much synthetics and you have bleached skeletons, too much naturals and you're stuck with invertebrates. A good balance between the two, in my opinion, was struck until the mid–1980s, when the fashion for loud fragrances (Poison, Giorgio, Opium) caused an over-reliance on high-impact synthetics from which the industry has yet to recover. It is a bit like being in a crowded restaurant where the conversation noise increases during an evening until everyone is shouting.

As always, there are economic factors at work: now that much workaday chemistry (the commoditized materials which are out of patent) has moved to countries like China and India, the great fragrance houses make their money from discovering and patenting new molecules. Whether these are essential to making great fragrances is debatable: after all, the palette available to the perfumer is enormous already, and there must surely come a point of diminishing returns where a new material makes an incrementally smaller difference. New molecules, however, are very important in selling fragrance, not least to the brands themselves. Fragrance manufacturers have to convince the brands that their product will be different, and the easiest way is to tell them that it will contain a novel 'captive' molecule that nobody else has.

On the cost side, novel materials are increasingly expensive to certify. Regulatory pressure is increasing, especially in the EU, largely because the precautionary principle – the notion that people have to be protected rather than informed – now guides much policy-making. *Caveat vendor* is the rule, and nobody wants to end up with lawsuits, even if the worst thing that happens is a skin rash. The forces at work are probably more closely related to good old-fashioned self-interest than to a great desire to improve the lot of humanity. For example, dermatologists, not normally the most glamorous specialists in medicine, were recently plucked from stygian darkness

to opine on the allergen properties of fragrance, and their recommendations promptly turned into EU regulations.

∾ *Potato crisps and other art forms* ∾

An area which, in my opinion, is ripe for revolution is that of flavours. As I explained earlier, flavours are still figurative, to borrow a term from the visual arts. The bases sold by flavour companies (all major fragrance companies have a flavour wing) have names like 'lemon', 'grapefruit', etc. Things are not as simple as they seem, however, and some corners of the flavour world look more like fragrance. For one, chocolate has always been flavoured with vanilla, which for the last hundred years has meant synthetic vanillin and ethylvanillin. For another, the most successful mass-market edible of all time, Coca-Cola, is as abstract a composition as any in classical perfumery. I defy anyone outside the industry to name more than one ingredient in Coke flavour. In fact, I would say that it is precisely the abstraction of Coke that has made it so successful.

Abstraction in flavours is not new: *haute cuisine* arguably begins where you cease to understand how things are made. The great chef Alain Ducasse once said that he visited a colleague's restaurant and 'could not understand what he was eating', whereupon he asked to be taken on as an apprentice in the kitchen and stayed several years. Perhaps the nearest thing to natural-products perfumery are cocktails, which have gone through a series of boom-and-bust fashions since the 1920s. If one day I find a perfume that gives me the euphoric feeling of a Negroni by external use only, I'll be a happy man.

Maybe the world is ready for truly creative synthetic flavours. Already in the UK, potato chips – or 'crisps' as they are known locally – scale new heights of fancy ranging from

lamb in mint sauce, without trace of either being involved in their manufacture, to a recent 'hedgehog' flavour I have yet to try. I once went into a pub and asked for 'burnt clutch and nitromethane' flavoured crisps and the waiter spun round to look at his rack before realizing I was having him on. Perhaps in future the rich will eat organic food, and white trash like myself will enjoy bilge-and-mutant-cucumber flavoured crisps.

∾ *The future* tout court ∾

When I give talks about my smell work, people occasionally ask me whether I think my vibration theory applies to other receptor-molecule interactions, such as those in the central nervous system. My answer is no, because I believe that the nose faces a unique task that has required what may turn out to be a unique adaptation: detecting any molecule that comes its way. To do that, you need a system based on general physical principles rather than the specific interactions which we commonly call 'lock and key'. That being said, I do not believe for a minute that we really understand even those mechanisms which are supposed to be lock and key.

The situation in the pharmaceutical industry, especially when it comes to drugs that act on the nervous system (tranquillizers, stimulants, hypnotics, antidepressants, anticonvulsants, etc.), is not unlike that prevailing in the fragrance industry. Two lines of argument are being pushed at the same time, often with comically contradictory effects. On the one hand, biology now reigns supreme in the field, and people are using receptor structures to design new drugs rationally – in other words, to make them 'fit' the receptor etc. On the other hand, pharmaceutical companies are generating tens of thousands of candidate molecules, often by automated

combinatorial chemistry methods, and testing each and every one for effect. This, as I always point out to my colleagues in flavours and fragrances, is what you do when you do not have a theory.

As my physicist colleague Marshall Stoneham has said, it is all very well to have a lock and key, but something has to turn the key! Is it thermal agitation, as the biologists suppose? Is it something more subtle? There is, for example, fascinating evidence that the potency of Valium-like benzodiazepines has more to do with their electron affinity than with their shape. Why should that be? Nobody knows, but I'll wager that some interesting physics is going on that we shall soon discover. This field is ready for a leap forward, because vast sums now go to biomedicine, and ideas as always will follow the money. Biophysics is now coming of age, and the great surprises of this scientific century will come when we finally reverse-engineer life's technology. Most of it, I'll wager, will be understandable only with the help of quantum physics and chemistry. Very soon in this field the time for amateurs like myself will be over. I can't wait.

Printed in the USA
CPSIA information can be obtained
at www.ICGtesting.com
LVHW040303230224
772568LV00009B/59